The Herbert History of
ART AND ARCHITECTURE

GOTHIC

Florens Deuchler

Published in Great Britain 1989 by
The Herbert Press Ltd, 46 Northchurch Road, London N1 4EJ

Copyright © Chr.Belser, Stuttgart
English translation © 1973
by George Weidenfeld & Nicolson Ltd, London

Translated by Vivienne Menkes

Printed and bound in Hong Kong by South China Printing Co.

A CIP catalogue record for this book is available
from the British Library.

ISBN 1 871569 07 9

CONTENTS

PHOTO CREDITS Jean Achille, Troyes 154 – Archives Photographiques, Paris 59, 61, 62, 164, 167, 189, 202 – Badisches Landesmuseum, Karlsruhe 103 – Bayerisches Nationalmuseum, Munich 115, 136 – Bernisches Historisches Museum, Berne 193 – Bibliothèque Nationale, Paris 150, 166, 197 – Bildarchiv Foto Marburg 19–28, 31–37, 42, 45–49, 53, 54, 63, 65–67, 69–72, 77–83, 85–87, 89, 90, 92, 98, 100, 102, 107–109, 114, 116, 120, 123–127, 130–133, 163, 165, 168–170, 176, 178, 179 – Joachim Blauel, Munich 138, 139 – British Museum, London 151, 152, 155, 156, 158, 160, 162, 172–175, 182, 184 – Courtauld Institute of Art, London 30, 157 – Jean Dieuzaide, Toulouse 128'– Walter Dräyer, Zurich 134, 135 – Frauen-haus-Museum, Strasbourg, Foto Franz 200 – Hans Hinz, Basel 187 – A. F. Kersting, London 29, 39, 40, 44 – Kindler Verlag, Munich 199 – Kunsthistorisches Museum, Vienna, Photo Meyer 137 – Liebighaus Frankfurt 94, 96, 129 – Metropolitan Museum of Art, New York 58, 64, 68, 73, 97, 101, 110, 159, 186, 191, 192 – Musée de Dijon, Photo R. Remy 198 – Musée du Louvre, Paris 113, 188 – Museum für Kunst und Gewerbe, Hamburg 95, 119 – Rheinisches Landesmuseum, Bonn 146 – Foto Ritter, Vienna 140 – Scala, Florence 145, 149, 190 – Staatliche Museen, Berlin, Photo Steinkopf 203 – Universitätsbibliothek Heidelberg 194 – Verlag Karl Alber, Freiburg 56 – Victoria and Albert Museum, London 195, 196 – Otto Winter, Kloster St. Paul 153 – Württ. Landesmuseum, Stuttgart, Photo Natter]201. All other photo-graphs were provided by the author.

INTRODUCTION

From the point of view of both art history and the development of the human mind, the Gothic period spans the peak and the waning of the Christian Middle Ages. Later generations saw the period between the Romanesque era and the Renaissance as a dark age, linking the term "Gothic" with the negative concept of a barbaric style, embodying all that is abstruse and unintelligible. The true significance and creative achievement of the Gothic era were not appreciated until the Romantic movement of the 19th century. The resolve to complete Cologne Cathedral (1842–80) grew out of a revival of interest in Gothic art; the Romantics—in a mood of piety, sometimes even of ecstasy—experimented with an art based very closely, down to its most minute stylistic details, on an examination of the Gothic style. For them, the stylistic repertory of the Gothic period proved to be astonishingly flexible and permitted the creation of entirely new products. Yet these, in their turn, are still often condemned as historical reconstructions, rather than creative explorations of a still fruitful approach.

The stylistic apparatus of Gothic art encourages the use of standardized units to form a whole. In other words, an architect working in the style can place the individual elements side by side or one on top of the other to suit his purpose. This flexibility has led to considerable misunderstandings. In Italy, for example, the basic Gothic forms underwent drastic alterations in scale and, instead of remaining essentially spatial conceptions, became two-dimensional patterns that are purely decorative. In fact, the technical achievements of the style allow the artist or architect to make the basic elements bigger or smaller, shorter or longer. This inherent flexibility is the fundamental distinction that separates Gothic art—both painting and sculpture—from Romanesque and Renaissance art.

The dimensions of Gothic architecture—which are thus, in theory, virtually limitless—did at times attain a positively gigantic scale, reaching the very limits of man's capabilities. Cathedrals were not only left unfinished, they were downright unfinishable.

Not a single one of the great French churches has come down to us as its architect originally planned it. Their interiors, however, are more or less complete and can give us a consistent and original picture of what the architect was trying to achieve. In selecting illustrations for this book, I have therefore largely avoided exterior views.

In choosing examples of sculpture to illustrate, I have given special emphasis to smaller objects, guided by the observation that the development of monumental cathedral sculpture—which has been illustrated so many times and is easily accessible—was often heavily influenced by the art of the goldsmith and of the craftsmen who worked in ivory.

Finally, in the field of painting, book illustration predominates. Since it has remained intact and has never been restored, it offers a reliable basis for forming a critical judgment of the Gothic style as a whole.

ARCHITECTURE

Gothic architecture reflects a combination of brilliant technical ability, artistic inspiration, and intellectual contemplation. Romanesque architecture is heavier (sometimes, if truth be told, more powerful), because it is conceived in simpler terms and is built up from elements that have fixed, square proportions. The Gothic master builder was a visionary, a daring expert in statics, a mathematician, and a geometrician adept at calculating in terms of the circle. The basic elements of Gothic architecture were governed by a new and flexible spirit. To take one example: the pointed arch, which was the most striking feature of the new style, is extremely adaptable. Unlike the rigid round arch of Romanesque architecture, its angle can be widened or narrowed. Peter Meyer has called the pointed arch "restless": "Our glance cannot pass smoothly from one level to the next as it can over a semicircular arch; instead, it is thrust upward by the sharp angle at the apex. The Gothic arch looks like a slit running up the wall from bottom to top, which might one day tear even further."

From a technical point of view, the pointed Gothic arch permits vaults to be constructed over four-sided or polygonal areas so that the apex (where the diagonal arches cross) is at the same height as the transverse arches and wall arches. (If semicircular arches are used, the resulting vault must necessarily be supported by arches of different heights; it will be irregular and hard to light.) From an esthetic point of view, it means that vaulted areas of the same width can have arches of various different heights, and that vaulted areas of various different widths can have arches of the same height. This offers virtually unlimited possibilities for highly subtle spatial modulations.

Other characteristic features of the Gothic style are the buttress or flying buttress (*Ill. 12*) and the rib vault (*20*). Forming the framework of a rib vault, molded masonry struts, or ribs, concentrate the weight of the stone on individual points, where they are supported by piers or buttressing. In the Late Gothic period, experiments with decorative patterns of ribs produced richly decorated church vaults. Buttressing takes the lateral thrust of arches and vaults and transfers it, as it were, outside the structure. In this way, the flanking walls of Gothic buildings were relieved of their chief burden, becoming thinner and thinner and less and less substantial, until in the end they virtually disappeared altogether. Buttressing, too, became increasingly complicated, as Gothic naves and choirs soared ever higher; in some cases, this led to irrational structural complexity. As a result, the east (altar) end of a Gothic church often seems just as important as the main façade, and it generally appears more important than, for instance, the transept façades.

Le Mans Cathedral (*32*) is an example of the way the spatial layers are frequently split up and arranged in tiers round the choir, in consequence of which the physical compactness that is typical of Romanesque architecture is entirely eliminated. It is, in fact, characteristic of the Gothic style "to experience the unity of the whole through a constant breaking up of the component parts, followed by a process of reconstruction" (Hans Sedlmayr).

The buttressing against the sides and east end of the Gothic church, which is essential to the support of the building, has a definite esthetic value as well. In Rheims Cathedral, for instance, the flying buttress becomes what Georg Dehio has called an "independent towerlike structure." The use of finials copied from the flying buttress (8) on pyxes, on tabernacles, and on the top of altarpieces shows that the buttress was interpreted as an esthetic entity in its own right. The buttress also illustrates the additive approach of Gothic art. An accumulation of structures of the same size and the repeated use of a shape in the smallest possible space are typically Gothic and are not found in either Romanesque or Renaissance art.

Pointed arches, flying buttresses, and rib vaulting were not, of course, Gothic inventions. Rib vaults had already appeared in Durham Cathedral (England) and in northern Italy. Pointed arches occurred occasionally in Romanesque buildings—in Burgundy, in Provence, in Italy, and again at Durham. And the use of flying buttresses to strengthen walls was known to the Romans. They were also used in various forms in Early Christian and Romanesque architecture. But Gothic builders were the first to bring all these elements together to create a unified stylistic repertory, characterized by new esthetic and stylistic features. A decisive factor here was the creation of a canopylike system of bays in which the wall was of secondary importance: The vaults, like canopies, confine space only at the top of the bay; at the sides, the volume contained within the bay is marked out by slender piers. Gothic architecture is made up of spatial prisms.

Where it comes into play, largely in the exterior zones of a building, the wall also has a new role, for it now acts as a screen rather than as a support. Gothic walls can look almost like lattices or can be virtually replaced by windows.

From the historical point of view, the first building to combine all these new achievements is the abbey church of St. Denis (1, 19). Today its location is a suburb of Paris, which in the 12th century, however, was a mere settlement separated from the capital by open country. The church was consecrated in 1144 by Abbot Suger. Rib vaults cover bays of various shapes, while flying buttresses support the radiating chapels at the east end of the chancel (or chevet). These are set close together and form a continuous rippling border around the ambulatory. Inside, there are no walls separating the individual chapels. The whole structure is a single interlocking unit, and the components are no longer kept strictly separate, as in Romanesque architecture.

Only a few buildings can be said to be of epoch-making importance. But the abbey church of St. Denis really does represent the foundation stone of Gothic architecture, initiating as it does the beginning of a long line of development. Its unknown architect, "one can safely say, invented the Gothic style" (Nikolaus Pevsner). Abbot Suger's church had a decisive influence on the majority of French cathedrals built between 1140 and 1250: Sens (20); Noyon (8, 9); Senlis; Notre-Dame in Paris (from 1163 onward, 2, 8, 9, 27, 35); Laon (from 1170 onward, 3, 9); Chartres (from 1194, 5, 8, 9); Rheims (from 1211, 6, 8–13); Amiens (from 1220, 8, 9, 49); and Beauvais (from 1247, 7–9). Only a few fundamental innovations were made later. At Noyon, for example (9), the wall is enriched by a triforium—a low passage set in the wall between the galleries, below, and the clerestory

windows, above, opening onto the nave in a series of short separated arcades. This represents only one step in the continuing attempt to reduce the walls to the absolute minimum necessary to support the building and to thrust the inner space upward.

Unlike Romanesque and Renaissance architecture, the Gothic style is characterized by a playful mobility, and this is also a feature of Gothic sculpture and painting. This quality is perhaps best reflected in a process already noted—the way walls were increasingly broken up. The solid masonry was reduced in visual importance by the use of tracery that unites architecture, sculpture, and windows. The filigree of stonework in the rose and other windows is part of the basic vocabulary of the Gothic style, and the many different variations on the basic structure are a very clear illustration of stylistic experimentation conducted over the years (19, 35, 36, 45–49). In fact, if we use the word "development" here, we must qualify it by saying that it involves a series of variations on a single theme —on the idea of articulating wall and window surfaces adorned with pointed arches. After about 1240, windows became so large that there was no longer any room for an inert strip of wall between them and the vaulting. Walls were, in a sense, driven into window openings and pierced through until they came to resemble latticework.

The basic geometric patterns found in French tracery of the 13th century can be quickly listed. One of the main decorative elements is the trefoil (a triangular design composed of three circles or "foils"), which first appeared as part of the Gothic repertory in 1200 and reached its classic development at Amiens Cathedral, whose triforia and windows were built after 1220 (9, 49). The use of the trefoil in tracery quickly became common: in St. Denis after 1231, in Sainte-Chapelle in Paris (1244–48), at Meaux Cathedral, at St. Sulpice de Favières, and also in Spain (Toledo and Burgos). We also find multifoils (generally quatrefoils), lobed triangles and squares, which are ingeniously fitted together in complex patterns in lancet windows and arranged in radiating patterns in rose windows. The French term for their Gothic architecture of about 1250–1350, *Rayonnant*, gives a very good idea of this feeling of radiation (35, 36). In contrast to it are the Perpendicular Style of vertical emphasis and reticulated ornament that became common in England around the middle of the 14th century, and the Flamboyant Style, which from about 1370 was the governing influence in the work of the Late Gothic period throughout Europe (42, 45–49). The Flamboyant Style is notable for combining a wide variety of flamelike and honeycomb shapes in a tightly knit intricate pattern of lines and open areas—in effect rather like a jigsaw puzzle without a picture.

The sequence of stylistic changes that took place between the Early Gothic and the Late Gothic periods can best be understood if we compare and contrast the façades of three different buildings. From the wealth of possible examples, let us select at random the following for discussion: the 12th-century façade of the abbey church of St. Denis (19); the 13th-century façade of the north transept of Notre-Dame in Paris (35); and the 15th-century façade of La Trinité in Vendôme (48). The west front of St. Denis is made up of a variety of different elements, and its Romanesque origins are still very much in evidence. If we compare it with the west façade of St. Étienne in Caen, which was built about 1070 and is the first real Romanesque example of a two-tower façade, St. Denis seems richer

and more delicate, in spite of a certain lack of stability in the articulation of parts. Plasticity has increased, while, at the same time, the structure has begun to look less substantial. This impression increases if we compare St. Denis with Notre-Dame, and becomes stronger still if we compare Notre-Dame with La Trinité.

Sedlmayr has suggested that in looking at St. Denis we sense the presence of the man who commissioned the building rather than the architect. For the style of the façade is not yet uniform; its coherence lies in its symbolism. Its individual elements—the doorways, the windows in the central register, the rose window, the tower—were later thought out afresh and redesigned. But from the sum of its parts, reduced to a common stylistic denominator, a uniform artistic style was later to emerge.

In St. Denis the main entrance is conceived as the *porta coeli*, the gateway to heaven. All the individual themes and the general iconography are designed to fit in with this concept. The façade should therefore be interpreted as a gateway flanked by a pair of tall towers leading into the City of Heaven. The unbroken ring of battlements suggests the idea of fortifications. The doorways are wider and deeper than at Caen, an innovation that also makes the façade seem richer. The three-fold rhythm of the façade, which in many instances corresponds to the arrangement of nave and aisles, was standard for many years and was abandoned later only occasionally, when special forms evolved, such as the German façade with a single tower (Freiburg-im-Breisgau, *56*). Even the north portal of Notre-Dame is constructed on the same three-fold pattern, though behind it there is a one-aisled transept.

The process of unifying the façade continued. At Notre-Dame, the sculptured Gothic gables above the porches encroach upon the horizontal arcaded structure behind (*35*). But the various members are clearly still intended to be read as individual elements.

At Vendôme (*48*) the portal and the façade merge to form a wall of darting flames. La Trinité and related buildings built about 1500 "look as though they are on fire, flaming and crackling" (Peter Meyer). A circular rose window conceived as a static form would have had no place in such a structure. So the central window, too, has burst into flames and been transformed into a tall pointed aperture, with variants of its basic shape repeated a hundred times in the little flames of tracery.

In general terms, the development of the Gothic style can usefully be divided into four main phases (though, of course, the attempt to fit these phases into specific periods in a sense violates what was an organic evolution). In the first phase (1140–90), the cathedral became the typical church of the French Royal Domain. Architects in Germany and Italy were meanwhile still working in late Romanesque styles, quite uninfluenced by the Gothic revolution; sometimes their work resulted in solutions that look similar, but they are not truly related. The second phase (1190–1250) coincides with the political expansion of the French Royal Domain, leading to the geographical spread of the cathedral. Normandy and England now produced rival styles of their own (for Early English Gothic, c. 1175–1250, see *18*, *29*, *30*), which sometimes led to independent developments and on occasion produced a reaction in France (*28*). Western Spain did not adopt the French-style cathedral until about 1220. During the third phase (1250–1300), the style of the High Gothic cathe-

drals gained foothold throughout Europe and became obligatory for virtually every church. The scale was often reduced and attempts were made to adapt the forms to fit more modest requirements. A fourth stage (beginning c. 1300) saw the emergence of local variants. English church architecture developed along individual lines—the Decorated Style (c. 1250-1340, *39*) and the Perpendicular Style (from 1340, *51*). In Germany we find a peculiarly German style, known as *Sondergotik*, or German Gothic. These variants have virtually nothing in common with the classic French Gothic of the early 13th century, except their most elementary features.

To discuss the Gothic style solely from the view point of its position in the history of art and architecture would result in a distorted picture. Any art is intimately bound up with intellectual achievement and, indeed, springs directly from it—although the artist himself is generally unaware of this fact, which is more the province of the historian. That the Gothic style was particularly subject to rationalization is shown by the fact that the architecture was virtually programmed and bound by certain rules. For example, stylistic variations within the Gothic—such as the art of the monastic Cistercian order (*23, 31, 38, 53, 54*)—can be traced back in large part to written regulations. For instance, the rules for art and architecture laid down by the Cistercians' General Chapter (which were formulated in 1134 and amplified in 1151, 1181, and 1213) make the following points: "Pictures and sculptures are forbidden in our churches or in any rooms in the monastery, because it is precisely on such things that one's attention fastens and thus the profit to be had from good meditation is impaired and an education in religious solemnity is neglected. We do however have wooden crucifixes" (Chapter 20). "The windows shall be plain and shall have no crosses or pictures" (Chapter 80). "Stone bell towers shall not be built" (Chapter 16, 1182).

Cistercian masonry is precision work of the highest order—painstaking care was devoted to cutting the stone—and its total lack of ornament makes it most impressive. Although the interiors of the churches were, according to the regulations, to be kept absolutely undecorated, this sometimes meant that chapter houses, dormitories, and refectories became all the richer. In fact, the most sumptuous chapter houses are to be found in Cistercian monasteries. The refectory was a separate entity within the overall scheme and was often built on a positively monumental scale. Possibly the most impressive example is the monks' refectory at Maulbronn (*31*).

The buildings of the mendicant orders of friars also seem to have been designed according to rigid statutes. The first mendicant orders were the Franciscan (their First Rule was established in 1210) and the Dominican (founded in 1216). Then came the Carmelites (1245) and the Augustinian Hermits (or Augustin Friars; 1303). The emergence of the mendicant orders was connected with the deepening of religious life and with criticisms of ecclesiastical and social grievances in the 13th century. Apostolic simplicity, austerity, poverty, abstinence, and religious zeal were the hallmarks of the monastic life led by the new orders. They gave sermons, heard confession, undertook pastoral duties, looked after the poor and the sick, traveled, and collected alms. Unlike the Benedictines and Cistercians, their activities were centered in towns, which were beginning to flourish at that date. The

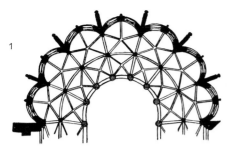

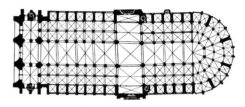

1 FORMER ABBEY CHURCH OF ST. DENIS, PARIS. Plan of the choir. Commissioned by Abbot Suger, 1140–43. The first Gothic choir to have its ambulatory and interconnecting chapels covered with a vault of uniform height (see façade, *19*).

2 NOTRE-DAME CATHEDRAL, PARIS. Plan. Choir, c. 1163–82. Double ambulatory, originally without chapels. The five-aisled nave dates from 1190 (see elevation, *9, 27*). The chapels between the buttresses are later additions (see the north transept, *35*).

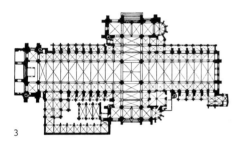

3 NOTRE-DAME CATHEDRAL, LAON. Plan. There were two building campaigns: c. 1170–90 and c. 1190–1210. The original apsidal choir was replaced by a square east end. Sexpartite vaulting (each bay's vault divided by ribs into six parts) over the central part of the church.

Franciscans devoted themselves to the poorer sectors of the community, while the Dominicans made contact with the higher echelons of the bourgeoisie.

About 1250, the mendicant orders began to build churches, all of which reflect the ideal of poverty and the importance of sermons. On the one hand, the emphasis is on simplicity, plainness, and austerity in design and the use of space, and on a policy of economy and restraint in the use of details and in the basic architectural elements. On the other hand, we also note the importance of large open areas; unlike the churches of the older monastic orders, whose worship centered around the altar and the mass, these were intended to be places where ordinary people might gather together to listen to a sermon (*14, 38, 41*). The Franciscans' program (Narbonne, 1260) stipulates that, as far as possible, too much interest (*curiositas*) in paintings, tabernacles, windows, pillars, and the like, together with any excesses (*superfluitas*) in length, width, or height, are to be avoided. The churches are not to have any form of vaulting, with the exception of the presbytery. Moreover, the bell tower is not to be constructed like a tower; and, furthermore, the windows are not to be decorated with narrative scenes or other images, though the main window behind the high altar may show Christ on the Cross, the Virgin Mary, St. John, St. Francis, and St. Anthony.

Yet, although the churches of the mendicant orders had their own individual features, they did not follow a rigid architectural pattern. The most common structures are the timber-ceilinged building with a single aisle, the wooden-roofed basilica, the vaulted

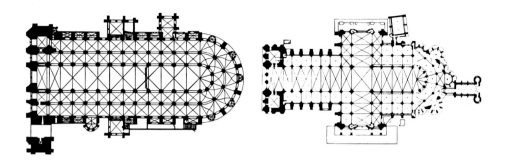

4 BOURGES CATHEDRAL. Plan. Probably begun 1195. Final consecration 1324. The original plan was related to Notre-Dame in Paris (2), with five aisles and no transepts or ambulatory chapels. The latter were added in the 13th century. Sexpartite vault over the central nave.

5 CHARTRES CATHEDRAL. Plan. The new Gothic building was begun in 1194, and work continued until 1260. Cruciform plan with three-aisled projecting transepts, long choir with double ambulatory, choir chapels of alternating size. Quadripartite vaulting over aisles, nave, and transepts.

basilica (such as the Dominican church in Esslingen, built c. 1250/55–68), and the hall church (a structure particularly popular in Germany, with aisles the same height as the nave, though narrower). The plan of the hall church is most probably related to that of secular buildings such as chapter houses, dormitories, and refectories. Two-aisled hall churches were built in the Romanesque period, but only as smaller sacred buildings. The mendicant orders carried the idea over into larger churches, the Dominicans building the earliest two-aisled mendicant hall churches in France: the Jacobin Church in Paris (now demolished), during the first half of the 13th century, and in Agen (begun in 1249), both of which are square-ended and without specifically articulated choirs. This development led to the church of the Jacobins at Toulouse (consecrated in 1292), with its slender central columns and powerful upward movement.

Today the Gothic cathedrals look grey and bare as they rise up from their towns. From a distance their silhouettes create a powerful effect, while from close by their most impressive feature is their accumulation of separate elements, all of which are in perfect harmony. Originally these stone giants were as colorful as Greek architecture once was. The narthex, or entrance hall, of Lausanne Cathedral, for example, was known as a *porta picta* (painted entrance), and the highly influential statue of the Virgin at Amiens (*80*) was gilded and known therefore as the "*Vierge Dorée.*" Similarly, a set of working drawings for Strasbourg Cathedral (Project B), copied in the 17th century, shows that the individual elements were colored red, yellow, and blue. A few blue vaults studded with stars—representing the canopy of Heaven—have survived, and the reconstructed colored decor of the Sainte-Chapelle in Paris can be considered accurate, as long as we ignore the dark tones of the 19th-century paint (*149*).

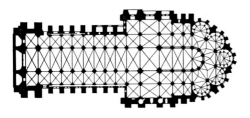

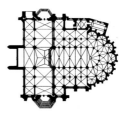

6 NOTRE-DAME CATHEDRAL, RHEIMS. Plan. Begun in 1211, various architects. Three-aisled transepts; choir with ambulatory and chapels. (See also *10–13*.)

7 ST. PIERRE, BEAUVAIS. Plan of choir. 1227–75. Nave not begun until after 1500. After the choir vault collapsed, piers were added in between the existing ones, and sexpartite vaulting was introduced.

The cathedral was designed to be a colorful, imaginative replica of the Heavenly City of Jerusalem. This symbolism was not, in fact, a Gothic innovation, since it has its roots in the early years of Christianity, but the visionary element was not fully realized until the Gothic period. Gothic art was the first to "portray, by means of all the heavenly arts, the Heavenly City of Jerusalem" (Sedlmayr). To this extent, Gothic architecture is representational art. The men of the Gothic age envisaged Heaven as a piece of heavenly architecture: as the Heavenly City, a heavenly throne room, a heavenly citadel. The literary sources of this vision can be traced back to early Christian thought, for the external appearance of Heaven was set down in *The Revelation of St. John.*

The man who created this vision in stone was the master mason. He ran the building lodge, as the association of stonemasons working on the larger churches was known. Unlike the city guilds, particularly in Germany, where masters and journeymen all had to be citizens of the town in question (as stated, for example, in the Regensburg regulations of 1514) and were not allowed to enter into contracts for work further afield, the lodges retained their freedom and had jurisdiction over their own affairs. They were not so much bound to a place as to a building, though individual lodges could in some cases legally attain an important position over a wide area. (Only the lodges in the German-speaking countries attempted to create an overall organization.) The Strasbourg lodge was recognized as the leading court of justice in Central Europe in matters pertaining to building, and its jurisdiction covered southern and western Germany as far as the Moselle, and the whole of central Germany. Cologne was deemed to be the main lodge in northern Germany, while Vienna ruled over the Habsburg dominions, and Hungary and Berne (later followed by Zurich) over the Swiss Confederation.

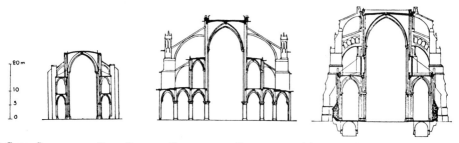

8 CROSS SECTIONS OF SOME FRENCH CATHEDRALS (drawn to scale). From left to right: Noyon,

The builders' workshop was erected very close to the church under construction and was generally a wooden structure, but was sometimes of stone. It was heated, since during the winter the masons worked inside it, carving stones; then, in summer, they could spend most of their time placing the stones in position. Since the building also housed the court of justice, it was the master mason's duty to prevent feuds, drinking bouts, and fornication.

On the artistic level, the master mason acted as an architect, from the drawing-up of the plans for the whole building to the execution of the individual details. In particular, he was responsible for making the forms or templets from which the stonemasons chiseled out the dressed stone. Thus he played a particularly important role in the evolution of a style, in that by directing the way the individual elements were fashioned, he had con-

9 ELEVATIONS OF SOME FRENCH CATHEDRALS (drawn to scale). From left to right: Noyon, Laon, and three-story elevation. The general trend was to reduce and finally eliminate the tribune,

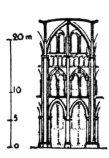
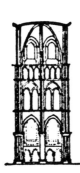
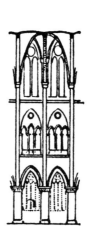
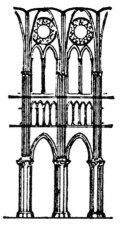

14

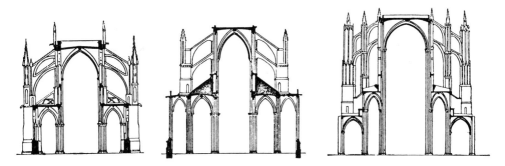

Paris, Chartres, Rheims, Amiens, and Beauvais, showing the overall increase in height.

siderable influence on the way the whole building would eventually look. Whether he was entirely dependent on his client or had retained a measure of artistic freedom determined whether a building was traditional or original.

Judging by the building regulations that have survived, a master mason would be given a new commission on the strength of work he had already accomplished. According to the Strasbourg regulations (Article 12), he had to have started his career in a lodge. It is interesting to note that if he took over a building that had already been started, he was not allowed to alter his predecessor's plans without getting the consent of the client, nor was he allowed to dismantle any stones or reject any pieces of masonry that were not yet in position, or belittle the work of the dead master mason in any way. The *parlier*, or

Paris, Chartres, Bourges, Rheims, Amiens, and Beauvais, showing the development of four-story with the space given over to the clerestory, in the interest of bringing in more and more light.

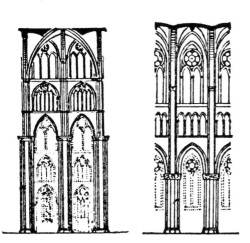
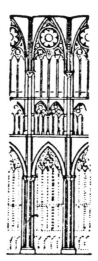

15

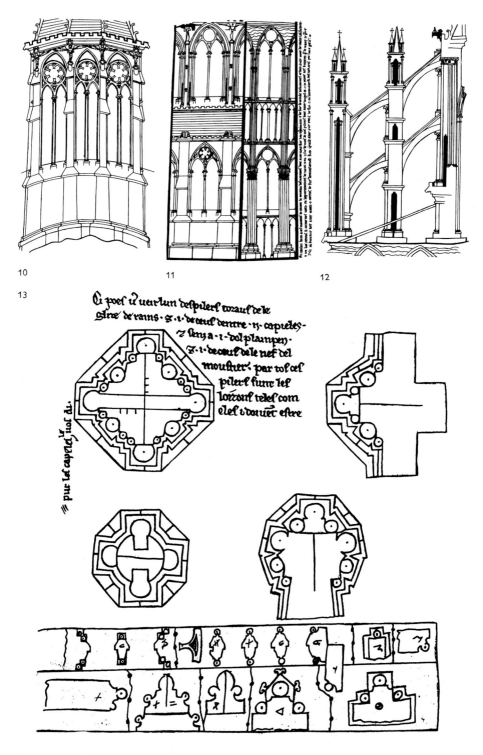

10

11

12

13

Ci poef u ueir lun despilers wraus dele
glire de rains. g. i. de ceus dentre. ij. capieles.
Z len; a. i. dol plainpen.
J. i. de ceus dele nef del
mouster. par tol cel
pilers funt les
loizous teles com
eles i doiuet estre

pur le capea; ios di.

16

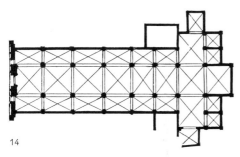

14

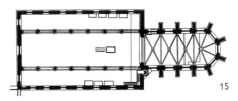

15

10 VILLARD DE HONNECOURT, SKETCHBOOK. c. 1220–30. Bibliothèque Nationale, Paris, MS Fr. 19093. Exterior view of one of the chapels of the choir of Rheims Cathedral.

11 VILLARD DE HONNECOURT, SKETCHBOOK. Exterior (*left*) and interior (*right*) elevation of Rheims Cathedral.

12 VILLARD DE HONNECOURT, SKETCHBOOK. Diagram showing structure of buttressing on the choir of Rheims Cathedral (with the triforium omitted). The support system has been transferred to the freestanding flying buttresses.

13 VILLARD DE HONNECOURT, SKETCHBOOK. Plan of piers and section through the walls of Rheims Cathedral.

14 S. MARIA NOVELLA, FLORENCE. Plan. Dominican church, begun 1246.

15 CHURCH OF CONVENT OF POOR CLARES, KÖNIGSFELDEN. Plan. Begun 1311. Long graceful choir with rib vaulting and no side aisles; the windows in the choir are set so close together that the result is a lanternlike structure filled with brilliant light. A rood screen separates the nuns' chancel from the lay congregation.

16 MARIENKIRCHE, DANZIG. Plan. Begun 1343; completed 1502. Originally planned as a basilica with buttresses and a square-ended choir. After 1484 transformed into a hall church (the aisles are the same height as the nave) with rich Late Gothic vaulting.

17 FREIBURG-IM-BREISGAU CATHEDRAL. Plan. Nave begun in 1235. West tower, c.1275–mid-14th century. Foundation stone of choir laid in 1354. Long choir flanked by chapels. Consecration on completion, 1510.

18 SALISBURY CATHEDRAL. Plan. 1220–65. Double transepts as at the influential French Romanesque abbey at Cluny, Cluny III. Behind the chancel is a hall-like, three-aisled chapel supported on thin piers (Lady Chapel, 29). Marks a new stage in the development of the Early English style.

19 FORMER ABBEY CHURCH OF ST. DENIS. View from the west. The façade was built in 1137–40 and restored in 1833–44. This building represents the true birth of the Gothic cathedral and is characterized by elements of extremely varied origin in both its architecture and its sculpture: richly carved fields (tympana) above the portals, like those of Burgundy and southwestern France; figures in the arches (voussoirs) around the portals, reminiscent of those in the old French province of Saintonge; large figures set in the walls, as in the Toulouse region. The selection and synthesis of these features, which were often highly fanciful, suggest that they were deliberately planned by the man who commissioned the church, Abbot

16

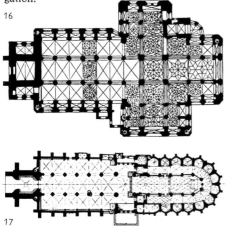

17

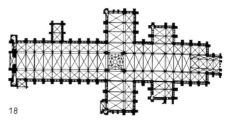

18

foreman, acted on behalf of the master mason, and his duties included making T-squares and rulers and seeing that the journeymen cut and chiseled their stones accurately. A journeyman could be received into the lodge by the master mason after he had spent time in educational travel. He had to lead an honorable life, receive the sacraments, and refrain from gambling (Strasbourg regulations). Apprentices had to serve a specified number of years: for example, in the 13th century, five years in Germany (Strasbourg regulations); in Paris, six years (Paris regulations).

The stonemasons' marks that can be seen on many Gothic buildings are generally considered to be marks of the men who actually did the work. Before a stone was placed in position, the mason recorded the part he had played by carving his mark into it. It seems certain that these marks were also used when it came to calculating rates of pay. It has been noticed that many stonemasons' marks are derived from four basic shapes: a squared circle, a triangulated circle, a quatrefoil, and a trefoil—derived in their turn from the square, the isosceles triangle, and the circle.

The first reference to masons' marks appears in 1462, in the Rochlitz regulations. An apprentice who had come to the end of his apprenticeship was given a mark by his master. Even the exact moment when the journeyman should carve his mark is stated in the regulations—before his stone was inspected and before it was placed in position.

The lodge regulations that have come down to us date without exception from the Late Gothic period and set out the exact duties of the master mason, the *parlier*, the journeymen, and the apprentices, as well as specifying fees and rates of pay. For the earlier period we have few written sources, though one is outstanding—a report on the new building at

Suger. He discusses his new building in three of his writings: the *Orationes* (1140–41), his book *De consecratione* (1144–46/47), and his statement of accounts, *De administratione* (1144–48/49). Suger was aware that he had created a new style, for he calls his work *opus novum* and *opus modernum* to distinguish it from the earlier basilica, which he calls *opus antiquum*.

Choir ambulatory, 1140–43 (*1*); consecration, 1144. The ambulatory and chapels have survived, though the upper parts of the choir were altered in 1231, when a pierced triforium was introduced; the north transept dates from the same period, while the new nave was not completed until 1281.

This pierced triforium inspired those in the choir at Troyes (1230–40), the nave at Châlons-sur-Marne (1240–50), Beauvais (begun 1247, see 7) and the choir at Amiens (begun 1258).

20 ST. ÉTIENNE CATHEDRAL, SENS. View from the choir looking west. The building was con-

structed under the supervision of Bishop Henri Sanglier from c. 1142 to 1160. By 1164 it was so near completion that the altar could be consecrated. The choir dates from before 1162.

This photograph shows how the naves of St. Denis and Chartres must have looked originally. The three-storied elevation (arcades, galleries, clerestory) and the width of the nave are in the ratio of 1.4:1. Important in the early cathedrals is not the rather archaic elevation seen here but the four-story system at Laon (*21*), which aims to push the wall upward. The fourth story was later abandoned, but the upward thrust continued.

Figure of St. Stephen over the main doorway, c. 1215–20; sculptural programs, *speculum naturale* (Mirror of Nature) and *speculum scientiarum* (Mirror of Science), 1220–30; transepts 1490–1517.

21 NOTRE-DAME, LAON. View toward the crossing and the choir. Begun c. 1160–65; square-ended choir, c. 1200. The triforium between the gal-

lery and the clerestory was introduced at Laon c. 1170–80. Behind the triforium, above the gallery vault but below its roof, diaphragm walls buttress the clerestory and spread the thrust of the high vault. The triforium is suspended like a box from the thin upper wall, its back wall resting on the vaults over the gallery. The whole wall has now become diaphanous (see the elevation, 9). This system was also adopted at St. Remi in Rheims, at Châlons-sur-Marne, and at Montier-en-Der. The four-storied elevation should be compared with the south transept at Soissons, begun c. 1150, and with Noyon, 1185–1200 (see the plan, 3).

22 ST. QUIRIACE, PROVINS. View of the choir from the southwest. This church, built at the same time as Laon Cathedral (c. 1160), uses the three-storied wall system, since it is a more modest building. The galleries still have rounded arches but, unlike Sens (20), they are entirely open. The main ribs terminate, as at Laon (21), at the capitals of the piers in the nave. On the left can be seen the bay of the transept, built in 1238, with its pointed triforium arches.

23 CISTERCIAN CHURCH, PONTIGNY. View into the nave. c. 1160–70; choir restored 1185–1200. Buildings of the Cistercian Order, with their compulsory renunciation of pomp and ornament, are marked by a severity that is reminiscent of the Romanesque period, by an ascetic plainness, and by the painstaking detail work of the masonry. Their plan was drawn up by St. Bernard of Clairvaux (died 1153). Similar buildings are Fontenay (1139–47) and the third Clairvaux church (begun 1153).

The Cistercian churches are the forerunners of those built by the mendicant orders of friars (for example, the Minors, the Franciscans, and the Barefoot Carmelites). They were retrogressive, in that they did without costly portals and doors. Their interiors are gigantic bare spaces with undecorated wall surfaces.

24 COLLEGIATE CHURCH OF NOTRE-DAME, MANTES. View from the northeast. c. 1180–1200. The walls, soaring upward, had to be made safe and stable by the use of buttressing from outside. Mantes is an example of an early and still relatively simple system of flying buttresses (see 12, 32). The choir is unusual in that it is not polygonal but semicircular.

25 CHURCH, ST. LEU D'ESSERENT. Chancel, c. 1180. Unlike Provins (22), the paired arches in the galleries are linked by a pointed retaining arch that articulates the area of wall between the gallery and the clerestory windows in the nave and thus makes it seem smaller. The main ribs supporting the vault end at the pier capitals, as at Laon (21) and Provins (22). The well-lit chapels in the choir are miniature apses arranged around the chevet. The use of so much glass increases the feeling of brightness and unifies the lighting by bringing it in from all sides. The ring of chapels is not an innovation in itself; the arrangement of chapels set close together without inert areas of wall between them derives from St. Denis.

26 BOURGES CATHEDRAL. View toward the choir. Begun shortly before 1200, probably 1195. Bourges belongs to the golden age of the Gothic cathedrals—between 1200 and 1225. The enormous French churches begun in this period did not have galleries. Their walls are divided into three stories—arcade, triforium, clerestory—with the height of the vault ever increasing. This trend toward verticality was accompanied by greater widths than ever before. The desire to unify the space can be seen in the way the transepts have disappeared. The arcades are so high that the aisle walls could also be arranged in three stories (this can be seen in the nave elevation, 9).

Building consecrated, 1324; minor alterations made up to the 16th century. (See the plan, 4).

27 NOTRE-DAME, PARIS. View of the northern wall of the nave. Begun 1163, with later alterations. The windows were enlarged c. 1225. For the original design of the windows see the choir chapels at Rheims, 10, or the aisle windows at Amiens. The earliest arrangement of the wall has been reconstructed in the eastern bay of the nave (far right in the photograph): it was originally in four stories, with round windows representing the triforium.

The spatial concept is governed by two decisive ideas: a simplified ground plan (see 2) and a sharp contrast in the elevation between the ground floor and the superstructure. Notre-Dame was the first cathedral to abandon the use of alternating piers in the nave; thus a uni-

form bay design was introduced throughout the building. The main ribs again descend only as far as the capitals of the piers supporting the arcades (see *21, 22, 25*). (Dehio speaks of "the foundations being shifted up to the abacus.") Again for the sake of unity, the outer aisle continues around the choir.

28 AUXERRE CATHEDRAL. View toward the eastern chapels from the southwest. Although begun in 1277, old-fashioned vocabulary and fragile articulation with slender pillars (as in the gallery story at Notre-Dame in Paris, *27*) are used here for the whole chapel. The delicate shafts are typical as early as the period 1215–25, in England (*29*) as well as France.

29 SALISBURY CATHEDRAL. View into the Lady Chapel. c. 1220–25. The chapel is the same height as the aisles and the vaults are supported on extremely graceful pillars. The effect is of "angular crystals. There is nothing rounded in the whole composition" (Peter Meyer). Salisbury is the epitome of the Early English style, which has stylistic parallels with work on the Continent, for example St. Germain, Auxerre (*28*). (See the plan, *18*.)

30 CHAPTER HOUSE, LICHFIELD CATHEDRAL. The springing of the vaulting. The chapter house was built between 1239 and 1249 and is another example of the Early English style. A central pier (not visible in this photograph) is surrounded by ten main ribs that support a vault with twenty diverging lesser ribs, which in their turn span the elongated ten-sided chamber. The cathedral was begun c. 1220; the vaulting in the nave, c. 1300; the west façade, 1280.

31 CISTERCIAN ABBEY, MAULBRONN. View from the south into the monk's refectory. c. 1220–25. The delicately articulated full Gothic style, seen at Auxerre (*28*) and Salisbury (*29*), became considerably more robust east of the Rhine. The architect appears to have come from Burgundy, and his work can also be seen at Walkenried and Magdeburg, from about 1240 onward.

32 LE MANS CATHEDRAL. View of the choir and the beginning of the northern transept from the northeast. Choir begun 1217; upper clerestory begun 1248, completed 1254. The east end is seven-sided, with a double ambulatory and strongly projecting radiating chapels. The low roof over the inner ambulatory permits the clerestory windows to continue down to the level of the arcade. This glass shrine and its vault hang lightly amid the buttresses and their supporting arches "as the body of a spider is suspended from its legs" (Peter Meyer).

33 NOTRE-DAME, DIJON. The nave wall. Begun c. 1220–30, completed c. 1240. The three-storied elevation is adopted here on a smaller scale. The main ribs end, as in many early examples (*21, 22, 25, 27*), at the capitals, which gives a feeling of instability. The unique two-part façade dates c. 1230.

34 CLERMONT-FERRAND CATHEDRAL. The lower portion of the nave wall. The cathedral was begun by Jean des Champs in 1262 (the early date of 1248 that has been given the building cannot be substantiated). Clermont belongs to a new generation of cathedrals that have no capitals at all: The clustered shafts soar up unimpeded toward the vault. New decorative elements appear in the triforium; tracery is used to articulate the windows and the arches. Other buildings dating from the same period: Narbonne (begun 1272), Toulouse (begun 1272), Limoges (begun 1273), Rodez (begun 1277).

35 NOTRE-DAME, PARIS. North transept. Begun by Jean de Chelle shortly before 1250. The details are related to those in the adjoining chapels in the nave, which must date at 1245. It therefore seems possible that Jean de Chelle began work on the transepts c. 1246–47. The Seventh Crusade of 1248–54 was no doubt responsible for the time taken to complete the additions. The south transept, the largest structure to be built in Paris in the 1260s, was begun in 1258. The giant rose windows, typical examples of the *Rayonnant* style, begin to look like flowers. The triforium and the rose, for the first time since St. Denis in 1231, form one vast expanse of window. The *Rayonnant* style quickly spread; by c. 1277 it had already reached Strasbourg, and by c. 1260 the Champagne district and the south of France (St. Nazaire, Carcassonne, transepts c. 1267).

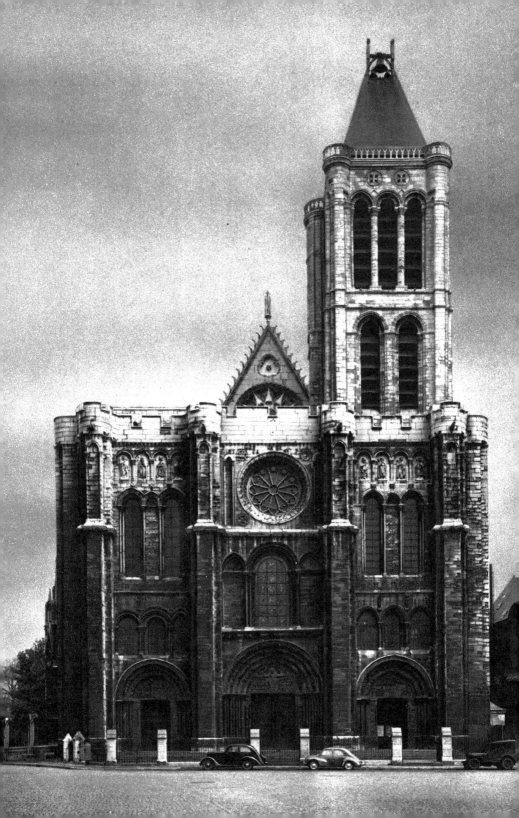

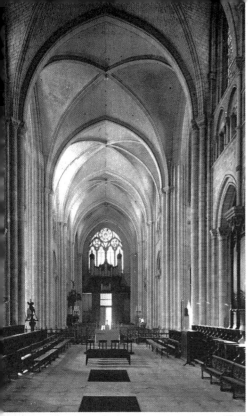

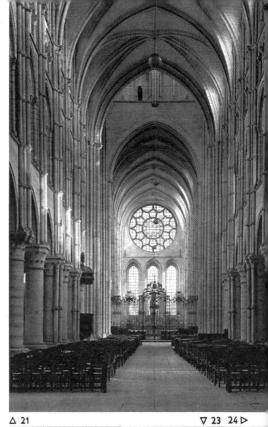

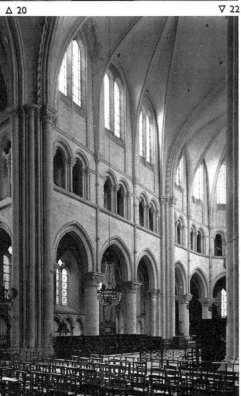

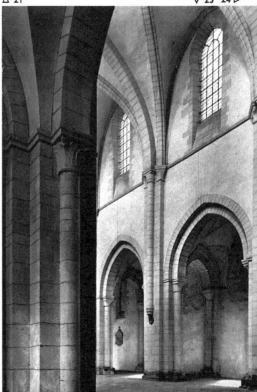

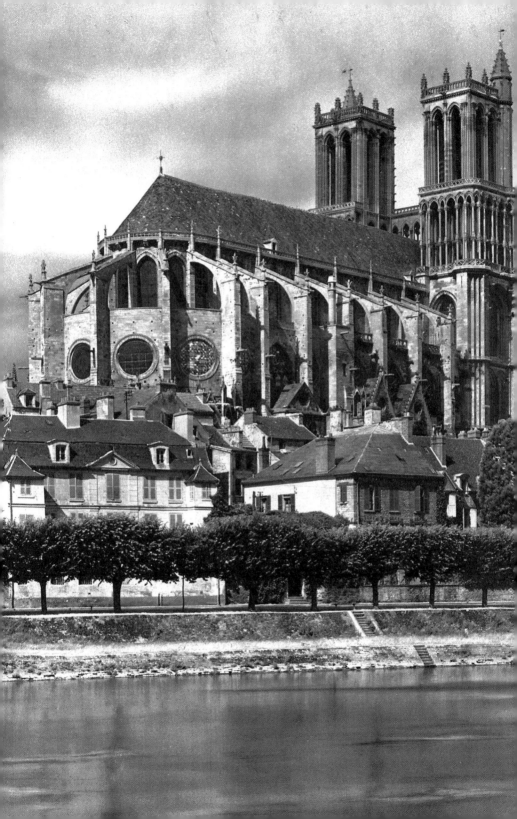

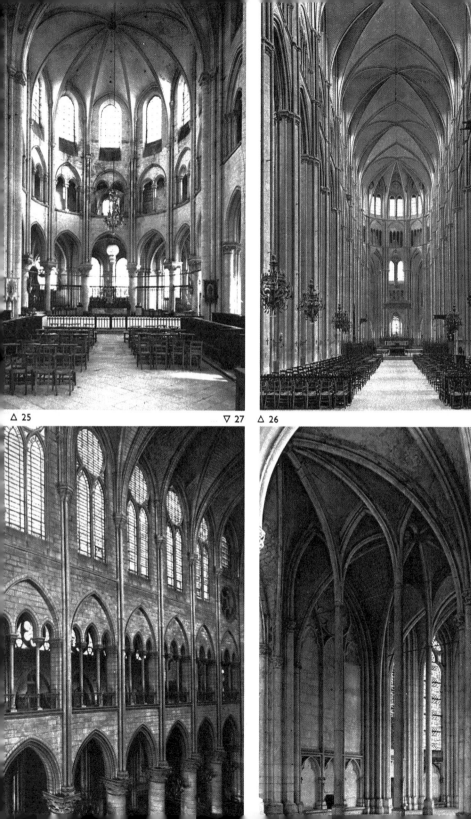

△ 25 ▽ 27 △ 26 ▽ 28

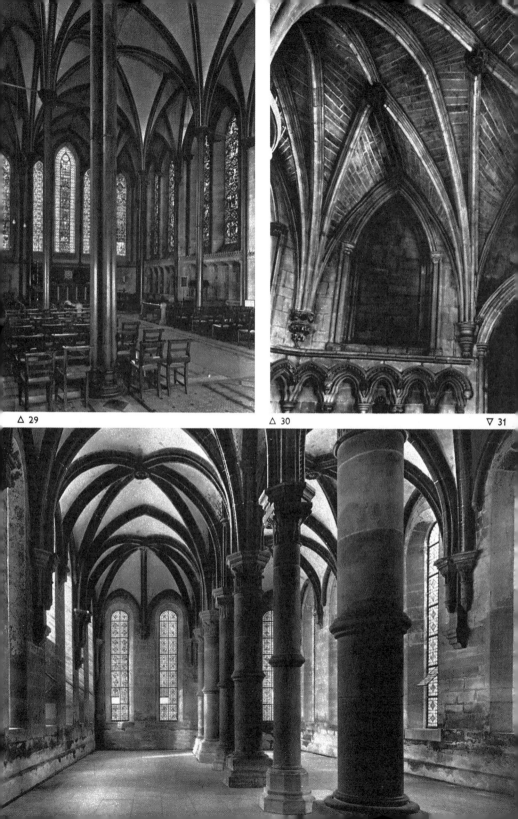

△ 29 △ 30 ▽ 31

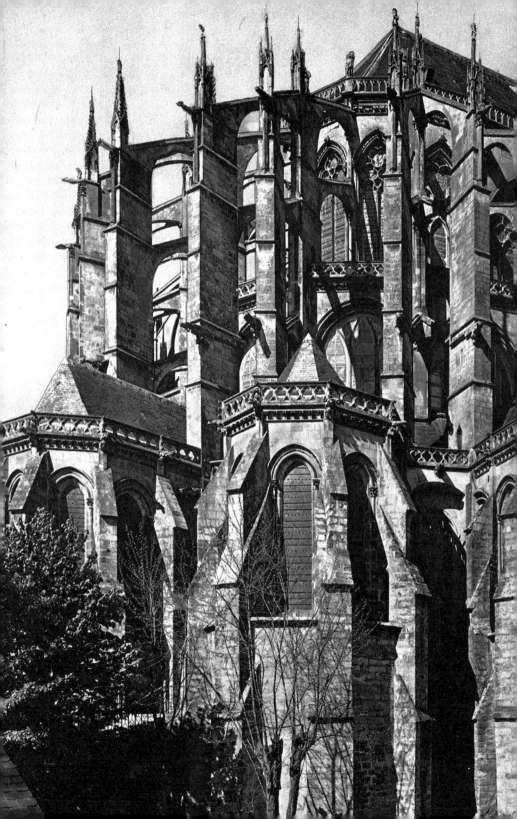

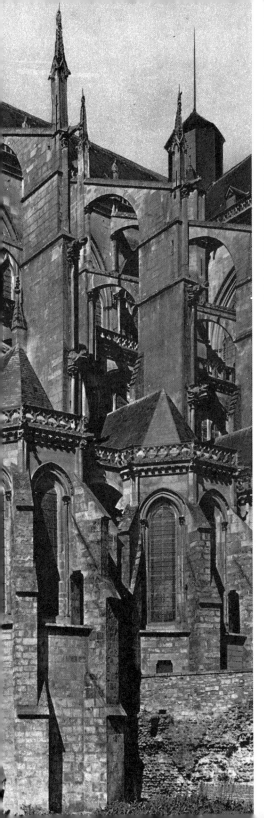

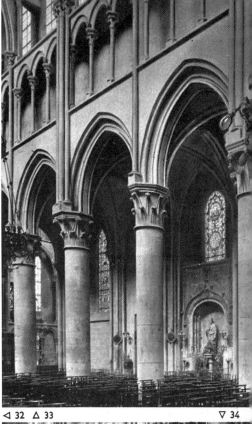

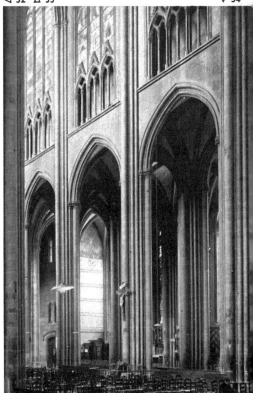

◁ 32 △ 33 ▽ 34

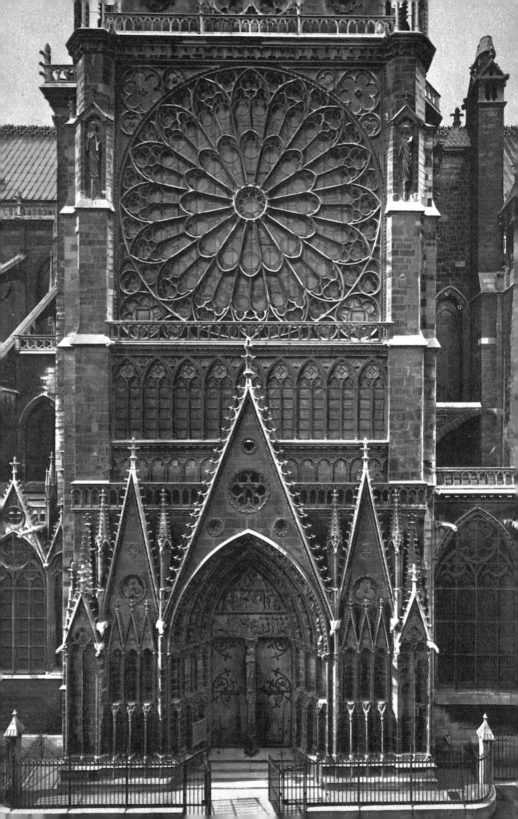

Canterbury, begun in 1175 by the French master mason William of Sens. The east end of the church, including the chancel, had been destroyed by fire in 1174, and William was entrusted with the rebuilding. A chronicle written by Gervase of Canterbury contains a detailed description of the new building. This is unique and gives us greater insight than any other document into the work of an architect in the early years of the Gothic period:

"Meanwhile, the brethren consulted how, and by what method, the ruined church might be repaired. Architects, both French and English, were therefore assembled; but they disagreed in their opinions; some undertook to repair, while others, on the contrary, affirmed that the whole church must be taken down, if the monks wished to dwell in safety. This, though true, overwhelmed them with grief.

"Among the architects there was one, William of Sens, a man of great abilities, and a most curious workman in wood and stone. Neglecting the rest, him they chose for the undertaking, and to him and to Providence was the work of God committed.

"And he, residing many days with the monks and carefully surveying the burnt walls in their upper and lower parts, within and without, did yet for some time conceal what he found necessary to be done, lest the truth should kill us in our present state of hopelessness.

"But he went on preparing all things that were needful for the work, either himself or by the agency of others. And when he found that the monks began to be somewhat comforted, he confessed that the pillars damaged with the fire and all that they supported must be destroyed if the monks wished to have a safe and excellent building. At length they agreed, being convinced by reason and wishing to have the work as good as he had promised, and above all things to live in security.

"Patiently, though not willingly, they agreed to take down the ruined choir. Attention was given to procuring stones from abroad. He made most ingenious machines for loading und unloading ships, for drawing the mortar and stones. He delivered, also, to the masons who were assembled, models for cutting the stones; and, in like manner, he made many other preparations. The choir . . . was taken down; and nothing more was done for the whole first year.

"In the year ensuing, Master William erected four pillars, two on each side. Winter being over, he placed two more, that on either side there might be three in a row: upon which, and upon the exterior wall of the aisles, he neatly turned arches and a vault; that is, three keys on each side. By the key I mean one vaulting unit, as the key [boss] placed in the middle serves to close and strengthen the parts on each side. This was the employment of the second year.

"In the third year, he placed two pillars on each side, the last two of which he decorated with small marble columns; and, because the choir and the transepts were there to meet, he made them the principal. On them keystones being placed, and an arch turned, from the Great Tower as far as the before-mentioned pillars—that is, as far as the cross—he introduced in the lower cloister [that is, in the triforium] several marble columns; above which he made another cloister [the clerestory] of different materials; after that, three keys of a great arch, namely, from the lower to the crosses: all of which seemed to us, and to everyone, inimitable, and in the highest degree praiseworthy.

35

"Thus the third year ended, and the fourth began; in the summer of which, beginning at the crossing [transept], he erected ten pillars, that is, five on each side. Adorning the two first, opposite to the two others, with marble columns, he made them the principal. On those ten he placed arches and vaults. Both the cloisters and the clerestory windows being finished, while he was preparing his machines for turning the great arch, at the beginning of the fifth year, the scaffold suddenly gave way, and he came to the ground from the height of the crown of the upper arch, which is fifty feet. Being grievously bruised, he was utterly unable to attend to the work. No one but himself received the least hurt. Either the vengeance of God or the envy of the Devil wreaked itself on him alone. Master William, being thus hurt, entrusted the completion of the work to a certain ingenious monk who was overseer of the rough masons; which occasioned him much envy and ill-will. The architect, nevertheless, lying in bed, gave orders what was first and what last to be done. A roof, therefore, was made between the four principal pillars; at the key of which roof the choir and the transept seem, in a manner, to meet. Two roofs, also, one on each side, were made before winter; but the weather, being extremely rainy, would not suffer more to be done.

"In the fourth year there was an eclipse of the sun on the 6th of September, at six o'clock, a few months before the architect's accident. At length, finding no benefit from the skill and attention of his surgeons, he gave up the work, and, crossing the sea, went home to France.

"In the summer of the fifth year, another William, an Englishman, succeeded the first William in the care of the work; a man of diminutive stature, but in various ways extremely ingenious and honest."*

It is during the Gothic period that the master mason begins to emerge from the anonymity in which he was shrouded throughout the early Middle Ages. He soon became far more than a mere craftsman, rising to the rank of creative artist. He was the only person able to envisage exactly how the finished building would look; other masons became specialists in limited fields, working only on parts of the buildings. The names that have come down to us from the 13th and 14th centuries include those of Robert de Luzarches, Pierre de Montereau, Jean le Loup, Jean d'Orbais, Gaucher of Rheims, Bernard of Soissons, Villard de Honnecourt, and Matthias of Arras. However, attempts to ascribe specific buildings in Paris, Amiens, Rheims, and Prague to these master masons are little more than conjectures.

It is significant that their names generally include their home towns, indicating that they probably worked their way up through the local workshop to become leading figures in their own right. It is not until the end of the 14th century that we can link names of artists more specifically with the buildings they worked on: Peter Parler (c. 1330–99) with Prague Cathedral (43); Ulrich of Ensingen (1359–1419) with Ulm Cathedral; Hans von Burg-

* The translation and notes are adapted from Charles Cotton (ed.), *On the Burning and Repair of the Church of Canterbury in the Year 1174—From the Latin of Gervase, a Monk of the Priory of Christ Church, Canterbury* (published by the Friends of Canterbury Cathedral; Canterbury Papers No. 3; Cambridge University Press, 1930).

hausen (active 1389–1432) with St. Martin in Landshut; Konrad Heinzelmann (c. 1390–1454) and Konrad Roriczer (c. 1410–15) with St. Lawrence in Nuremberg (55).

The main patrons were the bishops, some of whom also acted as architects. Tradition has it that in the case of monastic buildings, the abbot occasionally appointed one of the monks as "building prefect," to oversee the work according to the abbot's directions. The master builder, the stonemason, and the mason were lay brothers (*fratres conversi* or *fratres barbati*). The monks or friars must also have worked on secular buildings, for in 1157 the General Chapter of the Cistercians issued an order forbidding monks or *fratres conversi* to work for secular patrons. During the Gothic period, however, virtually all building passed into the hands of the laity, and monastic workshops were the exception.

Gothic architecture is not restricted to churches and monasteries; it includes the residences of citizens and the castles and citadels of the nobility, as well as public buildings of many kinds. There are no standard designs for these because the difficulties presented by particular sites and the use requirements varied greatly, but the style was so flexible that a large number of very impressive secular buildings were created.

Insofar as we can draw conclusions from miniature paintings of secular buildings that have since disappeared, the Gothic version of the Louvre must have been an important work, dominating the skyline of medieval Paris with its many towers and battlements. The Palace of the Popes in Avignon, although badly damaged, is one of the most powerful pieces of Gothic architecture to be seen today. Other buildings that were a source of wonder to their contemporaries were the seventeen castles built by that great lover of architecture, Duke Jean de Berry, who died in 1416. Several of the immensely detailed pictures in one of his Books of Hours, the *Très Riches Heures* (Musée Condé, Chantilly), are a good source for our knowledge of how buildings looked at that date. In the miniature for the month of March, for instance, we see the heavily fortified castle of Lusignan, one

36 STRASBOURG CATHEDRAL. Rose window in the west façade. The plans for the building were ready by c.1277 and the first story was definitely completed before 1298, though work continued until the end of the 14th century. The rose window is the most striking feature of almost all cathedral façades (*19, 35, 45–49*). Since St. Denis, the sun-shaped wheel had signified Christ, and in Strasbourg this motif became yet more radiant. *Rayonnant* tracery of a jewel-like brilliance covers the whole façade and was not surpassed in complexity until the Late Gothic period (*46, 47*), when the window openings are sometimes no longer discernible as individual elements.

37 AUXERRE CATHEDRAL. View toward the choir. Work begun c.1215–34, nave erected between 1309 and 1401. Unlike the piers at Clermont-Ferrand (*34*), which are made up of small rounded shafts, after 1300 we find piers with grooves and convex areas. Pier bases also become more complicated, and, instead of taking on the same outline as the whole pier, they have independent polygonal silhouettes.

38 S. MARIA NOVELLA, FLORENCE. View toward the choir. Begun 1246. This Dominican church, built according to Cistercian regulations, marks the beginning of Gothic architecture in Tuscany. The powerful arches, the emphasis on spaciousness, "the replacement of Gothic shafts with members that have a look of the classical pilaster about them" (Hans Sedlmayr) are typical of the way in which Italians transformed French Gothic elements to create their own style. The rectangular east end is reminiscent of other Cistercian buildings. (See S. Croce, Florence, *41*.)

39 EXETER CATHEDRAL. View into the choir. 1288–1308. The nave, which is covered with multi-ribbed vaults, is perhaps "the most unified of all churches in the specifically English High Gothic style" (Peter Meyer). Exeter is a good example of what is known as the Decorated Style.

40 WELLS CATHEDRAL. East choir. The parts of the choir that are visible in the photograph were rebuilt in 1320–63. The vaulting is full of original and imaginative flourishes that recall later Gothic work in Germany.

41 S. CROCE, FLORENCE. View into the nave. Begun 1294. Similar in its spatial organization to S. Maria Novella (38), this church was built at the same time as some Dominican Gothic churches in northern Italy: S. Domenico in Bologna, S. Anastasia in Verona, S. Maria della Grazie in Milan, SS. Giovanni e Paolo in Venice, S. Maria sopra Minerva in Rome (begun 1280). These were followed by the façade of Orvieto Cathedral (1310, designed by Lorenzo Maitani) and, in 1340, by S. Maria Gloriosa dei Frari in Venice, an important Late Gothic building.

42 PALAIS DES COMTES, POITIERS. Detail of the chimney wall, 1384–86. This wall in the palace of the Duke of Berry is a superb example of the secular version of the Flamboyant Style, in which the tracery consists of flamelike ribs of stone.

43 PRAGUE CATHEDRAL. View into the nave. Begun 1344, probably by the northern French architect Matthias of Arras; continued (from 1353) by Peter Parler. The three-storied wall, with its pointed arcades, open triforium with ornamental parapet, and tall windows, is one of the most impressive achievements of the Gothic style outside France.

44 GLOUCESTER CATHEDRAL. The southern walk of the cloister. 1381–1412; probably built by Robert Lesyngham. Fan vaults were first installed in the eastern walk of the cloister between 1351 and 1377 and were then adopted throughout. The subtle way in which walls, windows, and vaulting blend into a single unit through the use of ribs is unique. This is the earliest example of this type of vaulting, which becomes a characteristic feature of English architecture down to the 17th century. For a later example, see King's College Chapel in Cambridge (51). For examples where the wall is similarly dissolved, see the rose window in Strasbourg (36) and the west façade of Rouen (47).

45 ST. ÉTIENNE, SENS. Rose window in the south transept, 1490–97. An example of the Flamboyant Style. The undulating tracery is not restricted to the round window but spills over onto the stone panel and seems also to have grown above the tops of the lancet windows.

46 AUXERRE CATHEDRAL. Rose window in the north transept, 1392–1401. The ornamental patterns formed by the tracery illustrate the delicate and subtle designs of the period. An early and still relatively sober example of the Flamboyant Style. Later, more complicated versions are found at Sens (45) and Rouen (47).

47 ROUEN CATHEDRAL. Rose window and Gothic gable above the central doorway in the west façade. Flamboyant-style additions to the west front: 1386/87; 1485; and 1509–14. A wealth of flaming vertical elements covers the west front of the cathedral. "An abstract, insubstantial gable penetrates an equally ghostlike arcaded gallery" (Peter Meyer). The façade was completed by Roulland le Roux in the early 16th century. The individual pieces of tracery seem to melt into each other.

48 LA TRINITÉ, VENDÔME. West façade. c. 1500. The narrow façade of this church is not dominated by a rose window; instead, the whole wall seems to be ablaze, pierced by thousands of darting shapes. The doorways, built between 1485 and 1506, represent a somewhat more subdued type of Flamboyant architecture than that found at Rouen. The archivolts are adorned with cusps that form an openwork border. The spectator entering the church seems to push his way through a fluttering veil.

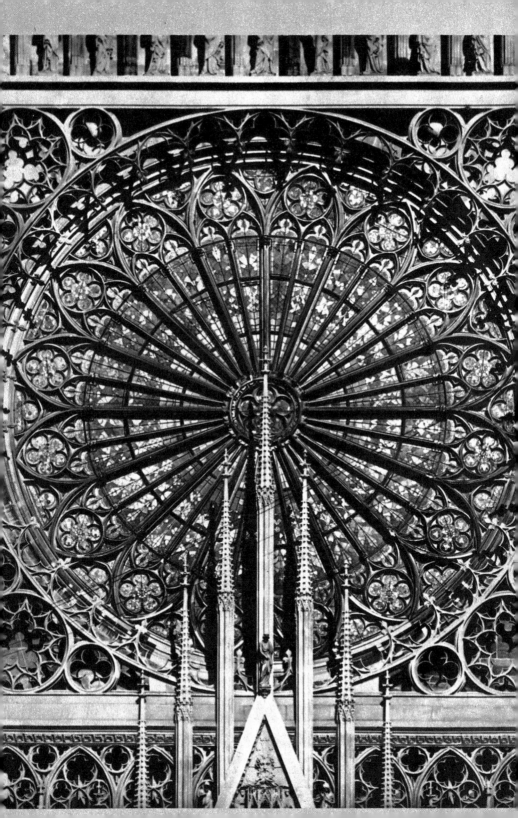

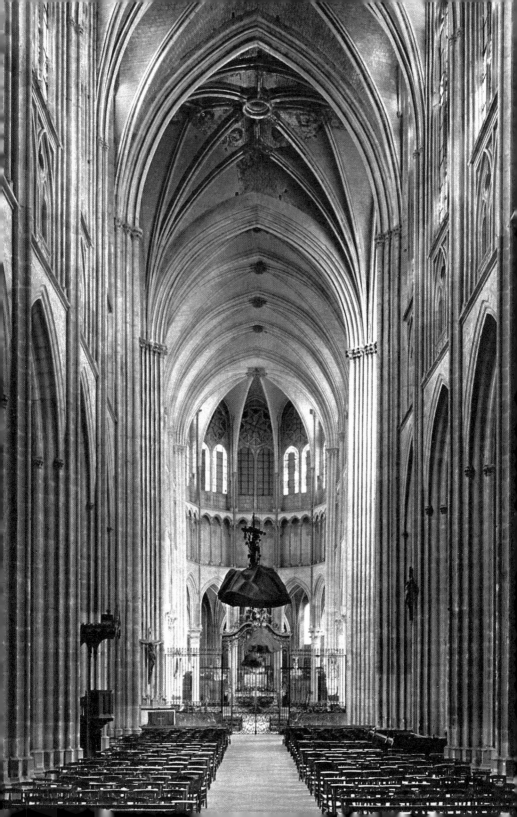

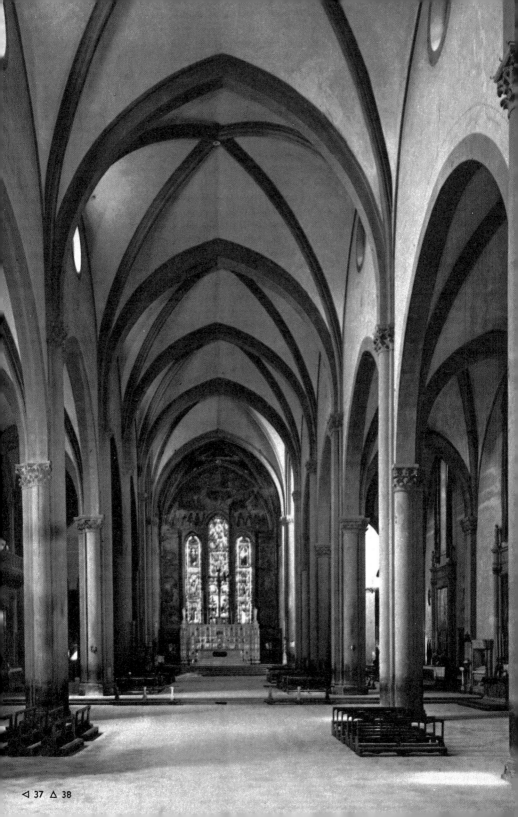

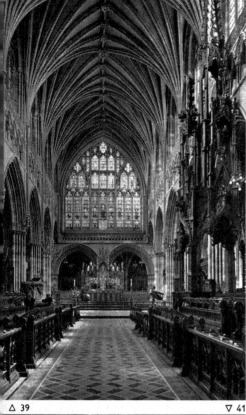

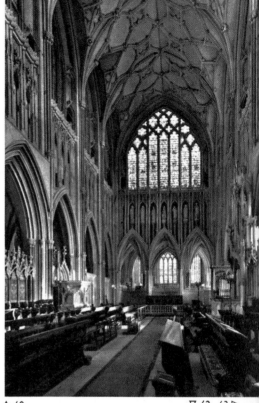

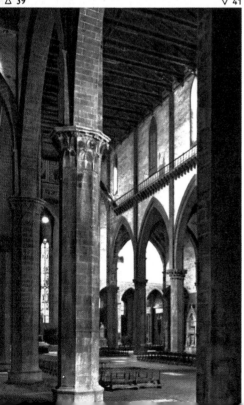

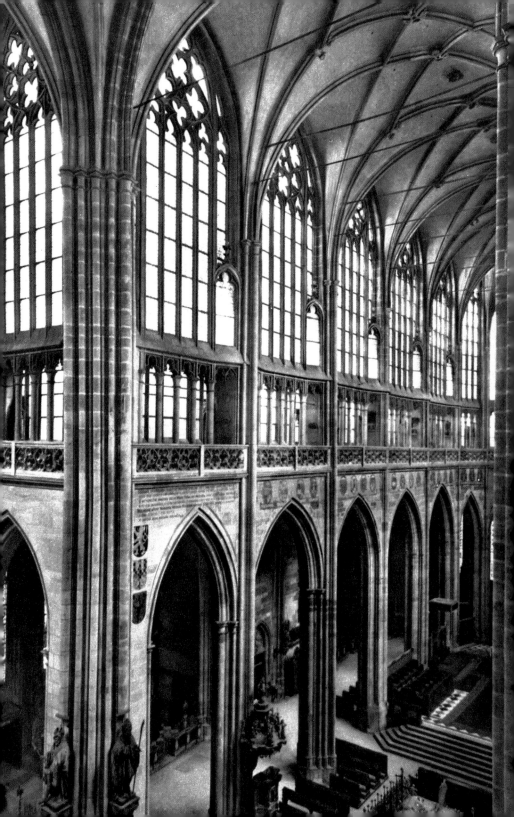

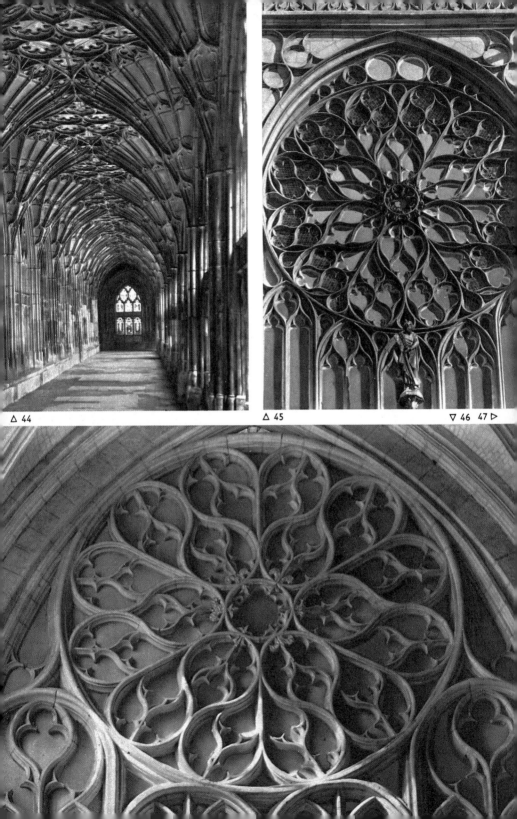

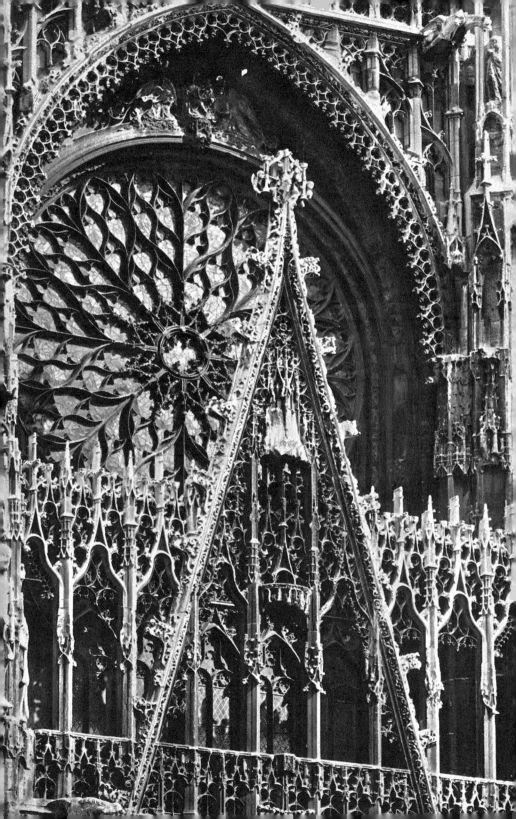

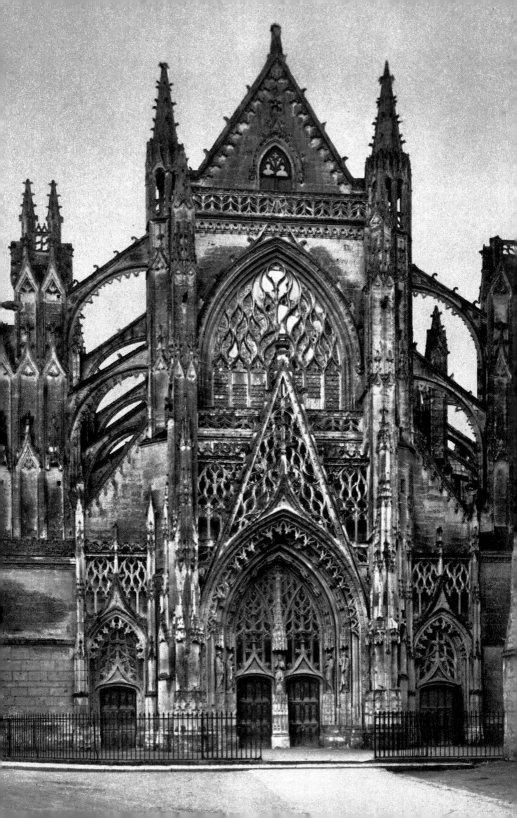

of the duke's favorite residences, which really looks like a whole town. The page for April depicts the charming castle of Dourdan, which Jean de Berry acquired in 1400 and then proceeded to fortify. The September page shows the castle of Saumur, which belonged to the duke's nephew, Duke Louis II of Anjou. This series offers one of our finest visions of late medieval architecture. The tiniest details have been recorded, so that there would be little difficulty in building a copy of each complex today.

In the house for Jacques Cœur, treasurer of Charles VII of France, in Bourges, built in the middle of the 15th century, we see the transition from country castle to town mansion that occurred at the end of the Gothic era. High ecclesiastical dignitaries in France wanted personal accommodations in the seats of their power; thus, the archbishop of Sens erected the impressive Hôtel de Sens—a striking building with towers and gables—between 1475 and 1519, and after 1490, Jacques d'Amboise, abbot of Cluny and bishop of Clermont, built his own Hôtel de Cluny (now a museum).

While few secular Gothic buildings have survived in France, both England and Germany still have a large number of medieval fortresses and castles, some of which are now in ruins. For instance, the walls and towers of Caernarvon Castle, Wales, date from the time of Edward I, as does the basic structure of Conway Castle (built by Henry of Elreton in 1284). And in Wells, a Late Gothic bishop's palace stands today next to the cathedral.

In the small principalities of eastern Europe, fortresses were often modeled on French buildings, and in 1333 Charles IV of Bohemia—who had been brought up at the French court and was married to a French princess—had Prague Castle restored along the lines of the residence of the French kings. Karlstein Castle near Prague (completed 1348–65), constructed to house the German crown jewels and the royal reliquaries, is matched in size only by the fortresses built by the Teutonic Knights, such as the Marienburg in West Prussia and the buildings belonging to the Hohenstaufen family in Italy—the *castelli* in Bari and Gioia and the earlier Castel del Monte.

Whole towns in the Gothic manner have survived in several places in western Europe. These "architectural landscapes" can supply us with a good deal of information about life in late medieval times. If they had not been pulled down before, the Roman and Roman-esque walls that had customarily encircled urban settlements were generally dismantled during the Gothic period. North of the Alps, this often resulted in a sharp contrast between the old and the new town, while in Italy we can generally trace an organic development, with new buildings radiating out from an earlier central core. The principal town square, or *piazza maggiore*, which was usually laid out near this center, remained the focal point of life in the Italian town. Throughout Europe, in Gothic times as before, the church formed the spiritual center of the city, but it now came to express as well the growing power and wealth of the bourgeoisie, who were patrons of the new building. In this period, too, the warehouse assumed an increasingly important role in the life of the town—betokening the successful trade being carried on by the townspeople.

Alongside the towns that expanded (and, in the Gothic period, also experienced a good deal of rebuilding—as the Flemish towns of Brussels, Ghent, and Bruges show), we should ◁ 48 mention that some new towns were laid out according to a uniform plan. An example of

this is Carcassonne in southern France, which in fact gives us an insight into both types of development. The upper town (*cité*), which grew on Roman foundations, assumed its present form in the 12th and 13th centuries, developing over the years in a haphazard fashion. Its structure is rather like a crown, dominated by the castle turrets and the cathedral (completed 1320). The lower town (*basse ville*) was laid out by Louis IX (St. Louis) in 1247 on a plan as regular as a chessboard, similar to Aigues Mortes (begun 1272) and Monpazier (begun 1284).

Berne is a good example of a northern town established in the Gothic period. Duke Berchthold IV of Zähringen founded it in about 1190 on a hill surrounded on three sides by the river Aare. The final expansion of the central city occurred in stages between 1344 and 1346, and on this tongue of land arose one of the finest Gothic cities in Europe. The minster (choir completed 1410) and its site play a large part in the overall impression created by the town, for from a distance it dominates the urban silhouette, seeming to grow upward from the matrix of the houses. Yet, when you enter the town, you have to hunt for it. There is no road leading up to it, which would make it clearly visible, and the surrounding squares have been kept small. This means that its towering bulk comes as a surprise after the succession of narrow streets and makes a deep impression on the visitor.

One or two buildings in Flanders illustrate another type of Late Gothic architecture. The skylines of Flemish towns are dominated by town halls and market buildings. The tower of the Cloth Hall in Bruges is reminiscent of the *torri* on town halls in Italy, while the Cloth Hall in Ypres (completed 1380 and destroyed in World War I) was the largest public building in the Low Countries, with a façade 433 feet long.

Another important secular building in the Late Gothic style is the Palais de Justice in Rouen. Bristling with fretted ornament, undulating gables, and sharp pinnacles, this magnificent example of the Flamboyant Style is "ironwork in stone, the last word in a pictorial architecture which aims above all at effects, movement, color, and illusion" (Henri Focillon). The Venetian Gothic palace deserves a chapter to itself. The finest examples lie along the Grand Canal, and the style reaches its peak in the Doges' Palace. Altogether different in feeling from the Flamboyant architecture of the North, this exquisite structure exhibits a restraint and delicacy that possibly reflect an oriental influence. The lagoon façade was built in 1310–40, that facing the Piazza S. Marco in 1422–39.

It seems important at this point to mention the external spaces created by architecture in which the artist—be he architect, sculptor, or painter—lived, absorbed impressions, and worked. For the environment surrounding the creative artist has as decisive an influence on his work as do his place of origin and the events of his era. Gothic artists were the first since classical times to discover the physical world around them, to recognize it for what it was, and to accept it as being worthy of portrayal. Thus the period witnessed the beginning of a long series of city views. Though at first these were idealized, from about 1400 they became much more realistic. Paintings of architecture, reflecting contemporary life, can be seen in 14th-century book illumination; we have already noted how useful this is to the architectural historian. In Late Gothic panel painting, we also find highly impressive cityscapes.

FOUNDING OF A CITY. Woodcut. Ulm, 1486.

49 NOTRE-DAME CATHEDRAL, AMIENS. Center of the west façade, with rose window. The Flamboyant tracery in the window was added to the 13th-century façade c.1500. Just below the rose is the Gallery of Kings—filled with sculptures representing the kings of the Old Testament—which was probably completed c.1236. The arrangement is not very successful: The rose window suffers because the central area seems constricted.

The cathedral was begun by Robert de Luzarches in 1220; the nave and the transept were vaulted by 1233; the choir was finished in 1236. The rose window in the south transept also dates from c.1500. A contemporary building is Beauvais Cathedral, begun in 1227 (7, 9).

50 ST. PIERRE, LOUVAIN. Choir screen, 1488. The choir screen was a feature of Gothic cathe-

drals (Sens, c.1220–30; Chartres, 1220–40; Strasbourg, c.1247; Amiens, c.1260); it was not found in ordinary churches until a later date. It was used when the dean and chapter wished to shut off the choir from the area where the congregation assembled. See the plan of Königsfelden (15) or the interior of a church painted by Jan van Eyck (203). It was here that the lectern stood and here that the Epistle and Gospel (lectura) were read (hence the German term Lettner). Later the name came to be used for an entire dividing wall.

The choir screen at Louvain, with its ogee arches, fits in with the rest of the church particularly well because it was made at the same time. The choir was built between 1425 and 1440; the nave clerestory followed in 1480. The latter has various features in common with Ste.

43

Gudule Cathedral in Brussels (1450–90). The triforium is articulated by bars of tracery that create a vertical rhythm leading to the lancet clerestory windows above.

51 KING'S COLLEGE CHAPEL, CAMBRIDGE. Vaulting, 1446–1528. The vast, box-shaped room with low flanking chapels set between the buttresses is covered by one of the most fanciful vaults of the Late Gothic period. This so-called fan vaulting is a feature of the Perpendicular Style.

52 COLOGNE CATHEDRAL. View toward the southwest from the north transept. This is the largest Gothic church in Germany and has five aisles. The plan is derived from Amiens (and St. Denis II) but is even clearer and richer. Building commenced under Master Gerhard in 1248, but only the choir (consecrated in 1322) and the base of the towers (begun in 1350) date from the Gothic period. The rest of the building was completed c. 1842–80, exactly as laid down in the original plans.

53 CISTERCIAN CHURCH, ALTENBERG. View toward the choir. After 1255. The foundation stone was laid by Konrad von Hochstaden. The plan follows that of Royaumont Abbey, France (consecrated in 1236), and also has analogies with Cologne Cathedral; in fact, Altenberg is a Cistericial interpretation, on a reduced scale, of Cologne Cathedral. (Royaumont is also a scaled-down version of the typical cathedral plan.) Altenberg is important in that it shows how quickly the Gothic style was accepted and became widespread east of the Rhine. The choir was consecrated in 1287, the whole church in 1379.

54 CISTERCIAN CHURCH, DOBERAN. Interior seen from the southwest. New building begun 1294–99. The choir was finished before 1329; the completed building was consecrated in 1368. In this important example of North German Gothic, the use of brick compelled the architect to adhere to a flat, rather cautious articulation. Brick buildings are found in two quite separate regions of Germany: in the north and in Bavaria. Northern Germany formed part of a larger cultural region, embracing the former dominions of the Teutonic Knights and extending south to Upper Saxony, Silesia, and Posnania, and southeast as far as Cracow. In

the west it joined the Netherlands, where brick was much used. Brick became popular in Germany quite suddenly, without any recognizable preliminary stages. It must have been introduced from outside the country; the most convincing explanation is that the idea came from Lombardy.

55 ST. LAWRENCE, NUREMBERG. View of the choir. After 1439. The church has three aisles and is laid out with a basilican nave attached to a hall choir (i. e., the vault over the various spatial areas is the same height). The choir was begun by Konrad Heinzelmann and completed by Konrad Roriczer in 1472. It is covered by complicated star-vaulting—a characteristic feature of the Late Gothic style. The choir wall is divided into two stories, each with its own row of windows, by a cornice with a parapet.

The tabernacle that can be seen on the left (1493–96) was designed by Adam Kraft, the most important German sculptor of the Late Gothic period. A bequest from the Nuremberg alderman Hans Imhoff the Elder, it soars upward to the springing of the vaulting. In front of the high altar is suspended Veit Stoss's wooden *Annunciation* (1517/18), a gift from a citizen of Nuremberg, Anton Tucker.

When viewing the interior of the church, which gains its principal effect from picturesque, two-dimensional qualities rather than sculptural, three-dimensional ones, it is instructive to remember that it was built at the same time as the great Florentine Renaissance churches of S. Lorenzo and S. Spirito, as well as the Pazzi Chapel and other buildings by Filippo Brunelleschi.

56 TOWER, FREIBURG-IM-BREISGAU CATHEDRAL. Begun c. 1275. Main building erected between 1330 and 1340. The three-aisled basilica (*17*), begun in 1200, was continued from 1235 on the lines of Strasbourg. The east end was replaced by a three-aisled Gothic choir with a ring of chapels as late as 1354; this was consecrated in 1510. The single-tower façade, a design that was used chiefly in Germany—for example, at Ulm (begun 1392)—is surmounted by an openwork stone spire that is very closely related to the work of contemporary gold- and silversmiths.

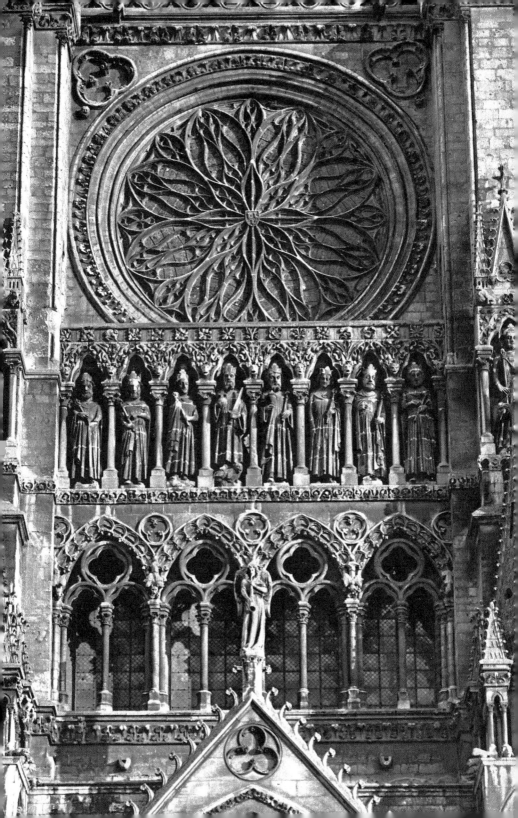

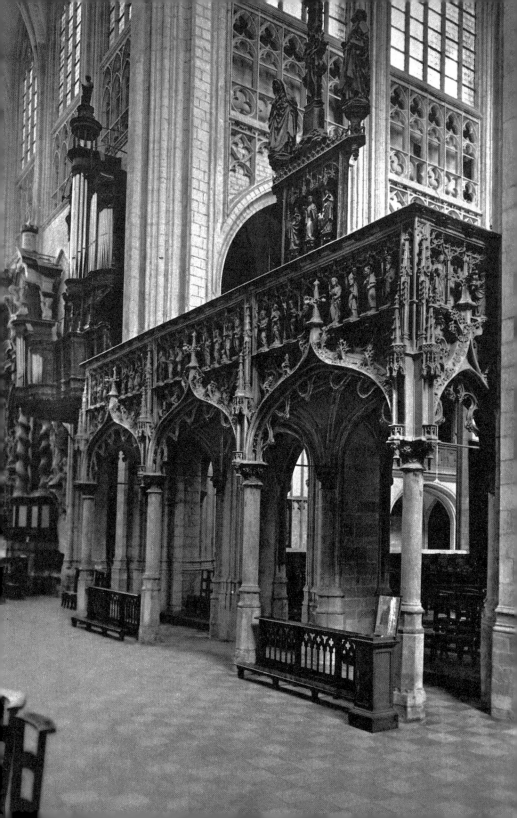

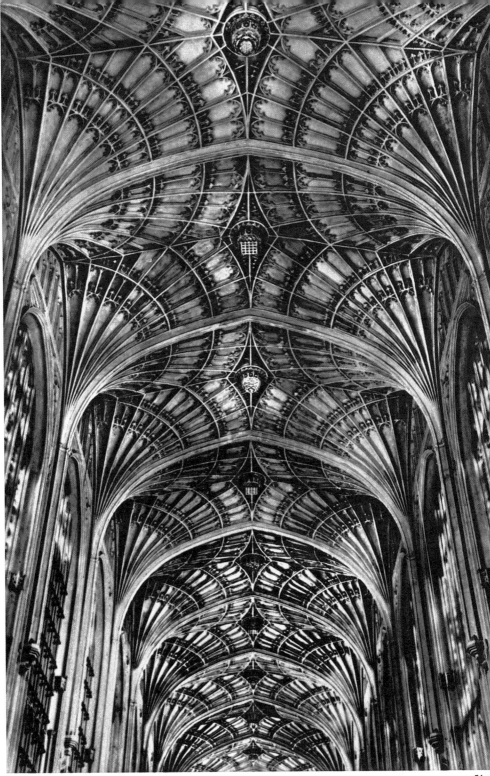

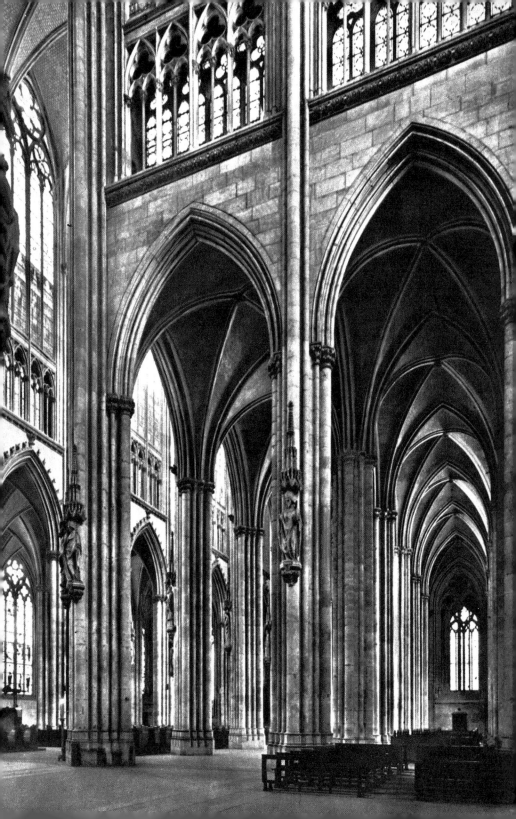

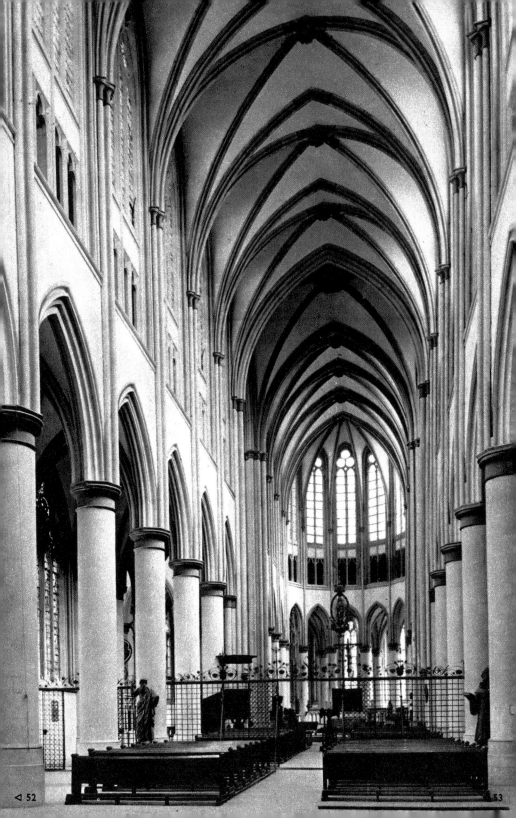

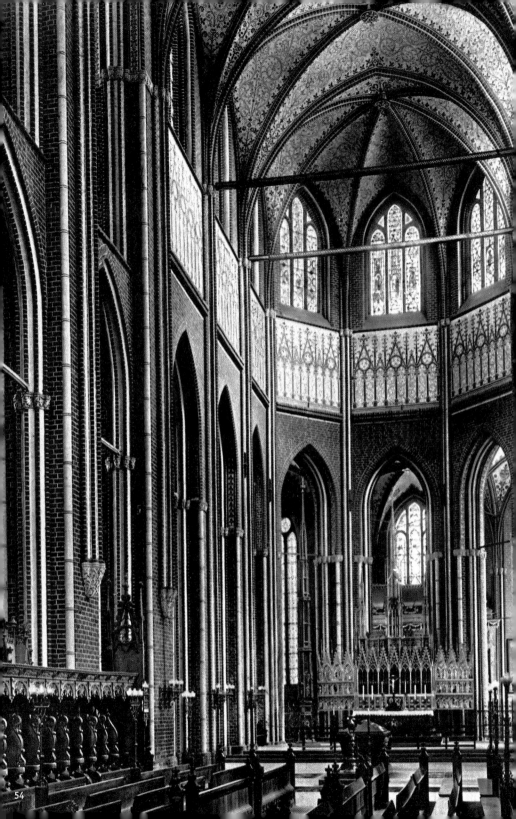

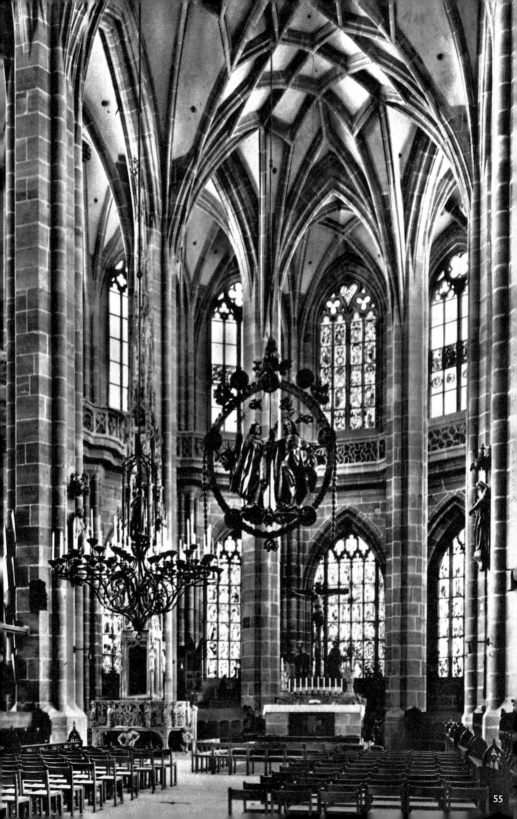

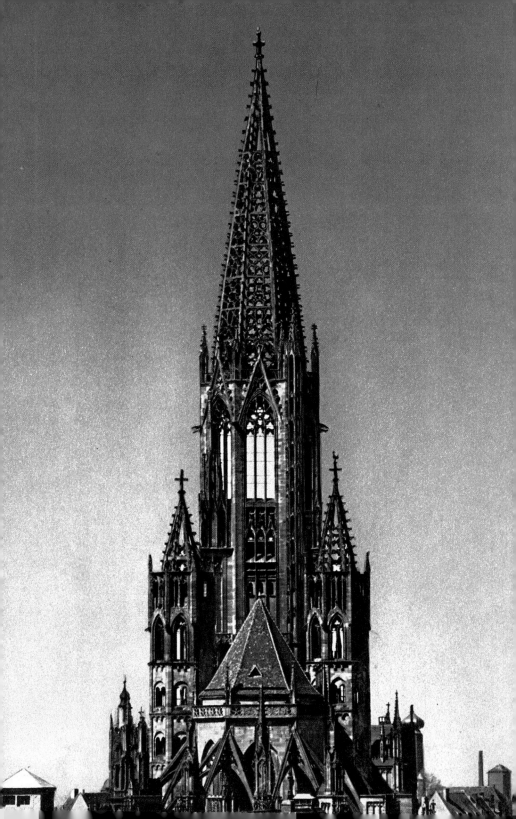

SCULPTURE

About the year 1200, sculpture in the Ile-de-France and eastern France underwent a dramatic change. In the course of a few years, the work being produced by sculptors in the French Royal Domain developed along completely different lines from the rest of Europe, where local Romanesque stylistic traditions were still adhered to (58–62).

The architectural tendencies we have already described—the striking differences between a 12th-century Romanesque wall and a 13th-century Gothic wall, for example, have parallels in sculpture. If we compare—to take examples from the two opposite poles in the process—one of the figures from the west portal of Chartres, with its ornamental drapery and elongated, columnar body, and a High Gothic figure such as the *Vierge Dorée* in Amiens (80), the striking difference in conception and execution will give us an idea of the far-reaching evolution of sculpture in France within a period of slightly less than one hundred years. Relief sculpture in the Romanesque period was set into a wall like precious jewels. Gothic sculpture is freestanding. It is displayed against the background of the wall, which gives it a completely new relationship with space. The life-size statues stand, often deliberately placed apart, under little architectural canopies that seem to surround them with a cloak of space. Figures of prophets and apostles gradually become more human: Their bodies are less stiff and they are arranged in groups as if speaking to each other. Indeed, subjects such as the Annunciation and the Visitation are often realistically portrayed on cathedral portals, as at Rheims.

There are many historical reasons for this fundamental change in style. Partly through a reacquaintance with classical art, which had come about through Byzantine influence, sculpture was filled with new life and humanized (58, 59, 61, 62). The pictorial world of the church was gradually enriched and at the same time bore the responsibility for representing elements from the real world. The human figure was now considered worthy of expressing a superhuman vision. This new—indeed revolutionary—attitude can be seen for the first time in the work of Nicholas of Verdun, a goldsmith from Lorraine, whose altarpiece in Klosterneuburg (near Vienna) (141) has been firmly dated 1181. This piece of enamelwork, which was subsequently transformed from decoration for an ambo, or pulpit, into a folding altar with three panels, dates from the very beginning of the Gothic era, both from the theological and the art historical point of view. It is so important that it deserves to be mentioned in the same breath as the west portal of Chartres.

Typology, a theological method of interpretation that explains, among other things, the Old Testament in terms of the New Testament, was elaborated in the Gothic period and determined the content and disposition of figures in most windows and doorways. Thus, personages, events, and deeds in the Old Testament were interpreted as prefiguring personages, events, and deeds in the New Testament, particularly the Passion and Resurrection ◁ 56 of Christ. At the root of this doctrine lies the conviction that from God's point of view

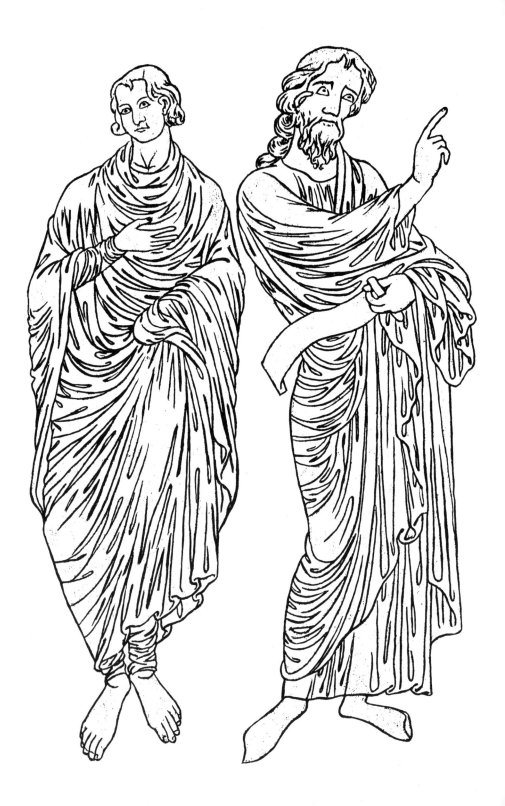

◁ 57 VILLARD DE HONNECOURT, SKETCHBOOK. c. 1220–30. Bibliothèque Nationale, Paris MS fr. 19093, fol. 28 recto. An apostle and a prophet. Possibly designs for a piece of monumental sculpture.

58 ENTOMBMENT OF CHRIST AND THE THREE MARYS AT THE TOMB. Carved lintel. c. 1190. Ile-de-France (from St. Pierre in Chartres?). The Cloisters, Metropolitan Museum of Art, New York. After 1180 we can detect a new trend in the portrayal of the human figure in the French Royal Domain, a trend that was inspired by classical and Byzantine models. This typical piece, which was influenced by work at Chartres, has the soft, flowing outlines that were to become an important element in the formulation of the Gothic style.

59 FRAGMENT OF AN ARCHIVOLT. From the Virgin Portal of Laon Cathedral. Abraham and Isaac (?). (Plaster cast made before restoration.) c. 1180–90. One of the most important workshops of the early Gothic period was at Laon. The drapery is boldly gathered up and drawn tightly around the bodies, as in classical sculpture. Byzantine influences have been reinterpreted by local methods to create an individual style that can also be seen in Braine (61, 62) and in part of the Ile-de-France.

60 FRAGMENT OF A TYMPANUM DEPICTING THE LAST JUDGMENT. c. 1190. Musée de la Maison Romane, St. Gilles. Unlike work being carved in northern France during this period (59), the powerful Romanesque tradition is still predominant here. The 12th-century schools of sculpture in Provence evolved an important local style of their own, which has links with northern Italy. A basic Mediterranean style can still be felt in this fragment in St. Gilles. The bodies are comparatively clumsy and stiff, and the treatment of the clothing is correspondingly schematic.

61, 62 FRAGMENT OF A TYMPANUM DEPICTING THE CORONATION OF THE VIRGIN MARY. c. 1200, definitely before 1216. St. Yved, Braine. One of the most important pieces of Early Gothic sculpture to emerge east of the Ile-de-France; possibly influenced by the gold and silver work and book illumination produced at the same date. The style has not yet achieved complete harmony. Mary's stiff posture, with her legs placed exactly parallel to each other, and the more relaxed treatment of Christ betray different prototypes for the two statues, which were not reduced to the same common sculptural denominator.

63 NICHOLAS OF VERDUN, BAPTISM OF CHRIST FROM THE SHRINE OF THE VIRGIN. Dated 1205. Cathedral Treasury, Tournai. This group of figures illustrates the work of the master sculptor at his peak. After his early altar (140), which has been definitely dated to 1181, Nicholas's work began to resemble the monumental sculpture of the period. This piece, a superb construction of silver and copper gilt and enamel filigree, represents one of the pinnacles of the classicizing phase of Early Gothic sculpture, which evolved into the full Gothic style c. 1200. Whereas the folds in the Laon archivolt (59) are still relatively schematic, the drapery here has become more flowing and seems to have a forceful life of its own.

64 BELT BUCKLE. c. 1200. The Cloisters, Metropolitan Museum of Art, New York. The two seated figures may represent King Solomon and the Queen of Sheba. The treatment of the drapery suggests that it is related to Nicholas of Verdun's workshop in Cologne and was made about the same time as the prophets and apostles on the Shrine of the Three Kings (65).

65 NICHOLAS OF VERDUN (AND WORKSHOP), THE FIGURE OF JONAH FROM THE SHRINE OF THE THREE KINGS. Cologne Cathedral choir. c. 1200. This seated figure of the prophet Jonah is a good example of the monumental treatment given to gold and silver work. The face has definite character and looks as if it may have been a portrait—a feature characteristic of German sculpture (see 81–84). Unlike the figure of the Holy Roman Emperor Henry II in Aachen (66), whose features are somewhat idealized, Jonah's face has an individual cast. The relics of the Magi were transferred from Milan to Cologne by Archbishop Rainald von Dassell. The shrine is an oak chest with applied embossed metal panels, enamels, precious stones, filigree work and figures in silver gilt and gold leaf, 1.8 meters long by 1.1 meters wide by 1.7 meters high. The general design and the long sides date from c. 1181–91, while the front

was executed c. 1198–1200 and the back c. 1220–30.

66 SHRINE OF CHARLEMAGNE. Detail. c. 1220–25. Cathedral Treasury, Aachen. The German town of Aachen possessed an important goldsmiths' workshop whose existence would be inconceivable without the stimulus given to it by Nicholas of Verdun. The seated figure of Emperor Henry II is comparatively lifeless and conventional. The treatment of the drapery is a typical example of the type of work that was then thought of as advanced (see 65).

67 SEATED VIRGIN AND CHILD. c. 1220. Wood. Schnutgenmuseum, Cologne. The delicate treatment of the drapery that can be seen on the Shrine of Charlemagne at Aachen (66) is matched in larger works such as this. Whereas the companion piece in New York (68) still belongs to the Romanesque conception of the Virgin as sedes sapientiae (Seat of Wisdom), this sculpture from Cologne is an early example of Mother and Child engaged in tender conversation. The gentle feeling of affection that is evident in the way their eyes meet was to become an important theme in later sculpture (see 80, 91, 94 ff.).

68 VIRGIN AND CHILD. From Flanders (Oignies?). c. 1210. Oak with traces of the original ground still visible. Metropolitan Museum of Art, New York. Mary is seated on a magnificently carved throne, displaying her Son to the faithful; Jesus wears a crown and his right hand is raised in blessing. The strictly repetitive arrangement of the figures is reminiscent of cult images from the Romanesque period, while the softly flowing robe forms an attractive contrast to the imperturbable solemnity of the group.

69 HEAD OF AN APOSTLE. From St. Étienne, Beauvais. c. 1200–10. Beauvais Museum. A new facial type emerged c. 1200 and soon became obligatory for sculptures of the apostles, Old Testament kings (see 64, 72, 73), and even Christ himself. The culmination of this trend is the figure of Emperor Henry II on the west façade of Basel Cathedral (102). Hair began to take the form of luxuriant locks flowing downward, covering the ears and sometimes combined with a short beard with wispy strands growing from cheeks and chin. The drooping

moustaches give a somewhat indefinite look to the face.

70 HEAD OF AN APOSTLE. c. 1210. St. Yved, Braine. Unlike the previous example, the eyes are treated with particular delicacy. They are almond-shaped and seem to be an organic part of the face. The high forehead and locks of hair falling from the part suggest that this strongly individual face may depict St. Peter.

71 HEAD OF AN APOSTLE. c. 1220–25. Dijon Museum. This is a highly dramatic version of the type of head shown in 69 and 70. Similar heads can be seen in the museum at Besançon and on the Virgin Portals and Angel Pillar (77) at Strasbourg. They all come from the same workshop, whose members traveled from the Ile-de-France to Alsace.

72 HEAD OF A KING. c. 1225–30. Soissons Museum. This fragment comes from the tomb of Clothaire in the church of St. Médard, Soissons; it is closely related in style to 73. The treatment is more naturalistic than in the previous examples.

73 HEAD OF A KING. From Paris (west façade of Notre-Dame?). c. 1220–25. Metropolitan Museum of Art, New York. This is the finest example of sculpture of this particular type. The eyes are as carefully carved as those of the Soissons head (72). It is conjectured that this autocratic head is an idealized portrait of the energetic and effective French king Philippe-Auguste.

74 HEAD OF ECCLESIA. From the Virgin Portal of Strasbourg Cathedral. c. 1225–30. Maison de l'Oeuvre Notre-Dame, Strasbourg. While male heads were beginning to show a dramatic character of their own, women's faces were also being carved according to a new canon of beauty. Ecclesia (representing the Church, or New Law), and blindfolded Synagogue (representing the Old Law, 76) are important stages on the path to a new idealization that culminates in the Visitation at Rheims (78) and remained standard for all figures of the Virgin down to the 14th century. The vivid contrast created between the simple beauty of the face and the piece of jewelry worn on the head or on the breast is also a typical feature of contemporary Gothic painting.

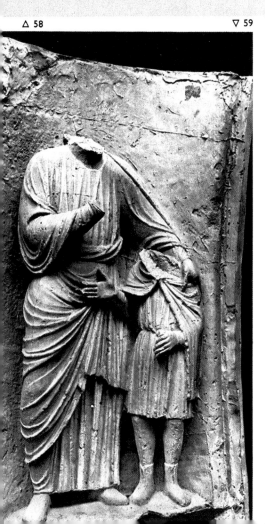

△ 58 ▽ 59 ▽ 60

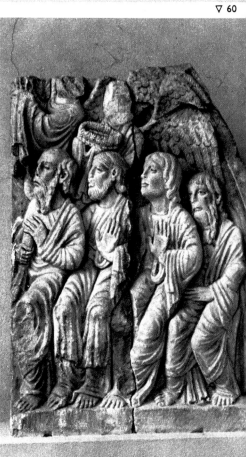

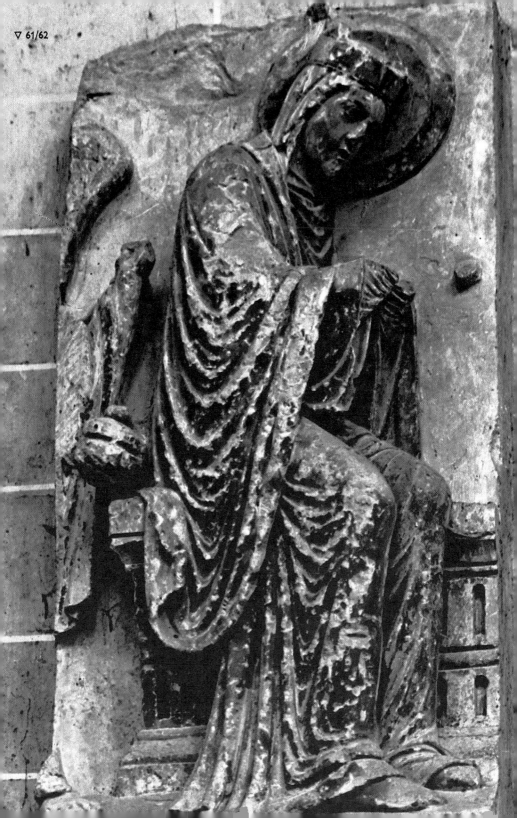

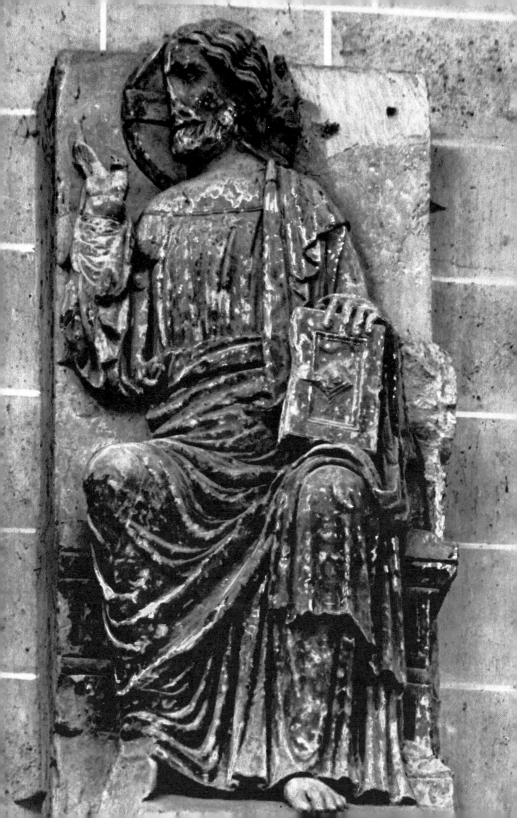

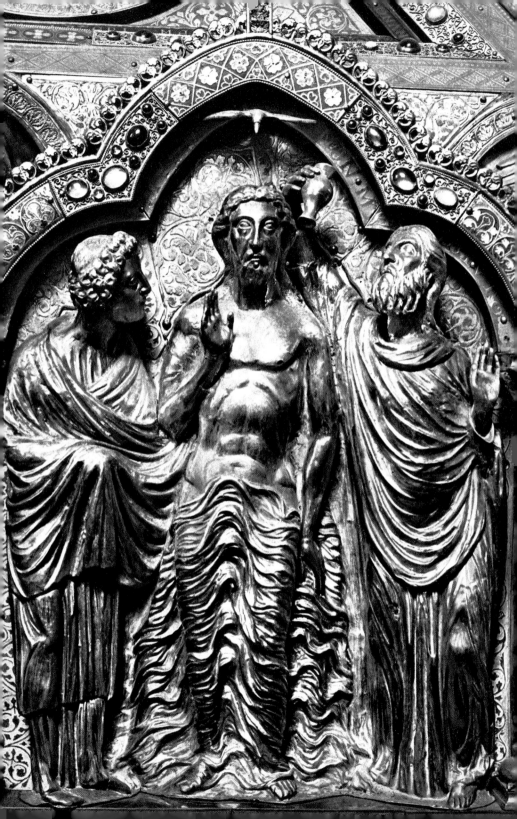

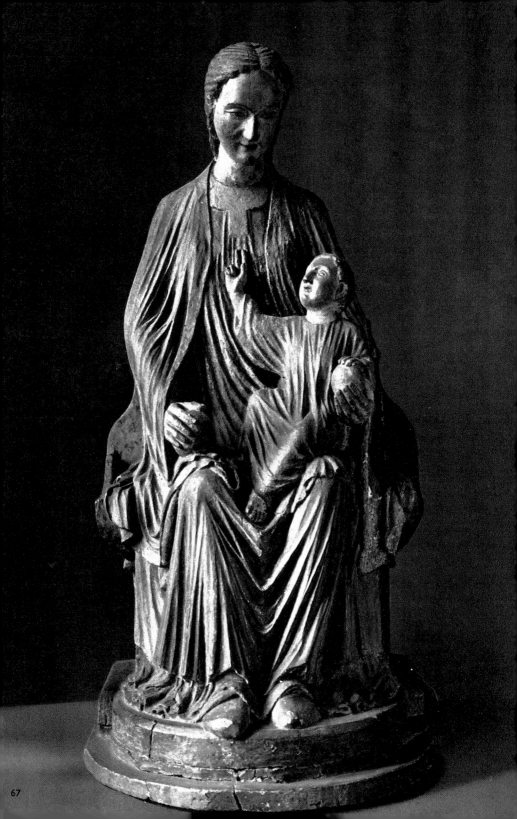

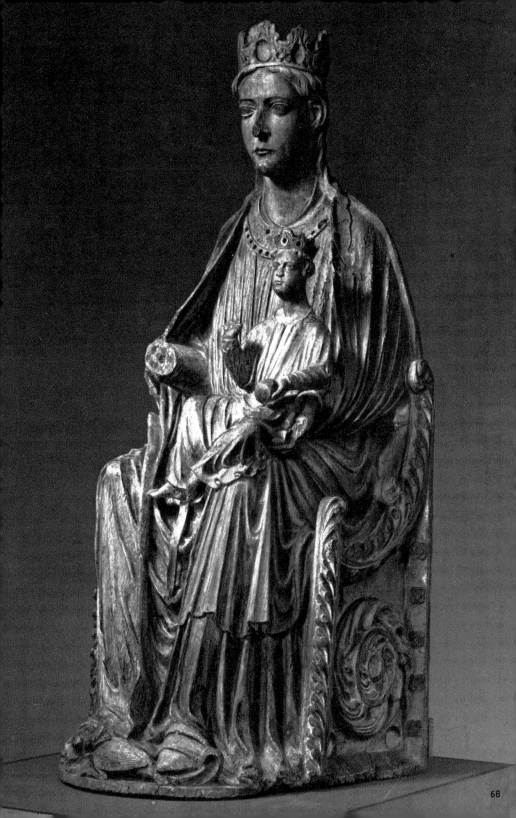

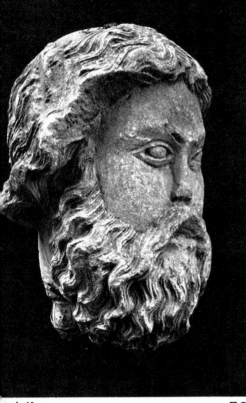

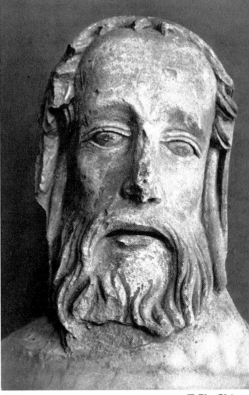

△ 69▽ 71 △ 70▽ 72 73 ▷

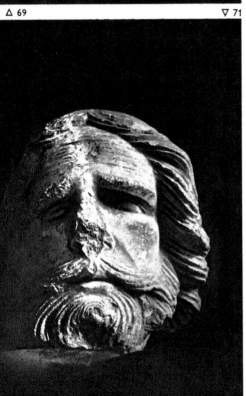

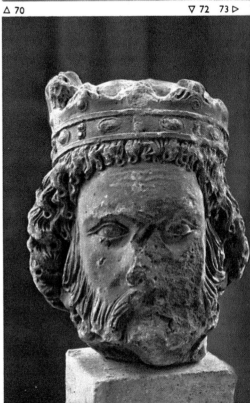

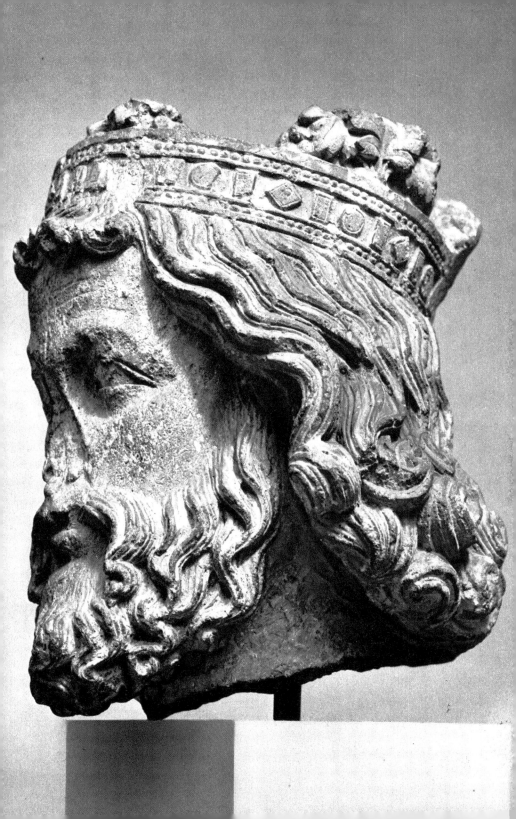

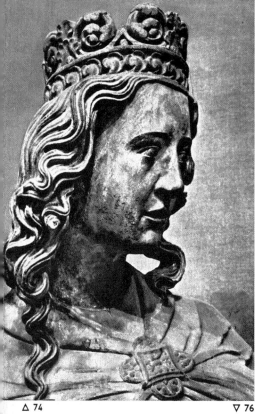

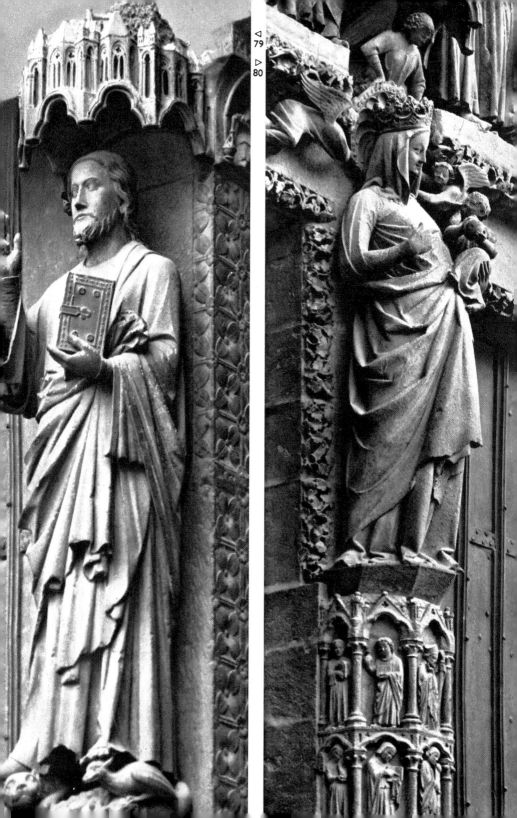

there is no such thing as historical evolution, since everything is already in existence. God's incursions into history are the temporal revelation of a uniform divine scheme of things established since the beginning of time. As this plan is uniform, individual events inevitably repeat themselves.

This form of typological comparison is clearly visible in the altarpiece at Klosterneuburg (*141*). Although the enamel panels of this powerful theological *Summa* are treated in only two dimensions, the very substantial figures show the artist's keen consciousness of three-dimensional form. The apostles and the figure of Mary in the *Ascension of Christ* scene (*140*) reveal his understanding of the modeling of a full-length figure from behind, from the sides, and from the front. It is not by accident that later works attributed to Nicholas of Verdun reach a pinnacle of perfection in chased silver figures actually treated in the round.

Work began on his *Shrine of the Three Kings* in Cologne (*65*) in 1181–91. The general design and the long sides date from this period. The reliquary casket was completed by Nicholas's workshop in Cologne about 1230; the front was executed in 1198–1200, and the back wall in 1220–30. The *Shrine of the Virgin* in Tournai (*63*) can also be dated accurately, since it bears not only the artist's signature but also the date 1205. In these works, Nicholas of Verdun created a fundamentally new and delicate system of drapery:

75 HEAD OF THE LITTLE ECCLESIA. c. 1225. Maison de l'Oeuvre Notre-Dame, Strasbourg.

76 HEAD OF SYNAGOGUE. From the Virgin Portal of Strasbourg Cathedral. c. 1225–30. Maison de l'Oeuvre Notre-Dame, Strasbourg. Companion piece to Ecclesia (*74*). There are also figures of Ecclesia and Synagogue in Bamberg Cathedral, c. 1235–37.

77 APOSTLE. From the Angel Pillar, Strasbourg Cathedral. c. 1225–30. This work of the Ecclesia Master (see *74*) has been called "the purest expression of the Christian and German spirit of the Middle Ages" (Harald Keller). Keller goes on to say, "It was executed just before the time when the Gothic style began to use drapery as the sole vehicle for expressing the figure's personality."

78 VIRGIN MARY. Detail of the *Visitation* on the west façade of Rheims Cathedral. c. 1230–35. This figure represents the finest achievement and, at the same time, the beginning of the final stage of the classicizing style that flourished in northern France after 1200. (After this we find mannerist versions of the same theme.) The sculptures on the west façade at Rheims are at times so closely related to classical antiquity one wonders whether the unknown sculptor could have seen examples of Greek or Hellenistic art, either in Greece or in the Eastern Mediterranean—perhaps on a visit to the Holy Land.

79 "BEAU DIEU." West façade of Amiens Cathedral. c. 1230. If we compare this piece of sculpture with a full-length figure of Christ from the first quarter of the century, we see that at Amiens the drapery has been treated in a new way. The novelty of this treatment lies in the manner in which the material has been gathered up to a single point, so that the folds fall into fan shapes; the effect produced gives emphasis to the head and to the hand, which carries, in this case, the New Testament.

80 "VIERGE DORÉE." South transept of Amiens Cathedral. c. 1255–60. The new method for treating drapery can be seen here, with the material gathered up so that it falls from a single point. This Madonna on a trumeau became the model for whole generations of sculptors in northern France.

His figures are clothed in supple folds that fit snugly around their bodies. The proportions given to the prophets and apostles on the *Shrine of the Three Kings* (*65*) are clear evidence that the artist had come to terms with the art of classical antiquity. This link with Mediterranean work is at its most obvious in the faces of the seated figures on the long sides of the casket, which are also directly related stylistically to the last of the enamels at Klosterneuburg. We still do not know the source of the artist's ideas. It is safe to assume, however, that the key lies in portrait heads from the late Roman era, where we are also confronted with specific personalities. There is no trace of idealization in Nicholas's work or in that of his Roman predecessors. The faces bear the stamp of a life that has been thoroughly lived, rather than a fixed canon of beauty or a design copied from a pattern book. Thus, the figures on the shrines in Cologne and Tournai seem to address the spectator directly, as though on equal terms. In every case, the stance of a figure provides an unmistakable clue to its role within a particular scene. In the *Baptism of Christ* from the *Shrine of the Virgin* (*63*), for instance, Christ is very much a part of what is happening; the angel on the left plays a secondary role. But the whole drama of the scene resides in the figure of John the Baptist. He is in the process of lifting the receptacle of baptismal water above Christ's head, and the effort involved in reaching above such a large figure has made him raise his other hand as well. The dynamic tension of his pose is beautifully expressed by. the folds of his robe. With Nicholas's work a new theatricality was introduced into sculpture, and new concepts came into force that, with a few local exceptions, remained valid well into the Late Gothic period.

Nicholas's influence on his contemporaries was swift and marked (*64, 66*), but we cannot say with any degree of certainty how the work of this great but isolated figure was disseminated. How did it reach Chartres and Rheims, for instance? When Nicholas confronted the classical world, he embarked on a conscious, Renaissance-like exploration that involved a reworking of the influences of antiquity. He did not copy exactly but transformed what he had seen into a more modern idiom.

It is instructive to remember that south of the Alps, close to the original source of classical art, a contemporary of Nicholas's was also coming under the influence of antiquity. The Italian artist Benedetto Antelami worked on the baptistery in Parma from 1196 to 1214; three of the portals are directly from his own hand. His work is full of quotes, conscious and unconscious, from classical art, but he never really came to terms with it, for, as a southern European, it was part of his unconscious heritage, his acquired vocabulary. A thorough study of classical antiquity did not begin in Italy until a hundred years later; the new approach took the form of what we call the Renaissance and overwhelmed the Gothic style that had been imported from the north.

The sculptural programs of Gothic cathedrals in France usually do not display a uniform style, for the groups of sculptors attached to the workshops clearly were large and often very mixed. The west façade of Notre-Dame in Paris, for instance, is executed in several different successive idioms. The lowest sections were built shortly after 1200, the windows about 1220, the south tower from 1225 to 1240, and the north tower between 1235 and 1250. The carving of the sculpture also extended over several decades. The

central portal was originally designed to be narrower and was begun by a classicizing workshop whose members came from Sens. It was completed many years later by another workshop. The left portal with the scene depicting the *Coronation of the Virgin* (1205–15) seems the most uniform of the doorways. In style it is diametrically opposed to the classicizing tendencies of the supple art practiced by the Sens workshop. It seems more rigid and may have been influenced by Byzantine art (during the first years of the century,

81 COUNTESS GEPA (or ADELHEID). Naumburg Cathedral. c.1245–50. The figures representing the founders of the cathedral that stand in the west choir have a special place in the development of a new method of portraying the human figure and a new way of treating drapery. An earlier stage in this development can be seen at Mainz, and, for later examples, see the sculpture at Meissen Cathedral. The founders at Naumburg are notable for a distinctive, almost startling individuality.

82 VIRGIN MARY. From a *Visitation* group in Bamberg Cathedral. c.1235–37. Here the Mother of God stands in a classical pose, with her weight on one leg. The heavy folds of her robe create effects of light and shade and seem to ripple. The kerchief made its first appearance at Rheims (see *78*), adopted as an artistic device to frame the face. Like some of the figures at Rheims, this Bamberg Virgin suggests that the sculptor may have been familiar with the sculpture of classical antiquity, perhaps provincial Roman work.

83 JONAH AND HOSEA. From the Choir of St. George, Bamberg Cathedral. c.1230–35. The two prophets face each other as if in discussion. The drapery has the restless look that is characteristic of the sculpture of late classical antiquity, and there is also a Romanesque note in the swirling folds. These folds are created by deep furrows, in a manner that originated in France. The technique may be borrowed from ivories and miniatures such as those in the Berthold Missal (Pierpont Morgan Library, New York).

84 HEAD OF THE BAMBERG RIDER. c.1235–37. Bamberg Cathedral. The Bamberg Rider is one of the most important illustrations of French influence on German art in the 13th century caused by the movement of artists from west

to east. The prototype for this head, which has been interpreted in many very different ways, can be found on the southern tower of Rheims Cathedral—though at Rheims the figure is in the traditional French style, and not a portrait. The German sculptor must definitely have been familiar with the earlier prototype, but he has used it to create a character that is both unmistakable and unforgettable. It has been remarked that the magic of this head depends on the way the clear underlying structure supports the precise modeling (Hans Jantzen). The cathedral was consecrated in 1237, which gives us a clue to its approximate date. (See also the Magdeburg Rider, c.1240–50.)

85 HEAD OF KING CHILDEBERT. From St. Germain-des-Prés, Paris. c.1240. Louvre, Paris. This head of a ruler illustrates the differences between French and German sculpture of the same period. The features are idealized (compare *84*).

86 MASTER OF NAUMBURG, ST. MARTIN DIVIDING HIS CLOAK. c.1235–40. Parish church, Bassenheim. This sandstone relief, known as the Bassenheim Rider, originally appeared on the west rood screen of Mainz Cathedral. The figures are full of individuality—the beggar emaciated and in rags, the princely horseman plump and richly dressed. The scene is set in a metope in the classical manner, protruding slightly beyond it. The sculptor clearly possessed great narrative power and must have been familiar with the work on the Judgment Portals at Amiens and Rheims. It is possible that some of the quatrefoil reliefs on the lower parts of the west front at Amiens are also by him. He traveled via Metz and Mainz to Naumburg, where he worked until c.1250.

87 SHRINE OF ST. ELISABETH. 1236–49. Sixth relief on the roof of the shrine. Gold. St. Elisabeth, Marburg. The relief depicts St. Elisabeth giving alms to the poor. The treatment of the folds is not dissimilar to that of the Bamberg Virgin (*82*), but, typical of gold and silver relief work, the figures are more intimate and less statuesque than freestanding sculptures.

88 ANDREA DI JACOPO D'OGNABENE, VISITATION. Detail of silver *paliotto*. 1316. Chapel of S. Jacopo, Pistoia Cathedral. The famous goldsmith's figures are influenced by French work. Mary (*left*) can be compared, for instance, with the Virgin in the north transept of Notre-Dame in Paris (*89*), for the folds of drapery hang in a similar way. We can also usefully contrast this *paliotto* with the Shrine of St. Elisabeth in Marburg (*87*). Whereas the German goldsmith of a hundred years before had to some extent moved away from western prototypes and invented his own style, his Italian counterpart has absorbed influences from the Ile-de-France school, which, in turn, had an important effect on the early work of Andrea Pisano.

89 VIRGIN AND CHILD. c.1250, possibly 1260. North transept of Notre-Dame, Paris. The Child has been destroyed. This particular type of Madonna, with a graceful figure and simple robe, and the compact treatment of the drapery were imitated again and again, in France and much further afield (see *99*, *100*). It was not until the end of the century that a new type of full-length Virgin was invented, one example being the Fontenay Virgin (*98*). For the position of the Virgin, see the view of the north transept (*35*).

90 APOSTLE (ST. JOHN?). From Sainte-Chapelle, Paris. 1245–48. Musée de Cluny, Paris. The long, heavy draperies, rather like those that are generally seen on statues of the Virgin (*89*), are here sharply interrupted by a horizontal roll of folds. This ingenious and deliberate counter movement can also be seen in paintings of the Virgin's drapery; it produces highly dramatic effects.

91 VIRGIN AND CHILD. Probably from the portal of the Augustinerkirche in Mainz. c.1240 (though some experts believe that it was executed later). Cathedral Museum, Mainz. Sandstone. Height 1.71 meters. Compared to the Virgin in Paris (*89*), this statue has a rustic and homely look, and her baggy robe is verging on the untidy. The dramatic treatment of her cloak, however, has an expressive quality foreign to the courtly style of her French counterparts.

92 ANGEL. c.1260–70. Rheims Cathedral. The affected, almost mannerist treatment of the face is part of the courtly tradition of France. Many widely differing interpretations of the smile have been given, but it should, in fact, be seen as the expression of a state of mind, an *état d'âme*. This brilliantly carved head framed by delicate little curls marks the beginning of a new style, whose influence spread beyond Rheims to the entire Champagne district.

93 GIOVANNI PISANO, PROPHET (MOSES). 1284–99. Museo Civico, Pisa. This statue of a prophet originally appeared high up on the baptistery. Because it was intended to be seen from below at a very oblique angle, it looks top-heavy when viewed at eye level.

94 VIRGIN AND CHILD. c.1250. Liebighaus, Frankfurt. This charming example of the new humanized Madonna and Child comes from the Moselle district.

95 VIRGIN AND CHILD. French. c.1270. Ivory. Museum für Kunst und Gewerbe, Hamburg. Unlike the seated figure in Frankfurt (*94*), this exceptionally fine piece represents the French court style; its chief distinguishing feature is the gracefulness and beauty of the Virgin's face. The folds are arranged around the body with the greatest delicacy and look rather like rose petals. The Frankfurt statue appears heavy and rustic (though perhaps more vital) by comparison.

96 YOUNG FEMALE SAINT WITH BOOK. French. c.1300. Liebighaus, Frankfurt. This fragment comes from the tomb of Philippe de France, brother of St. Louis. It was originally in Royaumont Abbey.

97 VIRGIN. French. c.1300. Ivory. Metropolitan Museum of Art, New York. Like the Frankfurt fragment (*96*), this piece heralds the style that is characteristic of the first half of the 14th century. The courtly style was reinterpreted: Figures became still more slender and more delicate.

◁ 81
▷ 82

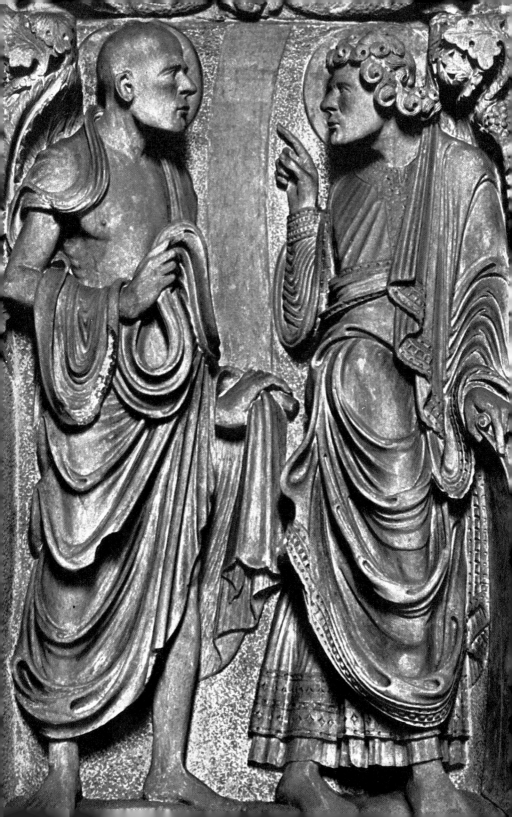

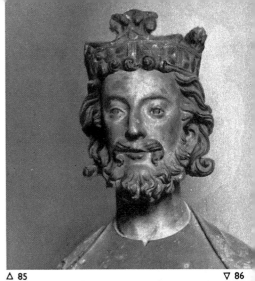

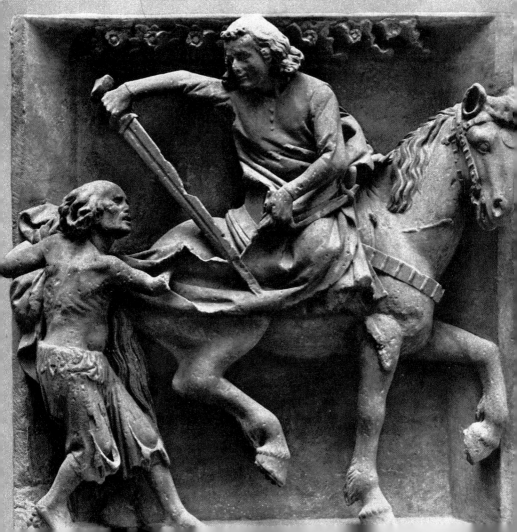

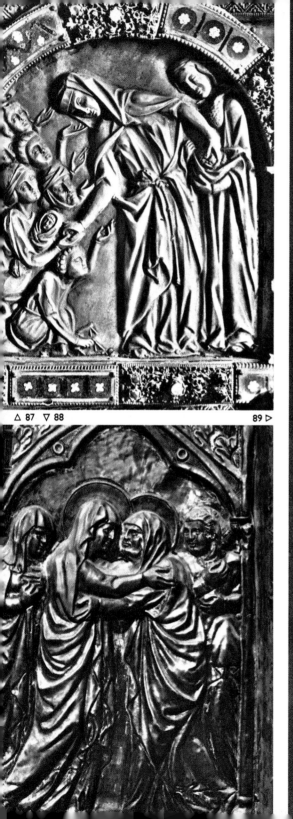

△ 87 ▽ 88 89 ▷

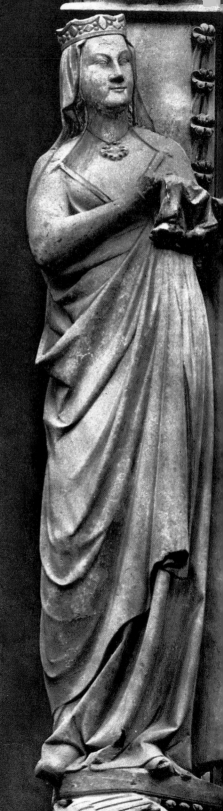

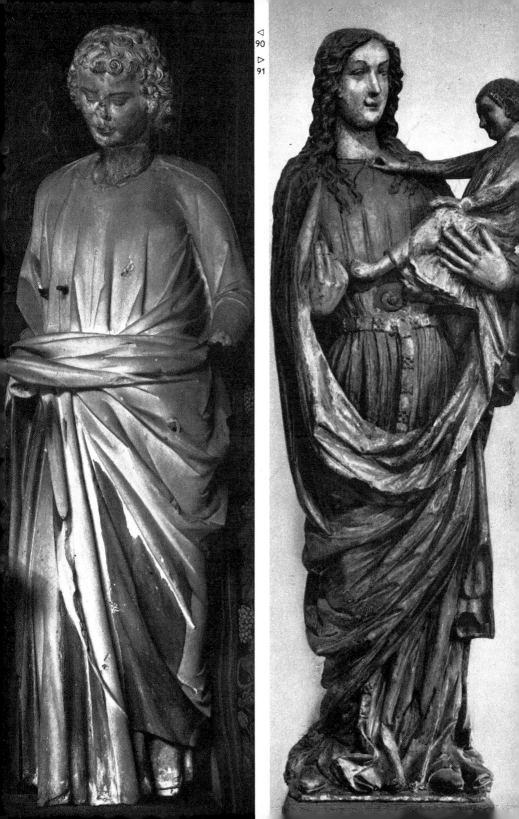

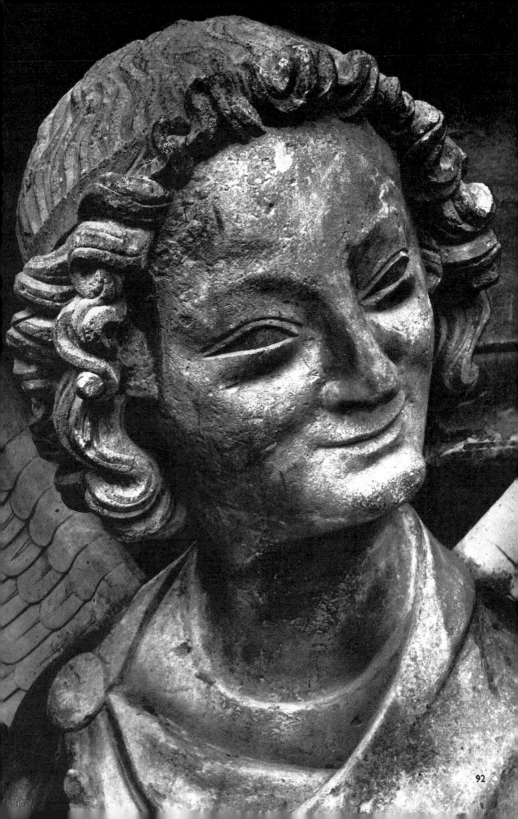

92

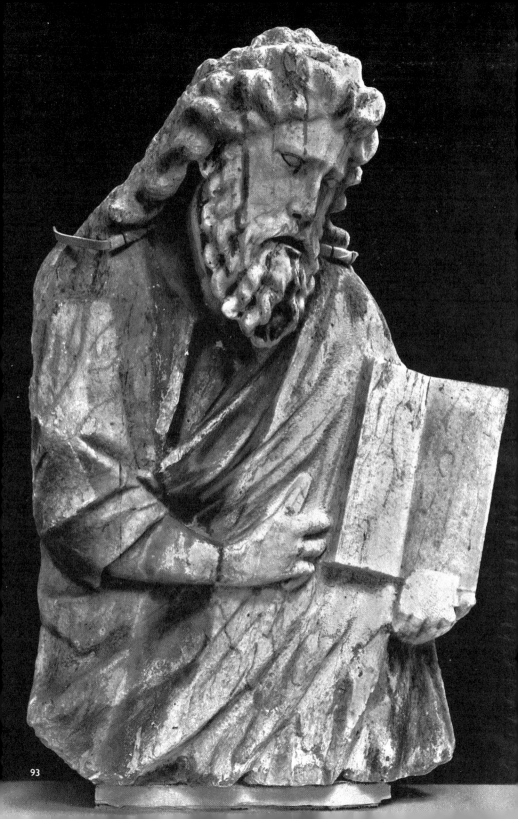

93

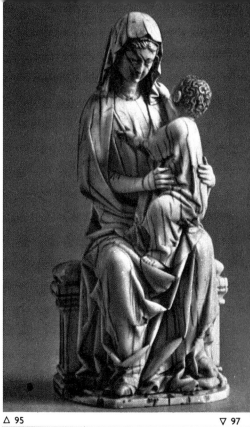

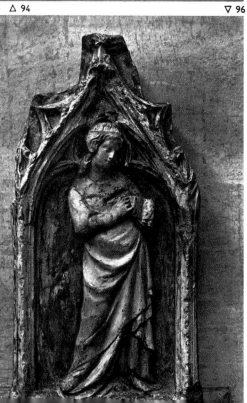

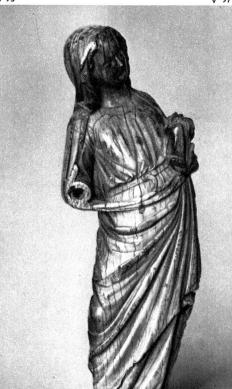

the Fourth Crusade was launched, and in 1204 the city of Constantinople was taken by the Crusaders).

French monumental sculpture was conceived and developed in Notre-Dame in Paris, in Sens, and in the portals and transepts at Chartres. The first stage in this development is again represented by the west façade of St. Denis (*19*), and the basic features of its sculptural scheme have survived to this day. But we cannot really speak of a uniform development until 1250. The way in which the treatment of the human head changed in the early 13th century from Romanesque otherworldliness to a style at once more human and more natural is illustrated by *69–73*. Even more impressive works of this germinal period can be seen in the sculpture at Rheims, culminating in the *Visitation* figures (*78*). This sculptural group is unique, for it is difficult to see in it any echoes of earlier traditions, nor did it really influence later work. The texturing of the drapery into deeply furrowed spoon-shaped folds is the only feature that enables us to link the statues with contemporary work and to see it as stemming from an indigenous tradition. The technique of cutting stone is illustrated in the architect Villard de Honnecourt's sketches (*57*). That the master sculptor of Rheims was familiar with the sculpture of classical antiquity is undeniable, but where he acquired his knowledge is a mystery that is still unsolved. A good example of this same problem is raised by the *Visitation* group at Bamberg (*82*). Were the sculptors familiar with provincial Roman art? Should we assume that they spent some time south of the Alps, in Greece, or the Eastern Mediterranean?

The golden age of the courtly sculpture of Saxony (*81*) and Franconia also occurred before the middle of the 13th century. In this development Strasbourg Cathedral played an important part, linking East and West. The movement reached its peak with the tomb of Henry the Lion, Duke of Saxony, and his wife Matilda in Brunswick Cathedral (c. 1240). Architectural sculpture, whose function in Germany was rather different from its function in France, reached its highest point in the decoration of Bamberg Cathedral, which was consecrated in 1237. The most impressive work here is in the reliefs on the screens of the St. George Choir. They depict apostles and prophets grouped in pairs and engrossed in conversation (*83*). Their taut faces, their penetrating gaze, and their garments dramatically rippling according to an inner rhythm mirror in a striking way the energies released by their conversations. With such work, we are clearly outside the sphere of influence of the French sculptors; there is little trace here of the French Gothic style. East of the Rhine, the degree of receptivity to the new style varied greatly (not only from one city to another, but from one region to another). Not everybody was as cosmopolitan as the prior who—according to a chronicle written in Wimpfen in 1258—appointed a stonemason who had recently arrived from Paris (*noviter de villa Parisiensis venerat*). He was commissioned to build a church in Wimpfen "in the French fashion" (*more francigeno*).

The spread of the Gothic style in East Europe continued to the end of the 14th century. Some of the stages of this development are represented by the following landmark monuments: the main doorway of St. Lawrence in Nuremberg (1330–40); the tympana of the Heiligenkreuz (Church of the Holy Cross) in Schwäbisch Gmünd (north portal 1340, south portal 1360–70); and the sculptured decoration on the Singer Tor of St. Stephen's,

Vienna (1370–80). Berne Minster was begun in 1421, but the sculpture dates from a later time.

"Pictura et ornamenta in ecclesia sunt laiorum lectiones et scripturae" ("Paintings and ornament in churches are a source of learning and scripture for the lay congregation"), said Durandus. The word *ornamenta* should be understood to include sculpture, which from St. Denis onward began to play an important part in the external appearance of a cathedral. The gigantic sculptural programs drawn up for the doorways (which include the stepped voussoirs, door jambs, the lintels, the tympana, and the archivolts) are ingenious intellectual constructions, part of a fully worked out iconography, with Christ and Mary, or possibly the patron saints of the respective churches, set in the center. Some of the principal themes in the areas around the central figures are Christ's incarnation, the miracles He performed on earth, His resurrection after death, and His second coming. The flourishing cult of the Virgin meant that most of the cathedrals became, as it were, the seat of "Our Lady" or "Notre-Dame." The most common scene depicts the Virgin being crowned by her Son (*61, 62*); or often she is standing on the doorpost, or trumeau, of the main portal, ready to receive the congregation (*80, 89*). Over the years this last image was isolated to form a devotional object on its own (*124–26*). In making our selection of illustrations, we have placed particular emphasis on the standing Virgin, since this type of figure gives a particularly clear idea of the stylistic development of Gothic sculpture.

An important early example of this type was executed about 1250 and appears on the doorway leading into the north transept of Notre-Dame in Paris (*35, 89*). The infant Jesus was originally held out toward the visitor as his Savior. The proud, supporting figure of the truly regal Madonna is one of the most important achievements of French—indeed European—sculpture. Her robe hangs in full folds; its effect could not be more simple or more monumental. The lines of her body are discernible beneath the material, and the differentiation between the weight-bearing leg and the free leg is effortlessly made. This pose is taken from the sculpture of classical antiquity, with all its monumental connotations. Incidentally, such a pose makes all the folds of the robe point toward the infant Jesus.

The *Vierge Dorée* at Amiens (*80*) dates slightly later, but the sculpture evolved from a different artistic tradition. The relationship between mother and child is treated in a different way, though the basic premises underlying it remain the same. The Amiens sculptor was not interested in the theme of the Christ Child held majestically aloft; he was more concerned with Mary's maternal affection for him. Jesus is gazing up toward His mother, and she is not treated exclusively as a means of supporting him but rather as a participant in the scene. This mother-child relationship is intensified and made even more human in the Fontenay Madonna (*98*), which dates from the end of the 13th century. The theme of the Christ Child playing with Mary's veil quickly became popular, and countless variants on it were devised in many different parts of Europe. Illustrations *91, 97, 99–101, 104, 109, 110, 123–25, 135,* and *137* show some of the ways the theme was developed.

A playful, somewhat frivolous note, with laughing faces and balletic poses, is a notable trait of Gothic sculpture. It can perhaps best be summed up by the term "precious."

Originating in Paris, it is perhaps most memorably expressed by the figure of an angel at Rheims Cathedral (92), which was originally planned to be placed alongside a saint, but in the end was used as a herald angel. The standing Virgin from the Sainte-Chapelle (100), now in the Louvre, dates about 1300. It stylistically related the Ecouis Virgin (c. 1313–15, Louvre), the Virgin from La Celle (c. 1320–25, Louvre) and the *Virgin Enthroned* at Sens of 1334 (121). The sequence culminates in a Madonna presented by Jeanne d'Evreux, Queen of France, to the abbey church of St. Denis in 1339 (125–26).

The superb quality of this French group of full-length Virgins is matched by a series of statues carved about 1400 on the eastern edge of the Gothic sphere of influence. These are known as the *Schöne Madonnen* (beautiful Madonnas). They are carved from limestone or cast stone and are painted in white, blue, and gold; they served as devotional images and were displayed individually inside a church. The Krumau Madonna (137) is the most important representative of this group, which also includes similar figures in Thorn, Wroclaw (Breslau), and Dresden. These *Schöne Madonnen* can be referred to as the purest examples of what is known as the Soft Style of European sculpture, which dates from about 1400 (see also 138).

The historical and stylistic roots of this type of art lie early in the 14th century. New and sometimes highly influential artistic centers grew up in Prague and Vienna, where members of the houses of Luxembourg and Habsburg had their residences. These centers produced important sculpture workshops, whose patrons, however, were not confined to court circles; they came increasingly from the bourgeoisie, which was now established on a sound economic footing. These new middle-class patrons stimulated the production of a different kind of art and a new stylistic era began around 1430. Late Gothic sculpture is marked by an increased

98 VIRGIN AND CHILD. c. 1290–1300. Abbey Church, Fontenay. The Madonna in this Cistercian abbey in Burgundy is one of the finest Virgins executed in France at the turn of the century. The very popular theme of the child Jesus playing with Mary's veil is repeated in such examples as the Cloisters Madonna (101).

99 GIOVANNI PISANO, MADONNA AND CHILD. c. 1299. Cathedral sacristy, Pisa. The folds here are more closely drawn together and the material seems heavier than in contemporary work in France (98). The robe is richly folded and the hem makes an interesting contrast.

100 FULL-LENGTH VIRGIN AND CHILD. From Sainte-Chapelle, Paris. c. 1300. Louvre, Paris. It is possible that Giovanni Pisano was familiar with contemporary ivories such as this one. The prototype for his Madonna in Pisa (99) and for this Virgin from Sainte-Chapelle is the Virgin on the trumeau of the north transept of Notre-Dame in Paris (89), which established the basic principles for the treatment of the pose and the drapery.

101 VIRGIN AND CHILD. From the Ile-de-France. c. 1330. The Cloisters, Metropolitan Museum of Art, New York. The remarkable features of this piece are its quality, which is very high,

and the exceptionally fine state of preservation of the coloring.

102 EMPEROR HENRY II. From the west façade of Basel Cathedral. c. 1300. The emperor's robe is a compromise between the 13th-century arrangement with the folds gathered at the side and a new type of treatment involving long hanging folds (see *108*).

103 VIRGIN AND CHILD. French. c. 1300. Badisches Landesmuseum, Karlsruhe. This rather stylized way of carving the face is typical of the beginning of the 14th century. The chin is gently pointed and the face is dominated by almond-shaped eyes with slightly upturned corners.

104 HEPPENHEIM VIRGIN AND CHILD. c. 1300. Cathedral Museum, Mainz. The folds of drapery are still gathered up to a single point, but the treatment is smooth, with no interruptions or corners. The infant Jesus is kept separate from the silhouette of the Virgin, and this new independence makes Him seem to join in their conversation as an equal. (See also *103*.)

105 GIOVANNI PISANO, DETAIL OF THE PULPIT. 1301. Pistoia Cathedral. The development of the Gothic style in Italy was less dramatic than in other countries. Italian Gothic figures appear as individuals, and the drapery plays a secondary role in the overall impression created by a piece of sculpture.

106 ST. GEORGE. c. 1300. Porta S. Giorgio, Florence. Along with French influences, the legacy of classical antiquity had a decisive effect on Italian Gothic sculpture. This relief would be very different had the sculptor not retained impressions of the art of the Roman provinces.

107 ADAM. From the balustrade of the north tower of Notre-Dame, Paris. c. 1310–20. Musée de Cluny, Paris. This graceful stance, in which one leg supports the figure while the other takes no weight at all, was a popular one. See Tilman Riemenschneider's *Adam* (1491) in the Mainfränkisches Museum, Würzburg.

108 FRAGMENT OF A STATUE. From the rood screen in Mainz Cathedral. c. 1300–10. Cathedral Museum, Mainz. The way the folds hang downward without touching the ground is typical of the early years of the 14th century.

109 FULL-LENGTH VIRGIN AND CHILD. From Abbeyville. 1310–20. Louvre, Paris. Sculpture in Paris uses earlier formulas that were based on the *Vierge Dorée* at Amiens of 1255–60 (*80*). This wooden figure is 1.18 meters high and again displays the traditional pose with the weight on one leg. The folds are particularly sharp and brittle here.

110 FULL-LENGTH VIRGIN AND CHILD. French. c. 1325. Metropolitan Museum of Art, New York. The curve of the Madonna's body is intensified.

111 GIOVANNI PISANO, CENTRAL SUPPORT OF A PULPIT. Completed 1311. Pisa Cathedral. The figures are unusually serious, in strong contrast to the gayer mood of French art at this period.

112 ANDREA PISANO, DETAIL OF A BRONZE DOOR. After 1330. Florence Baptistery. One of a series of 28 scenes from the life of John the Baptist. This one shows the saint being taken to prison. The artist has fitted his narrative into Gothic quatrefoil frames of a type that frequently appears on French cathedrals. The frame should be seen as a challenge demanding the ingenious use of angles and curves in a single composition.

113 MIRROR BACK. Paris, c. 1320–30. Ivory. Louvre, Paris. Like Greek and Etruscan mirror decorations, French Gothic examples are adorned with a wide variety of scenes that give us glimpses into the daily life of the period. The chess game on this mirror is being played inside a tent, whose folds skillfully enclose the scene within a rectangular frame.

114 MIRROR BACK. French. c. 1330. Ivory. Musée Bonnat, Bayonne. The storming of a fortress is a favorite theme in poetry and the visual arts at this date (compare the related subject matter in the contemporary Manesse Codex).

115 HEAD OF A MOORISH KING. Franconia. 1320–31. Bayerisches Nationalmuseum, Munich. Probably from an Adoration group.

116 HEAD OF KUNO VON FALKENSTEIN. Detail of a tomb effigy. 1333 or slightly later. Collegiate Church, Lich (Upper Hesse). This head and the one in *115* give a good impression of the ideal of beauty current at this period. The delicately carved features are framed by softly flowing locks and are deliberately given an individual stamp.

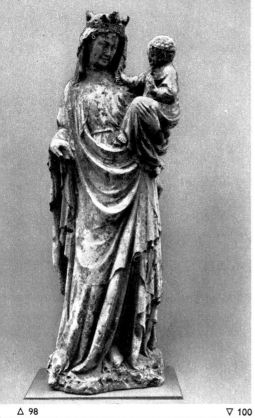

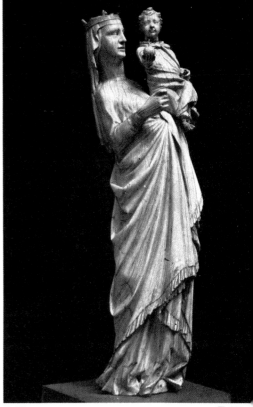

△ 98

△ 99

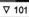

▽ 100

▽ 101

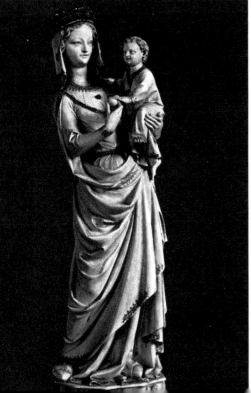

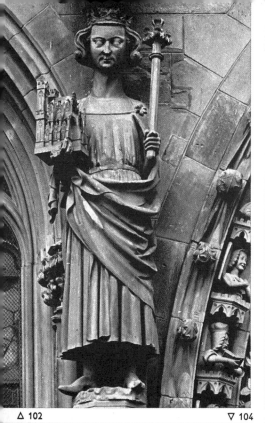

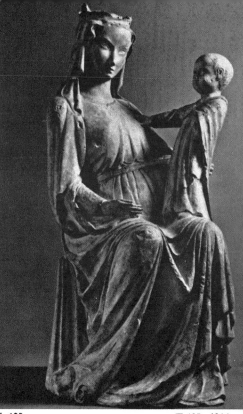

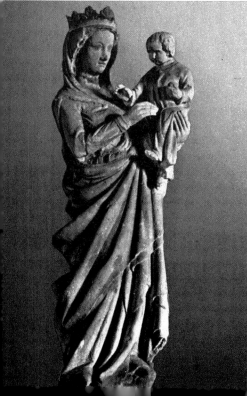

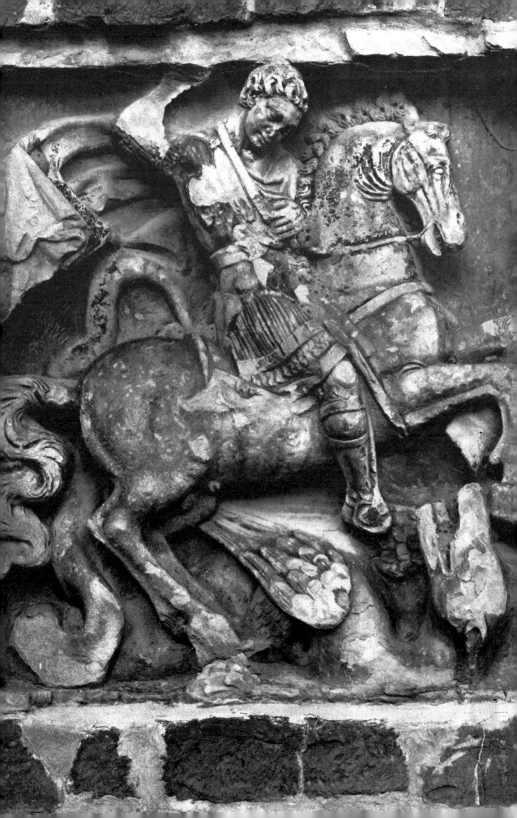

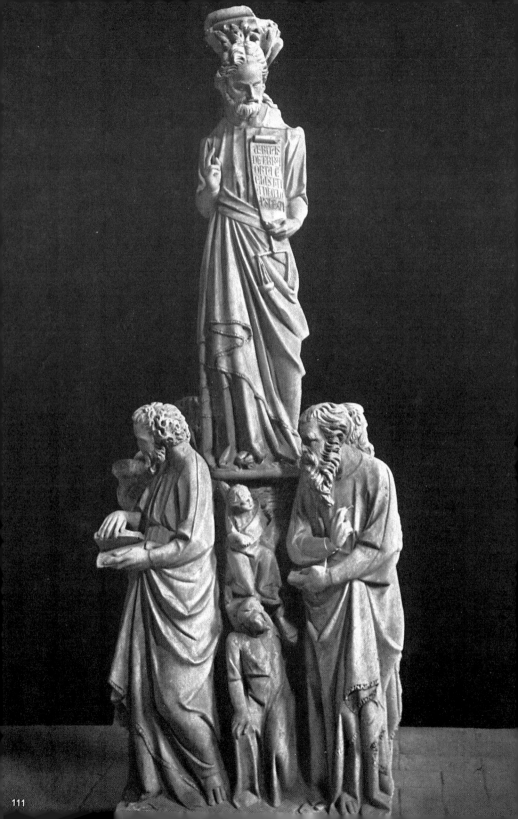

111

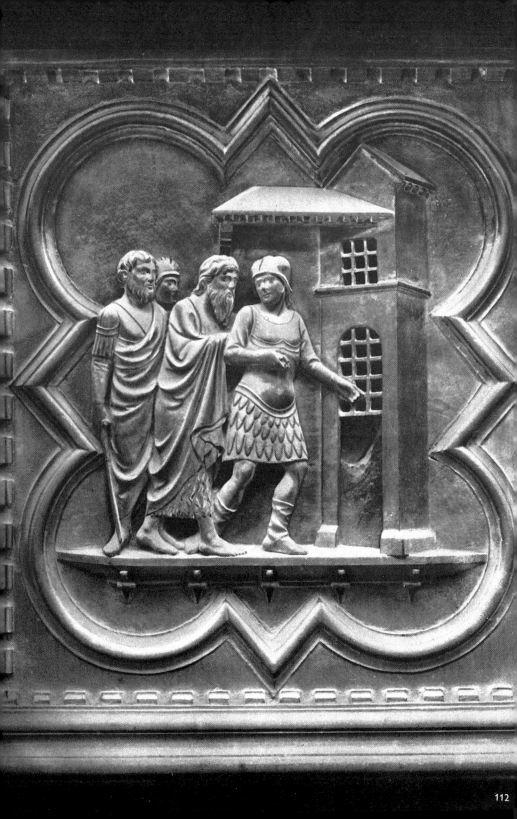

△ 113 ▽ 115 △ 114 ▽ 116

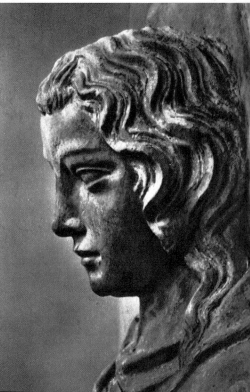

117 CHRIST WITH ST. JOHN. Upper Swabia. c. 1320–30. Stiftung Preussischer Kulturbesitz, Berlin. This oak carving belongs to a type very common in southern Germany in the early 14th century. The boy sleeping at Christ's side, a motif from portrayals of the Last Supper, has been singled out as a devotional image. (A parallel but earlier development can be seen in the case of the Pietà, which was originally part of a mourning group with many figures, then isolated as a single unit.) The Berlin statue is also an excellent example of the style common in the 1320s in southern Germany, which gradually became soft and flowing, especially in the area around Lake Constance.

118 ANDREA ORCAGNA, TABERNACLE. Detail of the back. 1348–59. Orsanmichele, Florence. This *Annunciation* scene is closely related to French work being produced at the same time (see *120*). This stylistic correspondence is not unexpected; since the middle of the 13th century there had been a good deal of cultural exchange between France and Italy.

119 THREE KINGS. Detail of an ivory triptych. French (Paris?). c. 1330. Museum für Kunst und Gewerbe, Hamburg. The crisp style of the piece is close to that of the *Adoration of the Magi* illustrated in *120*.

120 PART OF A CHOIR SCREEN (northern side). Paris. 1325–51. Notre-Dame, Paris, ambulatory. The two scenes depicting the *Adoration of the Magi* illustrated here (see *119*) are an index to the style of cornice that was common in Paris about 1330, with its generous drapery. (See *117* for a German example; *118* for an Italian one.)

121 VIRGIN AND CHILD. Donated by Manuel de Jaulnes in 1334. St. Étienne, Sens. This important piece of sculpture, together with Jeanne d'Evreux's silver Madonna of 1339 (*125, 126*), provides a clue to the dating of various pieces of sculpture from the Ile-de-France. The subject is the same as that of *68*, but the robe is treated in a new way, with the hem forming a ribbon of undulating folds. The base is carved with coats-of-arms, with little figures and an inscription concerning the donor, and also with scenes depicting the *Annunciation*, the *Visitation*, and the *Birth of Christ*. The arms of the throne are also richly decorated. The iconography of the lower part of the throne is important in relation to the d'Evreux Madonna.

122 ANDREA PISANO, WEAVERS (*Arte della Lana*). c. 1340. Campanile, Florence. The richly molded figure on the right shows the direct influence of the sculpture of classical antiquity. Such influence makes Italian work very different from contemporary French figures (see *123, 124*), which seem fragile and even unstable by comparison. This sculpture is very close to the work of Giotto (see *180*), who was working on the Campanile from 1334 to 1337, and who may well have been responsible for the scheme for the sculptures on the Campanile. They depict the various stages of life from the creation of man and the beginnings of human culture, as well as allegories of the ethical powers ruling the world.

123 FULL-LENGTH VIRGIN AND CHILD. Southeast pier of the crossing in Notre-Dame, Paris. 1330–35.

124 CHASED SILVER VIRGIN AND CHILD WITH DONOR. Eastern France. c. 1330. Cathedral Treasury, Aachen. This full-length Madonna and the one at Notre-Dame (*123*) were the immediate forerunners of the most important work of the century, Jeanne d'Evreux's Virgin and Child of 1339 (*125, 126*). The style of the Paris Madonna, who is set on a pedestal as if she were a monument, is strangely vague and ill-defined, providing, as it were, a summary of a number of formulas that would come into vogue during the next few decades. It represents the average of work produced in Paris at this date, and the importance of the d'Evreux Madonna cannot be understood without comparison to it. The style of the silver figure, which is also set on a pedestal, paves the way for many of the details on the d'Evreux Madonna, but it lacks the elegance of the courtly style of its Parisian counterpart.

125, 126 VIRGIN AND CHILD. Donated to the abbey church of St. Denis by Queen Jeanne d'Evreux in 1339. This silver-gilt example of the goldshmith's art represents the high point of three-dimensional Gothic art in Paris. The graceful figure of the Madonna is slightly curved and stands on a pedestal engraved with an inscription regarding the donor, the date, and various scenes from the lives of Mary and Christ. The statue is in an excellent state of

preservation, with only a brooch on the Virgin's breast and her crown missing (the raised attachment for the crown can be seen from the back). Whether the base is contemporary is an open question.

127 HEAD OF A VIRGIN. Lorraine. c.1350–60. Musée de Cluny, Paris.

128 HEAD OF A VIRGIN ENTHRONED. Southern France. c.1350. Musée des Augustins, Toulouse. This head and the one shown in *127* illustrate a tendency, which became common in the 14th century, to give the Virgin rather childish or youthful features. This type is very different from earlier representations, in which Mary is portrayed as knowing the fate of her Son and therefore looks reflective and melancholy.

129 NICOLAUS GERHAERTS, HEAD OF A SIBYL, known as Bärbel of Ottenheim. Fragment of a sandstone bust from the door of the pulpit in Strasbourg Cathedral. 1463–64. Liebighaus, Frankfurt. 23.2 cm. high. This fragment, which was executed about a hundred years after the previous examples, illustrates how long the French ideal of beauty current in the 14th century remained valid for sculptors.

130 HEAD FROM THE TOMB OF GUIDO III OF LÉVY (died 1299). France. c.1300. Abbey church of Notre-Dame de la Roche, north wall of the choir.

131 HEAD FROM THE TOMB OF KING CHARLES V (died 1380). Former abbey church of St. Denis. Commissioned by André Beauneveu in 1364 and completed before the ruler's death. (The photograph shows a plaster cast.)

132 HEAD OF KING CHARLES V OF FRANCE. Executed c.1390 for the portal of the Hospice Chapel of the Quinze-Vingts, Paris. Now in the Louvre.

133 MARBLE HEAD FROM THE TOMB OF BERTRAND DE GUESCELIN (died 1380). Paris. Late 14th century. Former abbey church of St. Denis. (The photograph is of a plaster cast.) The four heads illustrated in *130–33* are all likenesses of historical figures and illustrate the development of portrait sculpture in the 14th century. A study of tomb effigies is a particularly good way of understanding the various stages by which the ideal of the sculpted figure changed. During the reign of Charles V (1364–80),

sculptors began to study the features of their sitters, and their work had a strong influence on book illumination. Charles was the first king of France whose features are known to us. Bertrand de Guescelin's face, here, has not been idealized; it may, in fact, have been sculpted from a death mask. This new fashion for capturing the sitter's individual personality reached its peak shortly after 1400, with Claus Sluter's prophets on the Moses Well at Champmol (*134*).

134 CLAUS SLUTER, THE PROPHET JEREMIAH. Detail from the Moses Well, a symbolic fountain once crowned with a crucifix. Completed 1406. Former monastery, Champmol, near Dijon. Claus Sluter was a Netherlandish sculptor, who from 1385 worked as assistant to Jean de Marville in Dijon, in the service of Philip the Bold. He took over from his master in 1389. This foreigner's realistic style revolutionized French sculpture; after the creation of the portal of the Carthusian monastery and the Moses Well, France gradually abandoned the Gothic tradition and entered a new era. Sluter freed the three-dimensional figure from its dependence on architecture, made his figures more expressive by giving them realistic features, and also created his own highly supple treatment of drapery, which is only very loosely based on earlier work.

135 VIRGIN WITH A BUNCH OF GRAPES. Burgundy. c.1440–50. Parish church of Auxonne (Côte d'Or). This very fine piece of sculpture shows the strength of Sluter's influence in Burgundy. His most influential work is his Virgin on the trumeau of the former abbey church of Champmol, which was placed there some time before August 6, 1391 (work on the portal was carried out from 1387 to 1394). To understand the full importance of this revolution, this volte-face in the direction of weight and volume and intensified interest in realism, we have only to compare this Madonna with earlier examples from the Ile-de-France, particularly the statuette donated by Jeanne d'Evreux, whose courtly style seems in retrospect perhaps a little mannered and over-refined (*125, 126*).

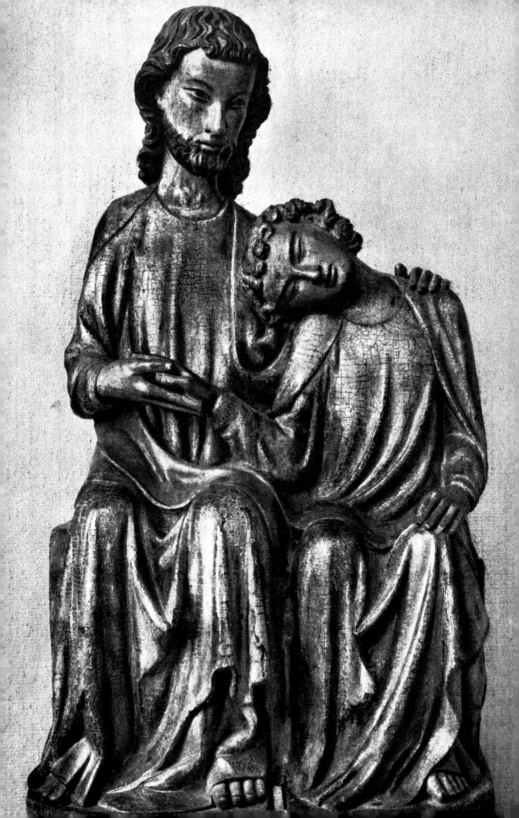

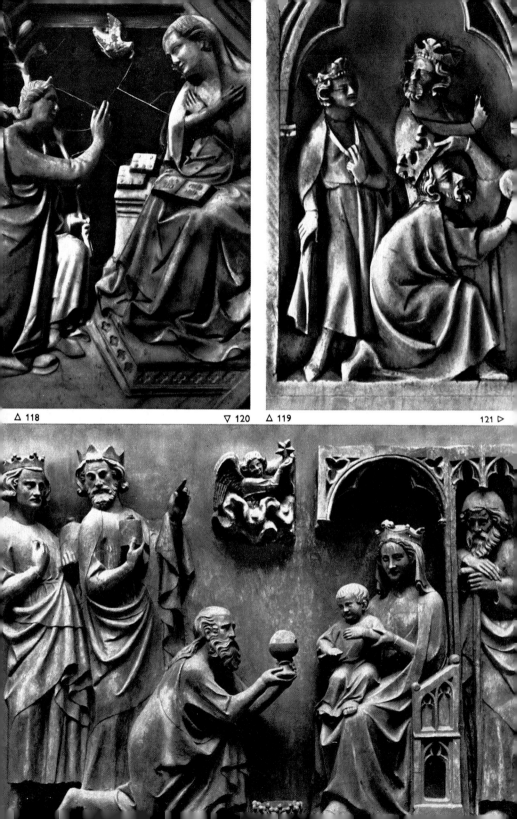

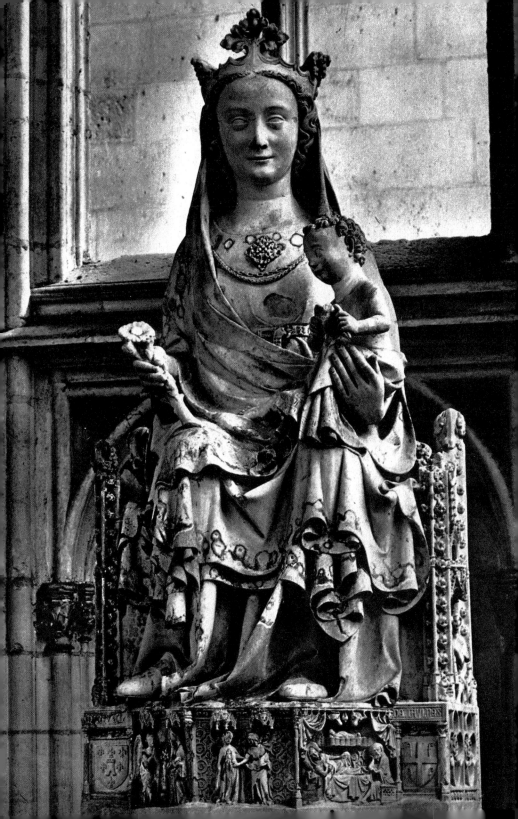

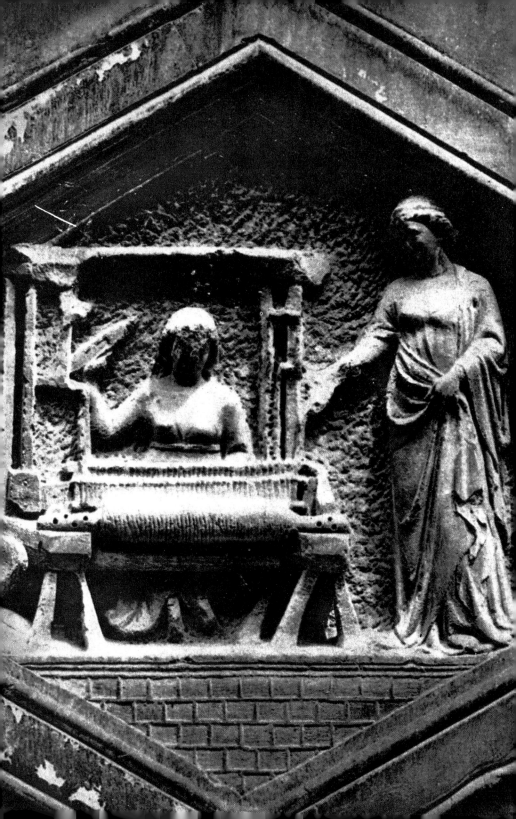

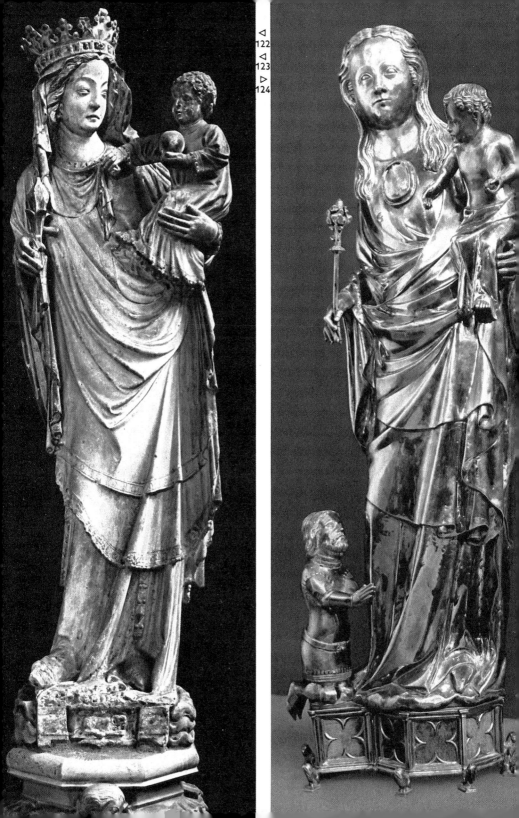

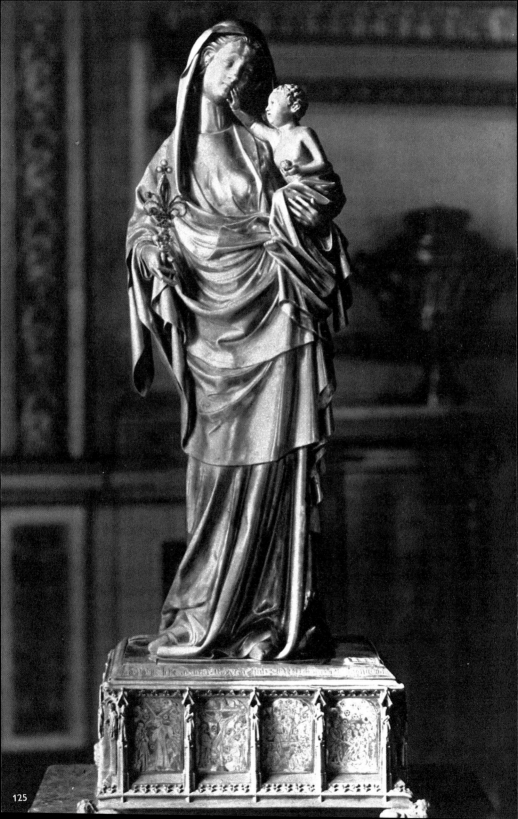

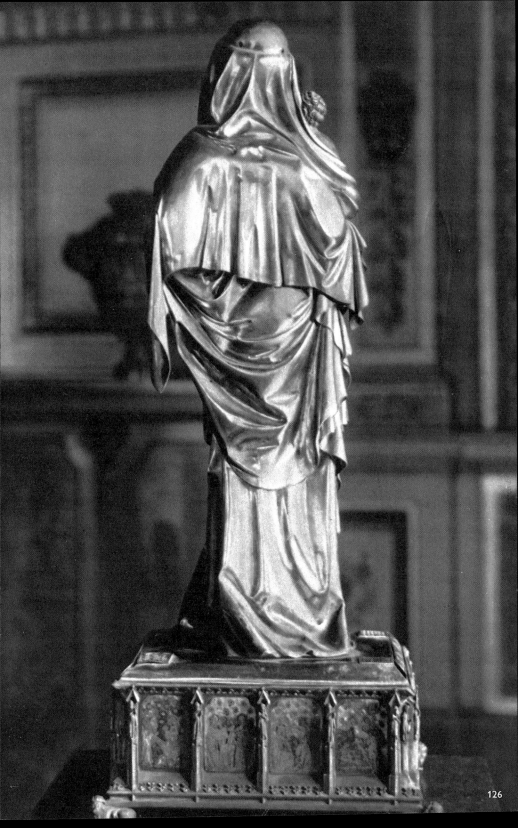

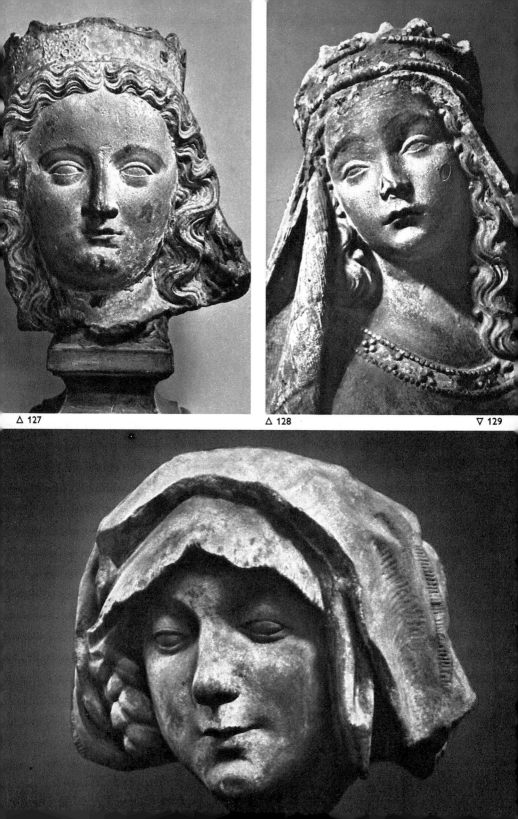

△ 127 △ 128 ▽ 129

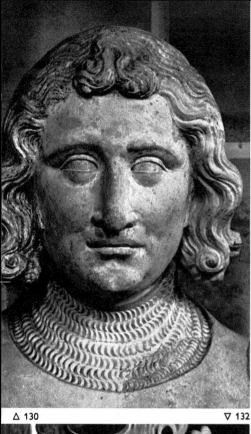

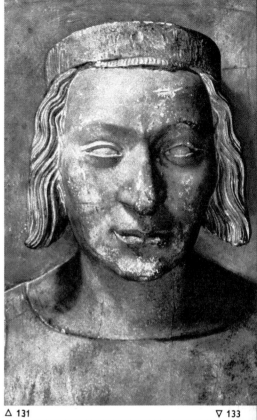

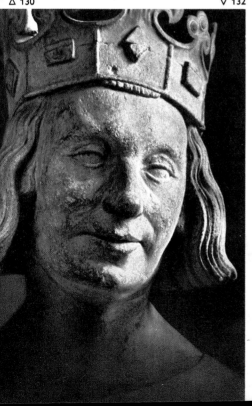

△ 130 ▽ 132 △ 131 ▽ 133

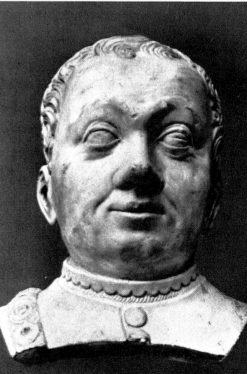

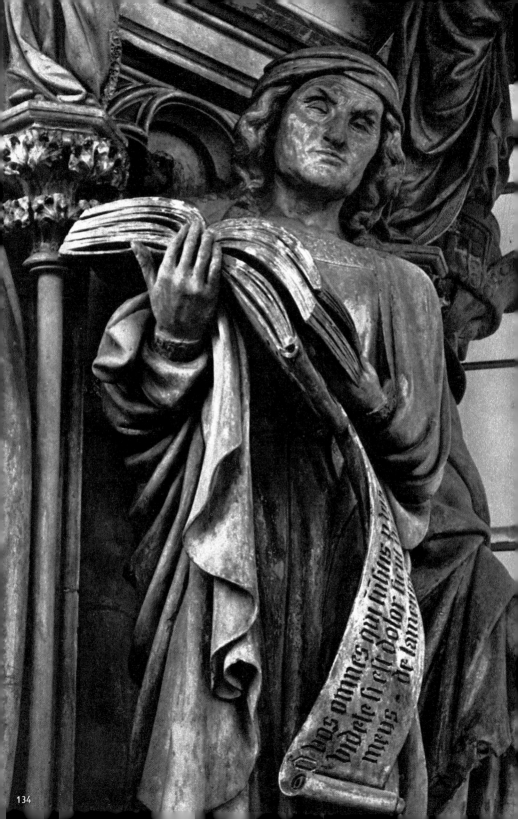

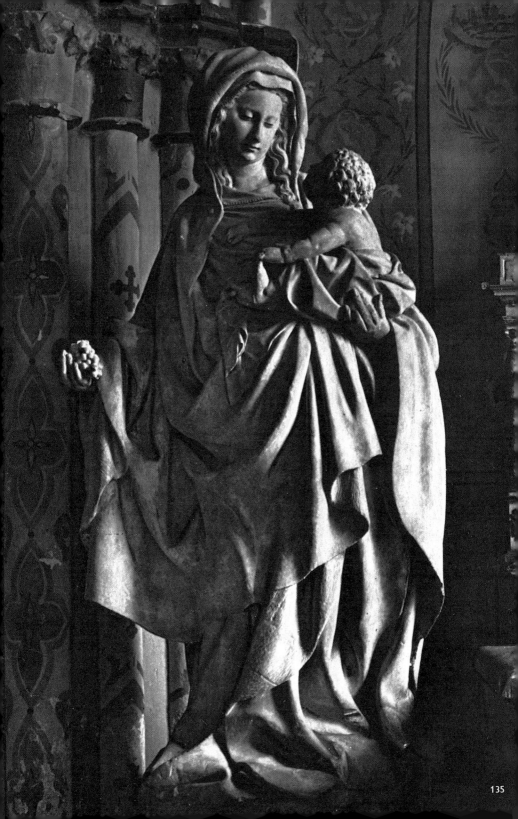

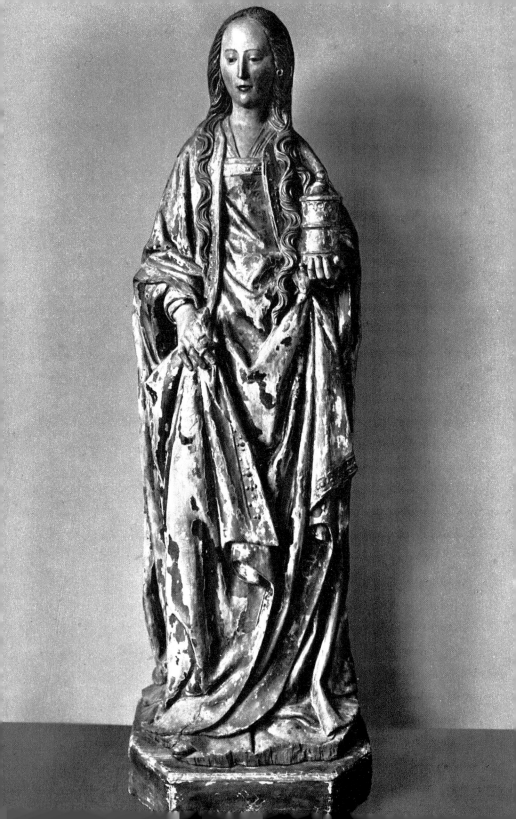

individuality. This departure can be detected, for instance, in the work of Hans Multscher (born c. 1400, working in Ulm 1427–67). He is one of the first medieval sculptors whose production can be followed over a fairly considerable time span. Comparisons between his *Virgin Enthroned* (*139*) and earlier sculptures on the same theme (*67, 68, 94, 95, 103, 121*) clearly illustrate the development.

It is against the background of Multscher's generation that we place the work of the outstanding group of sculptors active at the end of the Gothic age and the beginning of the Renaissance, among them Jörg Syrlin the Elder, Michael Pacher, Bernt Notke, and the three great Nuremberg masters, Veit Stoss, Adam Kraft, and Peter Vischer the Elder.

The Gothic ideal was realized in a far more pure and concentrated form in sculpture than in painting. It was here, too, that the first steps toward characterization were made, which do not appear in painting until the 14th century, and then only tentatively. By this time, sculpture had already become more humanized, and finally it became positively down-to-earth. It came within the intellectual range of middle-class patrons, while painting remained the province of patrons at court for many years.

Sculpture also gradually moved from the façade of the cathedral to the inside of the building. The most important commissions were now for folding altarpieces—shrines with carved figures and paintings, made up of a large number of different sections and wings. These create a monumental effect, but they are in fact small in scale, designed to be seen from close by and intended to encourage personal devotion. The most costly examples sometimes include highly complex cycles of paintings. And it has rightly been said that often a complete sculptural program suitable for a cathedral is concentrated in the tiny space of an altar. Themes of Christ appear alongside comprehensive sequences of images referring to the deeds performed by the local saints.

At the center of these altars there is generally a flat, nichelike shrine filled with figures or full reliefs. This is richly painted or gilded, sometimes so naturalistic that it conjures up a living Christian *theatrum*. Today the wings of these altars are generally left open, but in the Middle Ages they were opened only on church holidays. When they are closed, we can see that their exterior surfaces are also carved with figural decoration. (In the Low Countries in the 15th century this carving was replaced with a type of *trompe-l'œil* painting that simulates sculpture by the use of grisaille, or gray monochrome.) In many instances, such paintings depict the Annunciation, as a sort of prelude to all that is to be seen within.

The whole altarpiece is set on a long rectangular pedestal with a carved or painted predella panel. Liturgically, it acts as a receptacle for relics or for the pyx with the consecrated wafer. In the Late Gothic period, these carved altars generally culminated in a tall, tower-

◁ 136 MARY MAGDALENE. Eastern France. c. 1500. Bayerisches Nationalmuseum, Munich. Height 1.61 meters. The strong influence exercised by Sluter did not subside in France until c. 1500, in the wake of the Italian Renaissance. The saint's robe betrays its French origin, but the slender figure, the simple outline, and the Italianate features show that sculpture was again turning in a new direction.

like structure. The crowning element was richly carved and consisted either of several canopies one inside the other, or a lacy web of tracery, or a crystalline structure made up of golden pinnacles and gables. Figures were sometimes added here, too, in such scenes as the Coronation of the Virgin, the Ascension, or simply God the Father with his hand raised in benediction. Veit Stoss's great altar in St. Mary, Cracow (1477–89), is 13 meters high and almost 11 meters across when the side panels are open. Michael Pacher's altar in the parish church of St. Wolfgang is almost as high (11.10 meters); it was commissioned in 1471 and completed in 1481. Such systematic development of the "classic" premises of the 13th century occurred scarcely anywhere but in Germany in the Late Gothic era.

Italian sculpture clung for many years to Romanesque traditions; Gothic forms did not flourish there until the mid-13th century, with the work of Nicola Pisano. The process of assimilation was a complicated one and varied from one region to another. The use of French forms was initially limited to ornamentation, to eye-catching decoration. At first glance, Nicola's marble pulpit in the baptistery in Pisa (signed and dated 1260) has little of the Gothic about it; its arches are all semicircular, for example. But the inset trefoils awake echoes of French tracery, and, as has been remarked (H. W. Janson), the Gothic quality and human feeling in the narrative scenes are notable. The Gothic leitmotiv of the classical quatrefoil frame was first used in a systematic way by Andrea Pisano, on his door for the baptistery in Florence, which was completed after 1330 (*112*). His figures, as do Nicola's, owe much to the legacy of classical antiquity and of Byzantium. But Gothicism was no more than a short phase in Italy, culminating in Giovanni Pisano's Madonna in Pisa (*99*), whose robust grandeur provides a clear illustration of the differences between French and Italian Gothic. Italian art of the 13th and 14th centuries (*118, 122*) is a kind of prelude to the individual art that was to come. In it lie the roots of the Renaissance.

137 VIRGIN AND CHILD. From Krumau (Southern Bohemia). Prague (?). c.1400. Kunsthistorisches Museum, Vienna. Height 1.12 meters. This limestone figure is one of the finest examples of the *Schöne Madonnen* (beautiful Madonnas), and one of the most important achievements of what is known as the Soft Style in Germany. It is possible that this type of Virgin first emerged in Bohemia, though influences from France and the Low Countries must be taken into account. The Krumau Madonna is outstanding "for the refinement of her spiritual expression and the harmony of her whole appearance. Her pose is restless in the most delicate way and full of rich subtleties, but it is still very much a frontal view and is not treated fully in the round in the way a column would be" (Theodor Müller).

138 PIETA. From the Seeon Monastery, Chiemgau, near Salzburg. c.1400. Bayerisches Nationalmuseum, Munich. Height 75 cm. This painted limestone sculpture shows how intense grief was expressed by sculptors working in the Soft Style.

139 HANS MULTSCHER, VIRGIN ENTHRONED. Ulm. c.1430–35. Bayerisches Nationalmuseum, Munich. Height 58 cm. This carved wooden statue was executed at roughly the same time as the grieving figure on the main portal of Ulm Cathedral (1429) and is an early work of Multscher. It shows the influence both of Sluter and of the Soft Style.

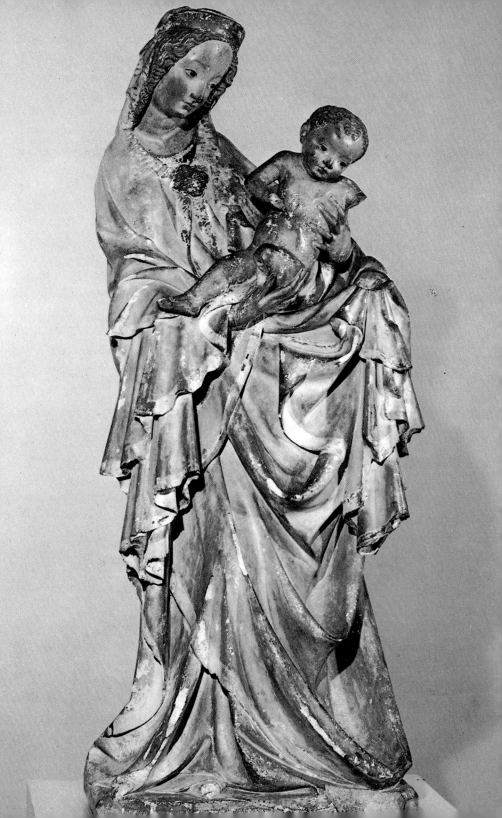

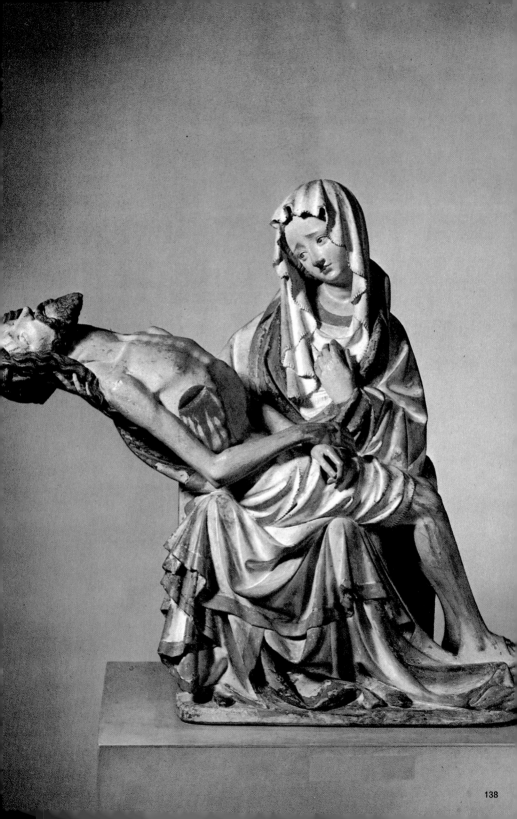

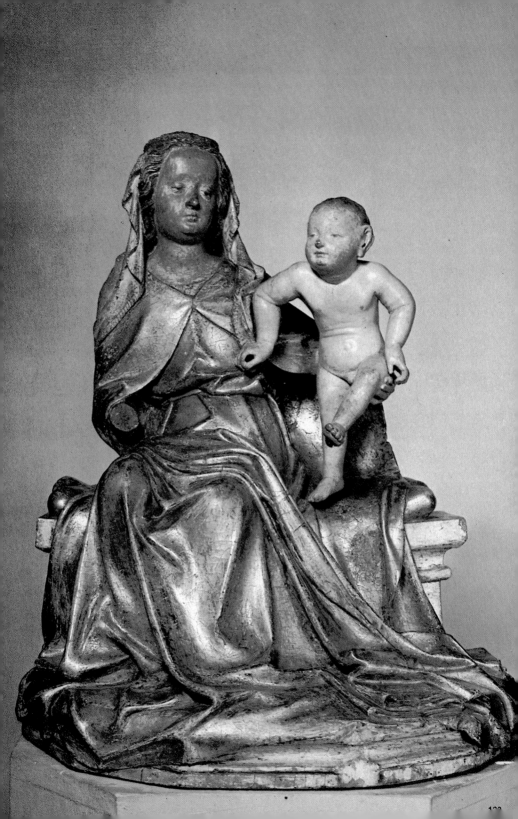

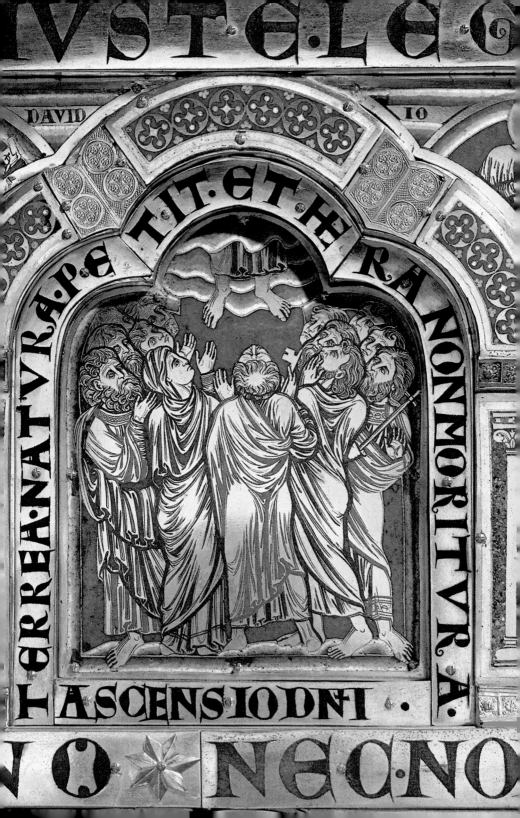

PAINTING

France's most important contribution to Gothic painting is the stained-glass window. Nothing definite is known about how or where glass windows first came into use. According to written sources, they were known at the end of classical antiquity and in the early days of Christianity. Theophilius Presbyter writes in his *Schedula diversarum artium*, a treatise of the 10th or 11th century, that glass windows had been in use in France for many years ("*quiquid in fenestrarum pretiose varietate diligit Francia*"). And a chronicle from St. Remi in Rheims, dated 905, reports that the glass windows in the church there told various "histories."

It is only in recent years that art historians have begun to make a systematic study of the windows in the French cathedrals and churches. It is true, of course, that the great majority of the original windows have been destroyed; some have been restored and others have been completely replaced. Even Abbot Suger of St. Denis commissioned a specialist to be responsible for the upkeep of his fragile stained glass.

From the viewpoint of the history of style, stained glass may have been less influential than book illumination. The important aspect of the development of stained glass is really not the detail of the windows, but their total effect within their architectural setting. Over the years the openings hollowed out of the wall began to be filled with various types of glass decoration. Initially, this took the form of simple circular medallions placed one above the other and set against a background made up of tiny motifs. The process already described in regard to architecture, whereby individual elements are assembled to form a whole, becomes particularly clear when we turn to stained glass.

The medallion window is the Gothic window in its purest and simplest form (*144, 161, 164*). At first, two rows of medallions were generally placed next to each other, but as the style developed, the circular shapes were transformed into interspersed squares, lozenges, and quatrefoils (*148*), linked together by subject matter. They began to overlap and to be arranged like a kaleidoscope so as to form new and larger patterns (*149*; see also *174*).

If we visit Chartres Cathedral, which can still give us a relatively authentic impression of how the original stained glass looked (*145*), we can trace the way this type of decoration became more and more complicated between 1200 and 1240. The original simple illustrations of single events or themes developed into highly complex and elaborate schemes as the glazier was increasingly required to create entire pictorial programs. It is well known that a considerable part of the importance of these colored picture Bibles was their didactic function. Men such as Abbot Suger in the 12th century and Jean Gerson in the early 15th century leave little doubt on this score: "The pictures in the church windows are painted for no

◁ 140 NICHOLAS OF VERDUN, ASCENSION OF CHRIST. Enamel plaque for an ambo, later converted into an altarpiece. 1181. Canon's Chapter, Klosterneuburg. (See *141* for a reconstruction of the altar.)

III/16 Resurrection of the Dead
I/17 The Heavenly City of Jerusalem
II/17 Christ as Judge
III/17 The Mouth of Hell

The Klosterneuburg Altarpiece is the masterpiece of this goldsmith from the Meuse region. It was commissioned by Provost Wernher (1168–94) and completed in 1181. The champlevé enamel panels were originally designed to decorate an ambo, or pulpit, which also acted as a ciborium (or baldacchino) for the altar beneath it. After a fire in 1330, the panels were converted into a folding altar on the instructions of Provost Stephan of Sierndorf (1317–35). While this conversion was being carried out, six new panels were added (in 1331): I/8, II/8, III/8, I/10, II/10, and III/10. The panels provide illustrations for sermons and represent a sort of picture Bible.

The various scenes are not arranged chronologically but according to a typological system. The parallels between the Old and New Testaments are set in a historical and theological framework, with the enamels divided into three horizontal registers. The top one depicts prototypes for Christ's life in the Old Testament, from the period before the Law (*ante legem*). The bottom register portrays events of the next Biblical era, the period under the law (*sub lege*), from the handing down of the Law on Mount Sinai to the end of the Old Testament. These two periods prepare for the coming of Christ, and the fulfillment of this divine scheme is the subject of the middle row, which takes place under Grace (*sub gratia*). This means that each scene from the life of Christ is contrasted with two prototypical episodes from the Old Testament. Thus His Ascension (*140*) is accompanied by a scene in the top row showing Enoch being taken up into heaven, while in the bottom row we see Elijah's dramatic disappearance. According to Genesis 5:24, "And Enoch walked with God: and he *was* not; for God took him." And we are told that Elijah was taken up "by a whirlwind into heaven" in "a chariot of fire," with his disciple Elisha looking on (II Kings 2:11).

The panels are executed with virtuoso skill, full of movement, dynamic gesture, and expressiveness. Earlier Mosan and French book illumination may have contributed to the development of Nicholas's style.

142 VILLARD DE HONNECOURT, SKETCHBOOK. c. 1220–30. Bibliothèque Nationale, Paris, MS fr. 19093. The distinctive manner in which the draftsman executed the drapery—which can only be described as a series of pothooks—is by no means an idiosyncrasy. The style (called *Muldenfaltenstil* in German terminology) first appeared at the end of the 12th century. It is handled with particular skill here. The increased repetition of the looped folds appears to be a late, mannerist phase of a development that began to die out c. 1250. The fact that the *Muldenfaltenstil* appears in such a pronounced fashion in, of all places, the sketchbook of a master builder, suggests that the looped folds may in fact represent a series of ciphers for a sculptor's guidance; they may have been intended to show him where the hollows of the folds were to go. The drawing thus served an instructive function—a graphic, two-dimensional device to help the stone mason achieve a three-dimensional result.

143 DEPOSITION FROM THE CROSS. Detail. Ingeborg Psalter. Northeastern region of the French Royal Domain. c. 1195. Musée Conde, Chantilly, MS 1695. The attempt to arrange groups, to make of single figures a united composition became an extremely important artistic goal c. 1200 and remained so throughout the Gothic period. This *Deposition*, which shows Byzantine influences, illustrates the idea very clearly. The head of Mary placed beside that of her dead Son is seen frequently in *Lamentatio* scenes from the East in which two figures join to form a single silhouette in a rather similar way.

144 CRUCIFIXION. Small round window, Chartres Cathedral. c. 1210. Although the scene fills the whole opening, the space is subdivided into circular segments, all of which adjoin the central medallion. On either side of Christ appear Longinus and Stephaton, with Mary and St. John (partly cut off in this photograph) outside the central medallion, Adam and Eve below, and a pair of angels above. Christ is nailed to a green cross, an allusion to the metaphor of the Cross as the Tree of Life (*arbor vitae*).

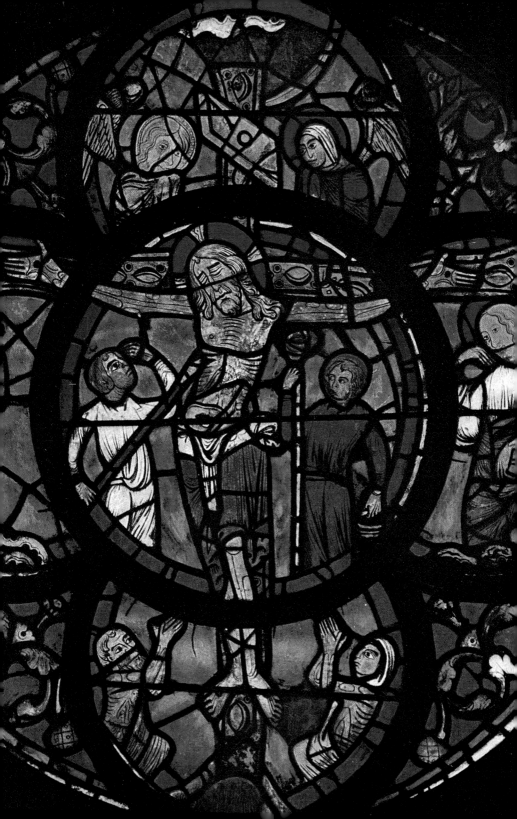

other reason than to show the common people, who are unable to read, what they are to believe." An early catechism from the diocese of Tréguier in Brittany exhorts the churchgoer to take the holy water, to worship the sacrament, and then to wander around the church and gaze at the stained-glass windows.

Over and above this didactic purpose there was of course a loftier, theological concept. The patriarchs, the prophets, and saints, as patrons of the church, are generally to be found in the north clerestory windows. Facing them, on the south side, appear the apostles, the martyrs, and saints of universal importance. In important places—on the west side or in the top story of the chancel, we will find the Tree of Jesse, representing Christ's genealogy. This deliberate link between the Old and New Testaments again predominates in many of the windows in the aisles, which should generally be read from left to right and from the bottom up.

The dominant color in 13th-century stained glass is blue, which was probably used with green at an early date, if we can judge by Limoges enamels and manuscripts of the period. There was also a brilliant ruby red. Gothic color harmonies were not built up from the earth colors—red, green, brown, and white—but rather, as in Romanesque frescoes, from the primary colors of red, blue, and gold (or rather, yellow). The subsidiary colors are purple, green, and white (see *144, 145, 147, 148, 154*). The colors filter the light flooding in from outside, which acquires a special significance in this context (*145, 149*).

Medieval thinkers saw light as a symbol of order and magnitude. According to the Neoplatonic metaphysics of the Middle Ages, it is the most sublime of all natural phenomena, a virtually immaterial substance and therefore closest to pure form. In fact, it is identical with beauty. Hugh of St. Victor and St. Thomas Aquinas attribute two main qualities to beauty: luminosity and the harmonious accord of individual elements and proportions. Luminosity was seen as the expression of ontological perfection and as mirroring God as the source of all things. Stars, gold, and precious stones were therefore described as "beautiful." In the literature of the period, beauty is most commonly accompanied by the adjectives "light," "light-filled," and "clear," in the sense of "bright."

The *lux nova* that Abbot Suger describes in regard to his new church of St. Denis refers to Christ. His theory of light can be found in his notes on theology and is based on the Neo-

145 ROSE WINDOW AND OTHER WINDOWS IN THE NORTH TRANSEPT, CHARTRES CATHEDRAL. c.1230. The use of the royal arms of France and Castile suggests that these windows were a royal commission. The center of the rose window depicts the Virgin Enthroned; below, in tall lancets, are David and Melchizedek, Solomon and Aaron, and between these, St. Anne with Mary in her arm.

◁ 146 HARVEST SCENE. From a *Speculum virginum*. c. 1190–1200. Rheinisches Landesmuseum, Bonn. The theme of sowing and reaping is divided into three sections. This arrangement suggests that the model may have been executed on a long strip, and that the scenes had to be cut up to fit onto this narrow page. The figures are arranged in pairs, turning toward each other as if engaged in conversation. The whole composition is most skillfully done, particularly the harvest scene in the central strip, which is visually sealed off by the architectural structure on the right, while still remaining part of the narrative sequence. The use of alternating colors for the frame and the background is a traditional device for creating a feeling of space.

platonic philosophy of Dionysius the Areopagite (who was wrongly identified with St. Dionysius, the patron saint of the church of St. Denis). In this we can read that man obtains a deeper understanding of the divine light via the light of the physical world. This idea explains Suger's interest in liturgical implements made of gold and silver, and also clarifies the importance he attached to his stained-glass windows. As he saw it, they had three basic properties: they were a vehicle for sacred love; they were strongly reminiscent of precious stones; and they appeared to contain a supernatural mystery, in that they glowed without fire.

From the point of view of function, stained glass developed along different lines from manuscript illumination. Stained-glass windows were used to instruct the people—the common throng—whereas illuminated manuscripts were generally intended for individuals, and were thus used for private devotional purposes. As panel painting had not yet developed, Gothic painting initially took the form of either monumental work—that is, stained glass—or miniature painting. The two media, in their ability to create a new pictorial world, had a strong influence on each other, despite their differences in scale. The figure, as seen, for instance, in Villard de Honnecourt's sketchbook (57, 142), is so conceived that it can be either reduced in scale or enlarged without losing anything in the process. Thus, monumental concepts can be found in illuminated manuscripts (143, 151, 168), while some images common to miniatures are seen in stained glass and in wall paintings (147, 161, 185).

Gothic manuscript illumination falls into two main periods. The first of these extends from the beginning of the 13th century to the time when paper began to be used as a writing material, in the last quarter of the 14th century. The second period lasts until the first woodcut illustrations at the end of the 15th century. The golden age of manuscript illumination, as is also true of stained glass, is the 13th century. The specifically Gothic style of illustration, which to a limited extent derived from local Romanesque traditions, was heavily influenced by Byzantine work.

From the documentary evidence available, we know that a whole series of laymen worked as illuminators in Paris. The contribution made by the monasteries is also important up to the 14th century, though it did not have a decisive influence in many places. Manuscript illumination was carried on in almost all the larger monasteries in the West. It is true, of course, that the brisk exchanges of illuminators and models between monasteries obscure stylistic differences, sometimes making it difficult to classify work on a topographical basis.

It was the church and the nobility that supported the production of illumination on expensive vellum. When we come to the period when paper was used for manuscripts, we also find the properous middle class beginning to commission and purchase work from illuminators. This was instrumental in bringing about the hunger for books that set in at the end of the Middle Ages, which contributed to the upsurge of manuscript production. Pen drawings were often tinted with colored inks.

Following the traditions of Romanesque art, Gothic painting generally reinterpreted material that was already in existence, and from the 13th century the narrative element predominates. Large cycles of paintings—some of them new inventions, such as the extensive series of Old Testament images in the Psalter of St. Louis (150, 166) and in Sainte-Chapelle—decorate the churches and shine forth from the windows as though relaying messages from

another world. Among the various styles of draftmanship that were practiced in the 13th century, the restless *Zackenstil* ("jagged style") of the years 1250–70 deserves special mention (*168–71*). Around 1300 a dramatic intensity is seen in larger figures with drapery falling in long folds (*172*).

A bold style evolved for historical events (*162*) and for interpreting the lives of the saints for which no earlier iconographic tradition existed (*160, 169, 177, 179*). The freedom with which models and prototypes were treated derives from the Gothic narrative tradition, which allows the artist to make a large number of genre embellishments or to add personal "marginal notes" (*183, 184*) that do not necessarily have anything to do with the main pictures. The spread of what are known as "drolleries" in the margins of pages of text or pictures is a typically Gothic phenomenon that began around 1250 (*173*). From the 1330s, grotesques and *bas-de-page* images became part of the illuminator's stock-in-trade. The first major achievement was made by the Paris illuminator Jean Pucelle (*191–92*), who rearranged the page to integrate text and pictures. This important artist and his evolutionary work are also partly responsible for the fact that illumination eventually escaped the limitations imposed on stained glass and went its own way (see *160–65*). Pucelle's attitude to the art of picture making also had a lasting effect on early panel painting, whose historical roots lie in manuscript illumination rather than in stained glass.

The initial task of the Gothic painter was to translate sacred stories into pictures. The painter working on such pictures saw himself as serving and praising God; only a few isolated examples of secular manuscripts with noteworthy illustrations are found in the 12th and 13th centuries. Because the drolleries in sacred manuscripts were less official, in that they appeared outside the main picture area, they opened up a new pictorial world, offering glimpses of everyday life that must have stimulated the Gothic thirst for storytelling in the most marvelous way.

An example of secular Gothic painting can be seen in the Manesse Codex (*194*). The chivalrous courtly culture of the age of the minnesingers, of which this provides a perfect summary, affected in its turn the religious images of the age. Peter Meyer has described the Manesse Codex as "the treasure house of the German minnesinger." This extremely comprehensive compendium of medieval German lyric poetry was probably compiled in Zurich, or at any rate in the area around Lake Constance, between 1315 and 1330. The 137 miniatures, each of which has a page to itself, were executed by four painters; a principal master (responsible for 110 miniatures) and three supplementary masters. Their style is rooted in the traditions of southern Germany, the region around Lake Constance and Swabia. This highly successful art is distinctly Germanic in character. Only the third supplementary master, who was active around 1330, reveals an intimate knowledge of French Gothic painting. In his figures we find the Western ideal of loveliness, the Parisian version of sweetness. They are the work of a highly gifted wandering artist; we know little of the itinerary he followed, but his art can be compared with the major achievements of his generation, such as the stained glass at Königsfelden (*187*).

In the early 14th century a new image of man emerged, based in part on early Gothic concepts. The portrayal of man as a symbolic figure or as a perpetrator of action developed

147 CHRIST BEFORE PILATE. Detail of a window at St. Étienne, Caen. c.1220. Church windows in the early 13th century were composed of a series of vertically arranged circular medallions. About 1220, the patterns were sometimes joined together to create a kaleidoscopic effect.

148 PRODIGAL SON. Detail of a window in Sens Cathedral. c.1220–25. The frames around the scenes include shapes that are particularly common in architectural carving. In this case, there is a quatrefoil combined with an inset lozenge. The narrative style is highly dramatic here, paving the way for the large cycles in the Sainte-Chapelle, Paris (149).

149 SAINTE-CHAPELLE, PARIS. Built by Pierre de Montreuil or Thomas de Cormont in 1243–48. The question as to who was the creator of this monumental glass shrine remains open. It is generally thought of as the quintessence of the Gothic style. The wall has been reduced to the bare essentials for the support of the structure, and the windows therefore take over the function of the wall. Light-filled, they form a screen between this world and the next. Biblical events from the Old Testament are portrayed in minute detail. Fascination with this type of ethereal architectural framework is reflected in book illumination (see 150). All the architectural elements were originally painted and gilded, though today, after restoration, they are probably darker than originally. Later examples of the capella vitrea ("glass chapel") are St. Germain-des-Prés and St. Germain-en-Laye.

150 BATTLE SCENE FROM THE OLD TESTAMENT. Psalter of St. Louis. Paris. c.1250–60. Bibliothèque Nationale, Paris, MS Lat. 10525, fol. 52 recto. The new type of architecture embodied in Sainte-Chapelle (149) reappears in the "framework" used in book illumination. The cellular division of the wall into light, disembodied particles is reflected in these delicate architectural backgrounds, which in their turn were copied widely.

151 ST. ANDREW THE APOSTLE. Oscott Psalter. England, c.1270. British Museum, London, Add. MS 5000, fol. 8 verso. The monumental style of this figure brings us close to the Westminster Retable, so this manuscript was probably commissioned by Cardinal Ottobuoni Fieschi (afterward Pope Adrian V), legate to England in 1265–68. The figures of the apostles in the Oscott Psalter each take up a full page and are set within close-fitting architectural frames. They mirror the style used for monumental sculpture at this date. The Muldenfaltenstil practiced in the first half of the century (142) has almost died out, surviving only in a few isolated loops. The drapery is treated in a rather summary way and the figures have a smoth, compact outline.

152 CRUCIFIXION. Evesham Psalter. England, c. 1250. British Museum, London, Add. MS 44874, fol. 6 recto. The Evesham Crucifixion is widely regarded as one of the major achievements of the English school of illumination in the 13th century. The unknown artist was a master of linear expressiveness; his picture shows none of the growing taste in England for French Gothic softness, as reflected in the miniatures of the Oscott Psalter. Here the plain frame barely contains the turmoil of the lines; this emphasizes the drama and tension of the scene within. The stylized ornamental details and fractured linear shadows create an image of remarkable emotional impact and dynamism.

153 BOOK COVER. From St. Blasien (Black Forest). Northern France. c.1250–60. St. Paul Abbey (Austria), Jewel Room. 38.6 × 27 cm. This silver-gilt cover with its decoration of precious and semiprecious stones, antique gems, mother-of-pearl, and enamelwork was probably made in Paris. A miniature version of an entire scheme for a church doorway has been concentrated in a tiny area, with the full-length statue of the Virgin and Child placed in the central doorway, rather than in its usual position on the trumeau (35), and figures of Reinbertus and Abbot Arnold of St. Blasien (1247–76) taken from the flanking walls of the portal. The "tympanum" is adorned with a Coronation of the Virgin (61–62), while the little figures of St. Blaise and St. Vincent at the sides can be taken to represent the archivolts. Set within trefoils and quatrefoils in the frame we find Christ Enthroned, the four Evangelists, the Virgin Mary, and the Angel of the Annunciation. Two of the figures have disappeared. The

PILATVS

SAOIAN

IAMICOIS

DICIT ISTE PETRO DICIS ET INDINSERVO

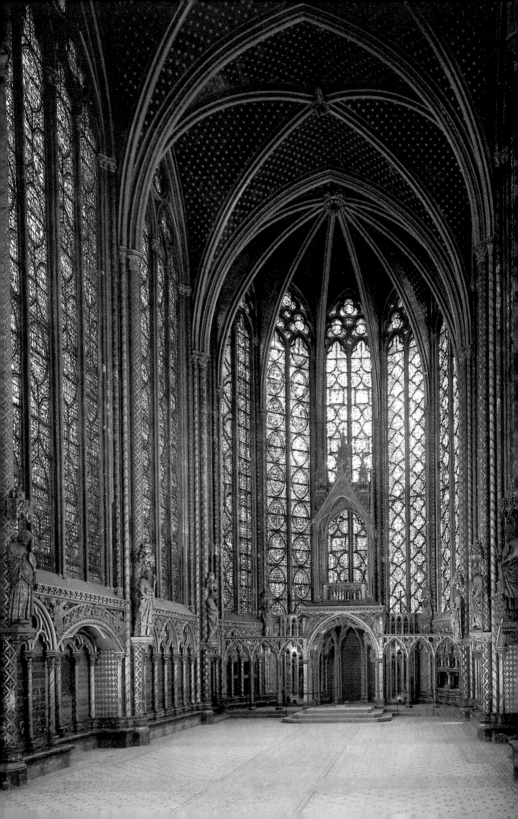

151

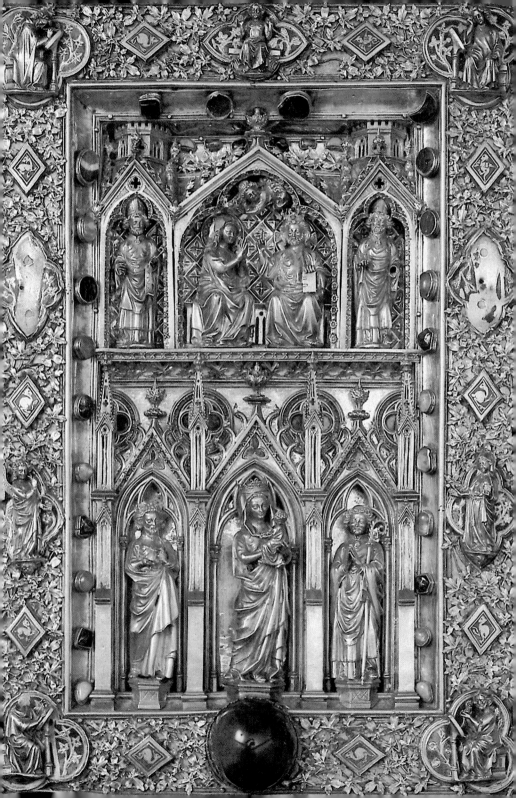

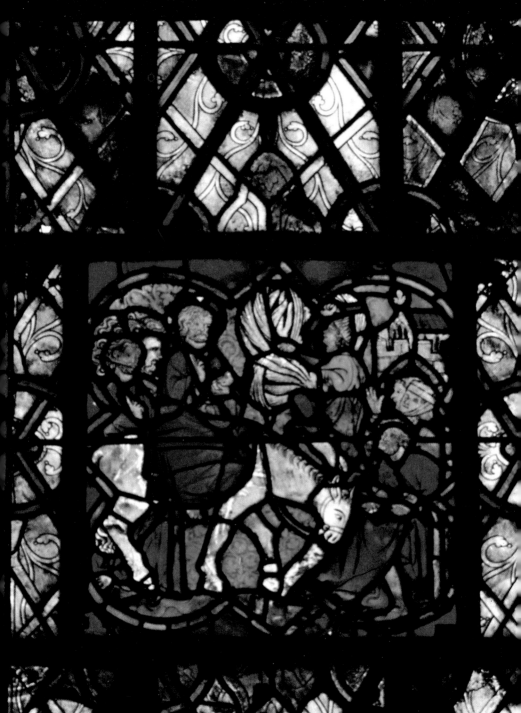

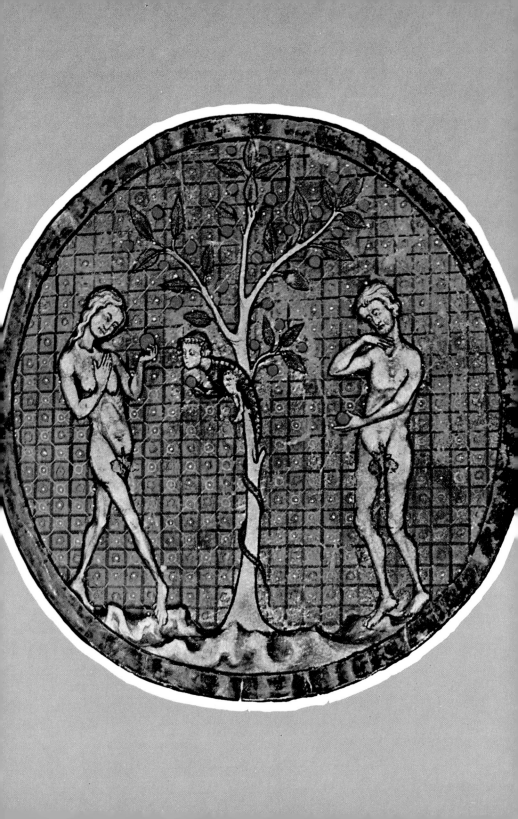

over many years. At first the stress was on the outline, so that both in stained glass and in manuscript illumination the reproduction of the human form created the effect of an object projected onto a flat plane. The backgrounds remained abstract patterns. Starting around 1350, painters began to surround their figures with space. At first a narrow stage was used to provide free play of movement, so that the figures could be portrayed three dimensionally. The painters' efforts to create background space are illustrated in this book largely by miniatures, which are usually in a particularly good state of preservation. With few exceptions (191–92, left), the figures are related to an architectural framework. This is a hallmark of the Gothic style. Illustrations 157 and 159, on the one hand, and 186 and 198, on the other, do of course represent a wide time span, which can be described as a "development" only in the most general way. What separates the two pairs of paintings is the understanding of spatial perspective that occurred in the interval. In 157 and 159 we find that the painter has attempted to create perspective in the architectural elements at the top, but the figures still appear beneath or in front of the architecture, not inside it.

It is not until the 14th century that we find figures inserted in a spatial box. Pucelle's Annunciation takes place inside a building, and the artist who executed the stained glass in the pilgrimage church in Strassengel (196) has managed to extend an architectural canopy over each whole scene. His solution seems more convincing than that of the embroiderer from Prague, whose Crucifixion group (193) does not harmonize properly with the perspectival treatment of the architecture. At Königsfelden (187), various perspective effects can be seen. We are nearer here to Giotto (180) than to Simone Martini's Annunciation of 1333 (190). In the latter, depth is negated, apart from the narrow stage on which the action takes place, although the individual figures are placed beneath arches in the Gothic manner, which has the effect of isolating them. The Gothic narrative method, in common with other manifestations of the Gothic style, is an additive one: The figures are like separate sentences

topaz in the center of the lower part of the framework originally covered a relic. The use of architecture as a framing device can be compared with the St. Louis Psalter illustration (150).

154 CHRIST ENTERING JERUSALEM. Detail of a window in St. Urbain, Troyes. c.1275. The glass in the slender lancet.windows is decorated in grisaille, interspersed with colored scenes from the life of Christ and figures beneath architectural canopies.

155 PAGE FROM A BIBLE. Northern France. c.1280–90. British Museum, London, Add. MS 11639, fol. 520 verso. The delicate, almost balletic figures, the relatively naturalistic little tree, and the circular frame into which the scene fits perfectly are all hallmarks of the style that prevailed in northern France at the end of the 13th century.

156 A PHYSICIAN. Medical treatise. Northeastern France. c.1170. British Museum, London, Harley MS 1585, fol. 13 recto. The Romanesque method of treating drapery was simplified toward the end of the 12th century, and the piece of hem that can be seen between the figure's legs is a typical feature of this new treatment. We see here the beginnings of the Muldenfaltenstil (see 57) in the elongated hairpin folds. The delicate hands are typical of the years c.1200.

157 ANNUNCIATION. Westminster Psalter. England. c.1200. British Museum, London, Royal MS 2A. XXII, fol. 12 verso. The style of this manuscript indicates approximately the same stage of development as the Ingeborg Psalter (143), though the figures are more static and seem inwardly calmer. The folds hang straight

joined together to make a whole tale. Whereas the introduction of a spatial element in miniature painting signifies the beginning of an important development, which would also be taken up by panel painting, the increasing use of perspective in stained glass represents the first stage in the decline of this art (*195*), which, at its most successful, is two dimensional, flat, and ornamental.

Painting developed in different ways in the individual countries in which the Gothic style flourished. A study of Italian examples will confirm the statement that we have already made about sculpture: objects imported from France were taken for their purely decorative value (*181*). Only once, and for a very short while, do we find the various national styles speaking with one voice. This occurred around 1400 when northern and Italian traditions mingled to produce what is called International Style. "It is absolutely essential to think of the whole of Europe when looking at the art of 1400" (Wilhelm Pinder). During this period, no single country played the leading role, nor can we say that any one city was preeminent. Paris, Dijon, Avignon, Prague, Cologne, Milan, and Florence were all reduced to the same common denominator from the point of view of their artistic activity. Otto Pächt speaks of the "unprecedented standardization" of the artistic vocabulary of Europe at the turn of the century. We must therefore credit the International Style with great intrinsic strength. It would be wrong to speak of it as transitional, even though the single tapestry does begin to unravel after 1430 and separate into a series of national strands (see *198–203*).

Insofar as stylistic phenomena can be explained at all, we can put forward two facts outside the strictly artistic sphere to clarify the rise of International Gothic. Secular patrons now began to play a more and more decisive role. Commissions came not only from the courts of Europe but also from the middle class, which was growing financially stronger all the time. The expansion of trade across Europe also fostered the exchange of works of art,

down and are not realistically draped around the figures.

158 St. Christopher. Westminster Psalter. England. c.1250. British Museum, London, Royal MS 2A. XXII, fol. 220 verso. The robe worn by the slender figure of the saint carrying Jesus on his shoulder has been treated with greater individuality than in early images. He has delicate limbs, and the drawing is rich in closely observed detail (notice his hitched-up trousers, the sling for carrying the infant Jesus, the headgear). Another interesting feature is the communication between the two figures. This idea played an important part in later work, particularly in a wide range of variations on the Mother and Child theme.

159 Lot and the Angel. From an annotated psalter. Northern Ile-de-France. c.1190–95. Pierpont Morgan Library, New York, MS 338, fol. 191 verso. This illustration is set within a frame, as a painting might be, though the angel's giant wings soar beyond it. The style is typical of the late 12th century. The narrative method is Romanesque with its paratactic arrangement (the scenes are placed one after the other to form a progressive sequence). The illuminator has used the same zigzag hemline in his work on the Ingeborg Psalter (*143*), but he has toned it down here under the influence of a new model, no doubt a Byzantine one. The figures are still rather squat; in the Chantilly psalter they are taller and a certain courtly elegance seems to emanate from them.

160 Scene from the Life of St. Guthlac. Guthlac Roll. Crowland Abbey (England). c.1190. British Museum, London, Harley Roll Y6.

so that French ivory Virgins found their way to Italy, small Italian panel paintings were exported to England and the Low Countries, the work of German goldsmiths was haggled over in Venice, and Florentine embroidery was known in Hamburg. Not only the products traveled; artists, too, wandered increasingly from court to court. The Italian Simone Martini, for instance (190), was in Avignon at the end of his life, and Claus Sluter, who came from the Low Countries, worked in Dijon (134). Over these cultural exchanges, like a gigantic umbrella, was spread the encouragement and patronage of the ruling houses of Europe. They perhaps were not a decisive influence, but they did give powerful impetus to the spread of artistic ideas and helped to transplant them from one culture to another. This patronage, as practiced by the dukes of Burgundy, of Berry, and of Bavaria, and by the Habsburgs and the house of Luxembourg, led the way into a new age.

One of the leitmotifs that runs through the pictorial world of the Gothic artist is that of people coming together, turning toward each other. They are grouped so that they can hold a conversation and cften appear to be talking together. A subject treated constantly is the Annunciation. In eariy work, around 1200, the figures stand stiffly facing each other (157, 159); the only indication that these are dramatic encounters is the restless movement of hands and fingers. What a change when we turn to Simone Martini's *Annunciation* of 1333 (190) or Andrea Orcagna's mid-14th-century interpretation (118). Compare Jean Pucelle's miniatures from Jeanne d'Evreux's Book of Hours (192) with Melchior Broederlam's altarpiece (198) at the end of the 14th century. The theme is gradually intensified and humanized, translated from an abstract pictorial formula into an earthly drama. The realistic observation of detail and the handling of space become correspondingly richer as well.

Other related themes are the vision (178), the apparition (186), and inspiration (189). The dialogue theme (83) is given a particularly delightful variant in the relationship between

This parchment roll, decorated with scenes set in medallions and depicting the life of the saint, is unique. The scene we have chosen shows St. Guthlac being rowed in a fishing boat to the island of Crowland. These drawings may possibly have been used as designs for a goldsmith or for a stained-glass window.

161, 164 DREAM OF THE THREE WISE MEN; JOURNEY OF THE WISE MEN. A pair of medallions from the righthand window in the choir of Laon Cathedral. c.1215. This sequence of photographs, including *160* and *165*, illustrates the role of the round medallion frame in the early Gothic period and the skill with which the various artists have overcome the difficulties presented by the roundel. The circular picture did not become important again until the Renaissance.

162 MURDER OF THOMAS A BECKET. From a psalter. England. c.1200. British Museum, London, Harley MS 5102, fol. 52 recto. This miniature appears to be one of the two earliest pictorial representations of the martyrdom that took place on December 29, 1170. If so, the artist had no iconographical tradition on which to base his interpretation. He therefore assembled the scene from a number of individual motifs. Points to notice here are the row of arcades that suggest a church interior, and the rich architectural superstructure, which contrasts strongly with the calm Gothic forms that appear discreetly in the background of images such as those in the Psalter of St. Louis (166).

163 VIRGIN ENTHRONED. From a Life of St. Denis. Paris. c.1250. Bibliothèque Nationale, Paris, Nouv. acq. franç. 1098, fol. 58 recto. The treat-

ment of the folds of Mary's cloak has all the features of the *Muldenfaltenstil* (see *142*) in its final form, as it can be seen in *165* and *167*. This miniature follows Villard de Honnecourt, but the folds of drapery are softer and are arranged in large loops and coils. The architecture is a framing device and should be understood in a purely symbolic way.

165 EXPULSION FROM PARADISE. *Bible Moralisée*. Paris. c. 1230–40. Bibliothèque Nationale, Paris, MS 11560, fol. 18. In this manuscript, which is a *bible moralisée*, or paraphrased bible, details have been made to look like imitations of stained-glass windows and are arranged in two rows of medallions. They indicate the very strong influence of monumental art on book illumination. Compare the Psalter of Blanche of Castille, MS 1186 in the Bibliothèque de l'Arsenal, Paris, c. 1225–30.

166 JOSEPH AND HIS BROTHERS. Psalter of St. Louis. Paris. c. 1250–60. Bibliothèque Nationale, Paris, MS Lat. 10525, fol. 16 recto. Joseph is being flung into the pit. The fragile architectural structure is used as a frame here and in a series of scenes from the Old Testament. The miniatures are by various different artists, all of whom are progressive, leading directly to the work of the most important painter of the second half of the 13th century, Master Honoré. For contemporary architecture see the north transept of Notre-Dame, Paris (*35*), the west portal of Auxerre, or the Portail de la Calende, Rouen.

167 CRUCIFIXION. From a psalter. Paris. c. 1260–70. Bibliothèque Nationale, Paris, MS Lat. 1073A. Christ on the Cross, flanked by Mary and St. John. This manuscript is a typical example of work being mass-produced in Paris at this date.

168 THE APOCALYPTIC CHRIST AS JUDGE. From a psalter. Southern Germany. c. 1260–70. Zentralbibliothek, Zurich, Cod. Rh. 167, fol. 288 recto. In contrast to the peaceful, seated Madonna with her soft drapery in the French example (*163*), this vigorous Christ from southern Germany is enveloped in restless, dramatically active drapery (in German, *Zackenstil*). The jagged outline of the figure is matched by the zigzag strokes that delineate the folds, which are not curved but end in angular patterns. They form a strange contrast to the rather ex-

pressionless faces of the figures, which seem to have been drawn from an earlier stylistic repertoire.

169 THIEVES STEALING THE JEW'S TREASURE AS HE SLEEPS. St. Maria-Lyskirchen, Cologne. Detail of a fresco cycle on the vault of the south chapel in the choir, depicting scenes from the legend of St. Nicholas. c. 1250–60. The crumpled drapery that we saw in the miniature from southern Germany (*168*) appeared in monumental painting in the second quarter of the 13th century. The Jew is wrapped in a piece of cloth that is puckered and rumpled, as though the restless sleeper knew what had befallen him. Here highly dramatic effect is achieved by purely graphic means. The wild outline of the figure (a forerunner can be seen in the sleeping figure of Jesse on the ceiling of Hildesheim Cathedral) could scarcely be further exaggerated. But c. 1300, a swing of the pendulum occurred in the form of a gradual softening and quietening of the lines.

170 TWO KINGS. From Historia Anglorum. St. Albans. 1250–59. British Museum, London, Royal MS 14 C. VII, fol. 9 recto. Attributed to Matthew Paris. The complete painting shows four seated kings—Henry II, Richard I, John, and Henry III. In the central section is Henry "the young king"—that is, the second son of Henry II. This painting was executed at the same time as the previous German examples (*168, 169*) and displays a similar tendency in its jagged outlines and folds. But English work of the years 1230–60 is more aristocratic and reserved.

171 ST. PAUL. Detail of a stained-glass window from Rouen Castle. c. 1260–70. Musée de Cluny, Paris. The dramatic note that is typical of this decade (see *168, 169*) sometimes extends to faces as well as drapery. The jagged shadows around St. Paul's eyes, together with his tangled beard and his curly hair silhouetted against the dark background to the right, give his face an expression of inner excitement.

172 CRUCIFIXION. From an illuminated manuscript. England (probably Lincoln). After 1280. British Museum, London, Add. MS 38116 (Huth MS III), fol. 11 verso. A dramatic heightening of tension is often achieved by means of caricatured figures with grotesquely

△ 160 ▽ 162 △ 161 ▽ 163

△ 164 ▽ 166 △ 165 ▽ 167

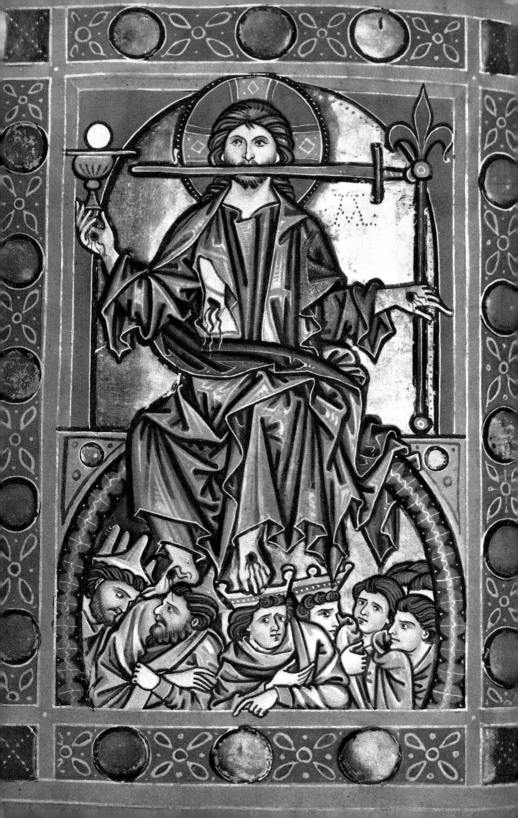

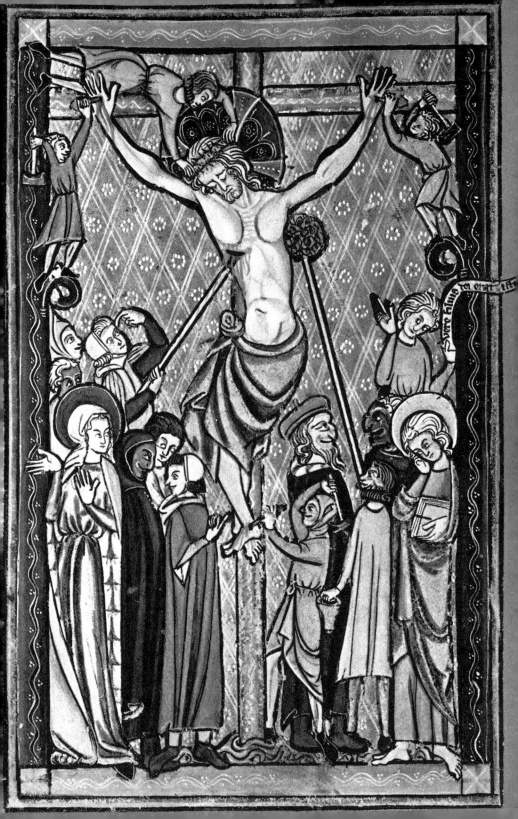

sūt ī īnīquītātibz: non est quī fa
ciat bonum

Deus de celo prspexit super filios ho
minū: ut uideat si est intelligens

distorted faces. In contrast to the two saintly witnesses of Christ's agony on the Cross, the other figures in the crowd are portrayed with distorted profiles. The hangman's assistants are perched on the "capitals" of the frame as they nail Christ's hands to the arms of the Cross. The frame was often incorporated into the picture to achieve comic effects. This scene is an early example of a theme that became common in the 14th century—the Hill of Calvary covered with many figures. The long folds of Mary's robe mark the beginning of a style typical of the years around 1300.

173 CHRIST TEACHING IN THE TEMPLE. Queen Mary Psalter. East Anglia (?). c. 1308 or 1310–20. British Museum, London, Royal MS 2 B. VII, fol. 151 recto. The narrative in this important manuscript is exceptionally rich and full of unexpected and imaginative details. In the illustration shown here there is a new relationship between the scene and the traditional architectural framework, which now confines the space in which the scribes listen to the child orator. The archway on the left is conceived as an entrance through which Joseph and Mary can pass to fetch their son, who is sitting perched on a tall shaft, just like the statue of a saint on a column. The artist has emphasized the shaft by placing it beneath a specific architectural element that culminates in a little round tower. The falcon hunt at the bottom of the page (known as a *bas-de-page* illustration) bears no visible relation to the main picture. This type of subsidiary scene often appears in the margins of manuscripts dating after 1300 and can be understood as the artist's expression of delight in the variety offered by the world around him. Painters accumulated a number of sketches of details such as the one shown here and made fuller use of them later.

174 SCENES FROM THE LIFE OF CHRIST. Psalter of Robert de Lisle. England. c.1320. British Museum, London, Arundel MS 83 II, fol. 124 recto. This is a late example of a miniature fashioned to look like stained glass, with six separate images surrounded by richly decorated frames. This page follows the courtly style of 1300–c.1350 that emphasized softly flowing lines. It seems at times to anticipate the

⌐ 173 Soft Style of c.1400. The beautiful lines are accompanied by somewhat expressionless faces that sometimes border on the stereotyped. The backgrounds have sumptuous patterns made up of series of small motifs.

175 SCENE IN A CONVENT. From a treatise entitled *La Sainte Abbaye*. France. c.1300–10. British Museum, London, Yates Thompson MS (formerly Add. MS 39843), fol. 6 verso. This detail is taken from a miniature depicting the Mass and a procession. It shows the abbess with two nuns, one of whom is ringing the convent bell. The outlines are large and soft, and the drawing inside the outlines is reduced to a bare minimum, with the folds of drapery falling gently to the floor. This miniature marks the beginning of the charming courtly style that culminated in such masterpieces as the window of the Nativity at Königsfelden (*187*).

176 SUSANNAH AND THE ELDERS. From an illuminated Bible written by Jean Papeleu for Guimard des Moulins. Paris. 1317. Bibliothèque de l'Arsenal, Paris, MS 5059, fol. 204 verso. Few scenic devices have gone into the conception of this picture, which is nevertheless one of the most delightful of the "garden landscapes" painted before the reinvention of the three-dimensional picture stage. Susannah's pose is that of a water nymph of classical tradition.

177 SCENE FROM THE LIFE OF ST. BENEDICT. *Trésor d'Origny*. France. 1312–14. Stiftung Preussischer Kulturbesitz, Berlin, Kupferstichkabinett, MS 78 B 16. The artist has been extremely skillful in his arrangement of the group of figures. All the faces are drawn with a soft line that is common in book illuminations of this date (see *175, 176, 178*).

178 FRÈRE LAUVENT, THE VIRGIN WITH THE KNEELING FIGURE OF THE DONOR. *La Somme le Roy*, written in Paris in May 1311, by Lambert le Petit, for Jeanne, Countess of Eu and Guines. Bibliothèque de l'Arsenal, Paris, MS 6329, fol. 1 verso. The portrait of the full-length Madonna is characteristic of the early 14th century. A swaying pose with the weight of the body on one leg (the French term is *hanchement*) is stressed here (a motive for the stance provided by making Mary take the donor by her wrist). For the treatment of the drapery in sculpture of this date see *96, 97,* and *100*. The embossed background is a hallmark of the precious,

courtly style that first appeared at the end of the 12th century; in the early 14th century it was replaced by the use of a screened back ground.

179 SISINNIUS AND HIS FOLLOWERS ON THE ROAD TO PARIS. *Vie et miracles de St. Denis*. Paris. Completed 1317. Bibliothèque Nationale, Paris, MS fr. 2091, fol. 123 recto. This is an example of historical painting, showing an event from the period of the Roman occupation of France. Artists were now beginning to develop an increased interest in depicting nature, and in the upper register of this page the general in command of the army is riding through a stylized but unmistakable forest. The architectural framework has been reduced to a minimum. The whole page is reminiscent of the monumental wall paintings of the period.

180 GIOTTO, ANGELS AND SAINTS PLAYING MUSICAL INSTRUMENTS. c. 1310. S. Croce, Florence. The figures are powerfully built, conveying a real sense of volume and weight, and simply dressed. Unlike northern European examples from the same period, each face has its own character. As is true of Italian Gothic sculpture, the conception and execution owe much to the art of classical antiquity. Giotto's masterpieces are frescoes in the Arena Chapel in Padua (1305–6) and also in S. Croce (c. 1320). He acted as master builder for the construction of the duomo in Florence from 1334 (see *122*).

181 LIPPO MEMMI, MAESTA. Detail. 1317. Palazzo Comunale, San Gimignano. The formal compactness of the figures, the monumentality of the group, and the intimate coloring have no parallels in painting outside Italy at this period. The Gothic style is interpreted here, as it is in Italian architecture and sculpture, as an ornamental pattern. The filigreelike architecture contrasts surprisingly with the heaviness of the figures.

182 CREATION OF THE FOWLS OF THE AIR AND THE BEASTS OF THE FIELD. Holkam Bible Picture Book. England. c. 1320. British Museum, London, MS Add. 47682, fol. 2 verso. In spite of the rich portrayal of nature called for by the subject matter, the artist has retained the usual patterned background. The birds and animals are placed very close together, filling as much of the picture surface as possible. The result is rather like a tapestry. Some of the creatures suggest that the artist observed nature very closely before painting this moving portrait of the Creator at work.

183 MARGINAL ILLUSTRATION. From a manuscript copy of the *Roman d'Alexandre*. Flanders. c. 1340. Bodleian Library, Oxford, Bodl. MS 264, fol. 96 verso. This charming detail is quite unrelated to the text above it.

184 MARGINAL ILLUSTRATION. Lutterel Psalter. England. c. 1335–40. British Museum, London, Add. MS 42130, fol. 62 recto. This sketch and the one shown in *183* are examples of the thousands of little marginal drawings in 14th century manuscripts. They depict incidents from everyday life and often strike a grotesque note because of the strange or equivocal nature of their subject matter.

185 FALCONRY. Detail of a wall painting in the Room of the Stag, Palace of the Popes, Avignon. Italian (painted by a follower of Simone Martini, *190*). 1344. This fresco is one of a whole series of paintings depicting scenes of country life. The usual minutely patterned background has been superseded by a richly varied landscape, which nevertheless retains a non-spatial, tapestrylike quality.

186 ROGIER VAN DER WEYDEN, CHRIST APPEARS TO HIS MOTHER. Right panel of an altar. c. 1445. 63.5 × 38 cm. Metropolitan Museum of Art, New York. This scene by the Flemish painter, who is known to have been alive from 1400 to 1464, is set in an ecclesiastical building, which is indicated by an architectural framework conceived as a doorway that is also used to circumscribe the scene. The double door at the back of the building allows us to look out into a broad landscape in which we can see a portrayal of the Resurrection. It was not until the 15th century, on the threshold of the Renaissance, that painters in northern Europe took the decisive step of setting a scene within an interior, with a view into a landscape. It has been remarked that of the three great masters of Late Gothic painting in Flanders (Jan van Eyck, Hugo van der Goes, and Rogier van der Weyden), it was Van der Weyden alone who recaptured "within the framework of the new (Renaissance) style... the emotional drama, the *pathos* of the Gothic past" (H. W. Janson).

Gloria in excelsis Deo

△ 175 ▽ 177 △ 176 ▽ 178 179 ▷

Ihic delachatur hec conao gentis inique
Vt deperdatur per eam grer sctis inique

181

Coment deu li puissaunt. En leyr felost oisel uolaunt. Aues diuerses
figures fourmaunt. Aceus q escoyent auenaunt. de tere fift creste erbes z flu
res. de queus les mures fount lurs cures. Bestes sure tere: en ewe peison.
E ren ne est saunuf noun. Car pur lui tut est. Ceel z tere z quant q est.
Cum ple pensost z le vousist. Been tot ku feet ceo dyst le crist. Bien ne fist de
sa uiesu. Fors home z femme ceo sorez cert teyn. Tutes choses il felost fluirist
E tut ple felost pur home seruir.

◁ 182 △ 183 ▽ 185 △ 184

Mary and the Christ Child (*94, 95, 125, 135, 137, 187*). It is focused more sharply, to most moving effect, in a *Deposition from the Cross* (*143*) and a *Pietà* (*138*). A similarly affectionate note is sounded in paintings depicting Christ with St. John, under the influence of the emotional mysticism of the monasteries (*117*).

Over the years, Gothic iconography traveled a long path, from heavenly rapture to courtly unapproachability, and finally to homey accessibility. The Queen of Heaven seated on her throne (*68*) became a mother in courtly apparel (*80, 123*) and finally a woman of the people, or at any rate of the middle class, who sometimes has her hands full with her lively son (*91, 139, 199*).

Another very interesting feature of Gothic art is the frame that enclosed the subjects. At first its significance is purely symbolic, giving a feeling of sublimity; it ennobles the wondrous events by the use of handsome architectural motifs and removes the image from the earthly plane (*163*). In the Late Gothic period, such forms were intended to represent sacred architecture (*186, 198, 203*); they were, therefore, virtually replicas of another world. But in the 15th century we find a homey note (*200*). Biblical events occur in contemporary rooms, giving the more human image of Mary an appropriate setting.

Two important technical achievements occurred during the Gothic age: first, the appearance of woodcut illustrations and then the invention of the printing press. The possibility of mass-producing pictures and texts revolutionized the art of western Europe at the end of the Middle Ages.

The woodcut is the earliest method of graphic reproduction. In its early stages, the details and subtleties that can be shown in a drawing or a panel painting were lost. In the simplification of its line, it is reminiscent of the work of artists in stained glass, who were forced by the constraint of lead bars to create simple forms (*204*). Woodcut book illustrations extracted the essential elements from a text and transformed them into an easily understandable picture, along the lines of a metaphor. The aim was to convey an idea in the most concise and explicit manner possible, leaving out any purely illustrative accessories. The effect was heightened by the use of a two-dimensional, outline-drawing technique, which made no attempt to portray objects in the round and was generally—so far as shading, if any, was concerned—restricted to a little cross-hatching.

A study of the manuscript illuminations of the earlier Gothic period is essential to an understanding of 15th-century book decoration. Up to the 1480s, book decoration was a direct continuation of manuscript illumination both in style and in subject matter. At first the typesetter, like the scribe before him, left space for the initial letters in Bibles and in liturgical and other printed matter; this was where the artist now placed his woodcut. As illustrated ecclesiastical tracts and increasing amounts of popular literature were produced on a more and more commercial scale, certain patterns emerged. Outline drawing (sometimes rather cursory) on fixed themes was generally traditional, so that the only differences between representations were the result of the artist's temperament. The use of shading increased the possibilities for imaginative effects. Later, shading was adapted to the woodcut, which, as book production grew faster and cheaper, became far more prevalent than hand drawings in book illustration.

186

187 NATIVITY. Detail of a Christmas window. c.1315. Former monastery church, Königsfelden. This royal commission required an entire workshop of painters trained in the court tradition; they may possibly have come from Vienna. The court style of the early 14th century reaches its height in the elegance of this window and the grace of the figures. This window and others contain perspective details that imitate contemporary panel painting and are influenced by Italian work.

188 ADORATION OF THE MAGI. Detail of a small panel painting. Cologne. c.1340. Louvre, Paris. This painting from the Rhineland represents the same stage of stylistic development as the Königsfelden window, of which Emil Maurer has said that the figures are "courtiers to their fingertips."

189 ST. JOHN AND THE ANGEL. Detail of a tapestry depicting the Apocalypse. Paris, from the workshop of Nicolas Bataille. Angers Museum. Ordered by Duke Louis I of Anjou, brother of King Charles V of France, this hanging was executed between 1376 and 1381 after designs by Jan Bandol (or Bondol) of Bruges. Bandol became court painter to Charles V in 1368. This is one of the masterpieces made in the royal workshop in Paris in the 14th century, a highly detailed portrayal of the Revelation of St. John. Like all important Apocalypses, it is modeled on illuminated manuscripts, and very closely related to them in style. The scene takes place on a narrow landscape-stage (representing the island of Patmos), behind which rises an ornamental background. As yet, there is no hint of interest in space. Other scenes, howerer, show the saint in elaborately conceived architectural structures, which give an optical rhythm to the tapestry.

190 SIMONE MARTINI, ANNUNCIATION. Altarpiece for Siena Cathedral. 1333. Uffizi, Florence. This courtly style, which can also be seen in northern Europe at about the same date, is most pronounced in Italy, particularly in Siena. The figures are placed on a narrow panoramic stage against a gold background. This frame is from the 19th century, but presumably the panel shape, at least, reflects the original. The little supporting columns in the center have been blown away by the angel's dramatic announcement. The way the angel has been fitted into the awkward area and Mary's frightened gesture as she shrinks back into the niche formed by the arcade are among the most daring feats of composition to be attempted at this period. Martini's brother-in-law Lippo Memmi (see 181) worked with him on this painting.

191, 192 JEAN PUCELLE, MINIATURES IN JEANNE D'EVREUX'S BOOK OF HOURS. Paris. c.1325. The Cloisters, Metropolitan Museum of Art, New York; (above) fol. 68 verso to 69 recto; (below) fol. 15 verso to 16 recto. These two double spreads represent the work of one of the greatest miniaturists of the late Middle Ages. Pucelle was active in France, but his style reveals a detailed knowledge of contemporary Italian painting. The Annunciation and the Crucifixion page derive from corresponding images in Duccio's Maestà (1308–11) in Siena.

193 CRUCIFIXION. Detail of an embroidered antependium (altar frontal) depicting seven scenes from Christ's Passion. From Königsfelden Monastery. Prague. c.1340–50. Historisches Museum, Berne. Whereas Jean Pucelle referred to an innovative model for his Crucifixion (191) and then interpreted it in his own way, this piece of embroidery from Prague is based on a popular model and thus lacks drama. The group is set within a complicated perspective frame made up of architectural elements, which in fact seems rather inappropriate in this context. The couched gold ground indicates the work of the Prague court school. Other examples of its work that have survived are altar hangings from Pirna in Dresden and in Kamp Monastery in Austria. The style of this piece should be compared to contemporary panel painting by Prague artists.

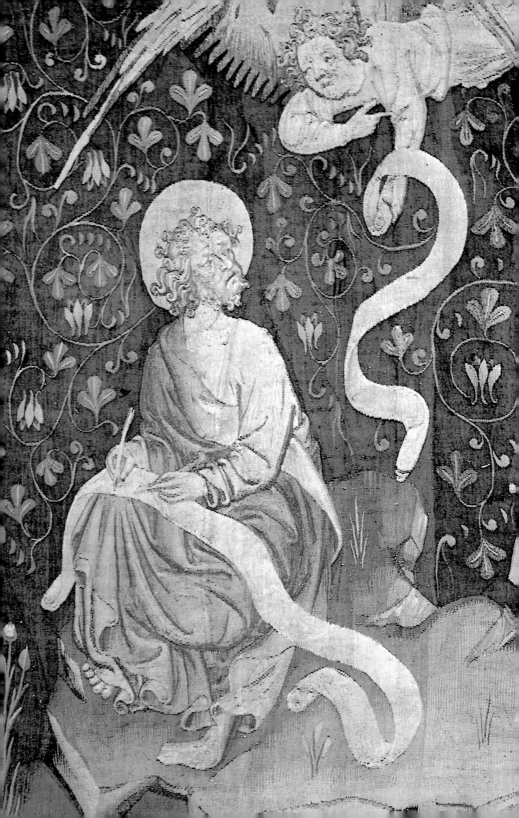

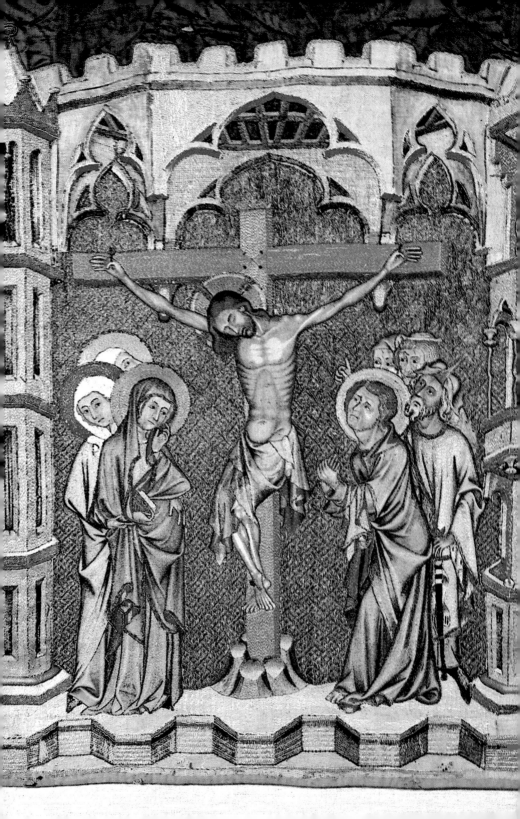

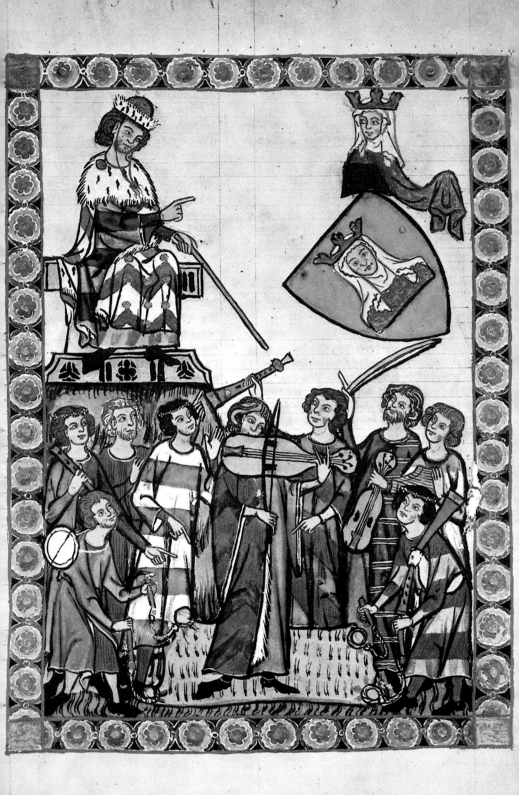

Of almost 40,000 items printed in the 15th century in about 1,100 printing shops in some 260 towns throughout Europe, roughly a third were illustrated, with Germany in the lead, both in time and in quantity. Academic literature on theological or legal matters and editions of the classics did not need illustration, but all printed matter aimed at the mass market required it. Even the very first printer-publisher of this kind of material, Albrecht Pfister of Bamberg, took the trouble to supply woodcut illustrations (*205*). We know of nine different items printed by him between 1460 and 1464. Printing illustrations and text together was a complicated business. The woodcuts were in fact often printed separately from the text. For his 1471 edition of the *Golden Legend* of James of Voragine, Günther Zainer of Augsburg printed first the woodcuts and then the text. It was only gradually that the basic idea of bringing the block to the same height as the next type became generally accepted. But as there were no standard dimensions, when wood blocks were bought or borrowed they had to be adjusted for each case. The frequent use of the same block for different purposes—particularly for pictures of towns, where only the coats-of-arms needed to be changed—can be explained by the fact that the reader was easy to please. He was satisfied by schematic portrayal and did not expect lifelike observation. In addition, woodcuts were expensive; economy often seems to have been the decisive factor.

The invention of movable type occurred in the Late Gothic period, though various methods of printing had been used earlier for reproducing text or pictures. Johann Gutenberg's innovation was the production of single letters of equal size, which he could put together to form texts of any line length; they could then be picked up and used again. His first

194 MEISTER HEINRICH FRAUENLOB AND HIS MUSICIANS. From the Manesse Codex. Universitätsbibliothek, Heidelberg, Cod. pal. germ. 848. The illustration shown here depicts the minnesinger with his "orchestra." This important manuscript dates from c.1315–30 and received its name from the noble Manesse family of Zurich, who collected the songs it contains. Unlike other manuscripts of the same type, these miniatures do not represent the first version of the pictures. The rich subject matter used for this series, which is in an exceptionally good state of preservation, was inspired and drawn from many different sources.

195, 196 ANNUNCIATION; MARY ENTERING THE TEMPLE. Stained glass from the choir of the pilgrimage church, Strassengel (Austria). c.1350–60. Victoria and Albert Museum, London. The chancel, consecrated c.1355, gives us an approximate date for the stained glass. The first stained glass showing the use of perspective is in Königsfelden (*187*). The Strassengel designer was heavily influenced by contemporary painting and boldly borrowed wholesale, though without managing to achieve a uniform spatial concept. The introduction of perspective into stained glass meant, of course, that glass painters no longer aimed, as they had for centuries, to create flat, two-dimensional images.

197 GUILLAUME DE MACHAUT, ALLEGORY. Paris. c.1370. Bibliothèque Nationale, Paris, MS fr. 1584, fol. E. This miniature shows Nature, dressed as a queen, introducing her well-behaved offspring *Sens*, *Rhetorique*, and *Musique* (Intelligence, Rhetoric, and Music) to a poet. This charming scene takes place on the edge of a delightful landscape that runs up to the top of the picture frame. There is little sky to be seen. In contemporary panel painting the sky was always presented as a gold background.

198 MELCHIOR BROEDERLAM, ANNUNCIATION. Detail of an altarpiece. c.1399. Dijon Museum. This Annunciation takes place in a complicated architectural setting that was doubtless influenced by Italian painting. The choice of

194

several different viewpoints gives the painting a wealth of different vistas, and the painter has made the most of them, showing a childlike naiveté in his enjoyment. His style leads us via the Limbourg brothers (who executed *Les Très Riches Heures du Duc de Berry*, 1413) to Jan van Eyck. The Broederlam Altar, which has carvings by Jacques de Baerze, is the first of an important group of folding altars that became one of the main types of artistic commission in the Late Gothic period. These include the Goden Panel in Lüneburg, c.1410; Altarpiece of the English Merchants by Master Francke in Hamburg, c.1425; Tiefenbronn Altarpiece by Lukas Moser, 1431; altarpiece by the Van Eyck brothers in Ghent, 1432; Last Judgment Altarpiece by Stephan Lochner in Cologne, c.1435; altarpiece by Hans Multscher in Wurzach, 1437; altarpiece by Konrad Witz in Geneva, 1444; and others.

199 KONRAD VON SOEST, WILDUNGEN ALTARPIECE. Left panel. Protestant municipal church, Bad Wildungen. 1404. Konrad von Soest was the most important Westphalian painter of the period around 1400. These scenes depict the Annunciation, the Nativity, the Adoration of the Magi, and the Presentation of Christ in the Temple. When open, this folding altarpiece is 7.5 meters wide by 2 meters high. It is a major example of the Soft Style. This delightful type of art, with its flowing lines and its relative absence of sharp corners is found all over Europe. Representative of the International Gothic, the style extended from Bohemia to France, and from northern Germany to Florence and Siena. We can guess that Konrad von Soest may possibly have spent some time in Burgundy and Paris.

200 JOSEPH'S DOUBT. Panel painting by a master working in the Upper Rhine district. c.1420. Strasbourg Museum. 1.14 × 1.14 meters. Here the picture frame surrounds a spatial box, which is interrupted on the right side by a perspective view. This may well be one of the earliest enclosed interiors in German panel painting. The delightful coloring, the richly imaginative treatment of the details, and the soft flowing lines of Mary's cloak are all legacies of the Soft Style, which is often found as late as the middle of the 15th century in

work produced in provincial workshops. The Strasbourg panel is the only remaining portion of a large altarpiece dedicated to the Virgin. Joseph, who left Mary alone before the Annunciation, returns to find that she is with child. As described in the Apochryphal Gospel of St. James, an angel is announcing the miraculous conception to him.

201 THE DEER QUEEN. From a German playing card. c.1430. Württembergisches Landesmuseum, Stuttgart. The unknown artist shows great skill in this little painting. He may well have modeled it on a seated Madonna or a female saint in an interior. All the elements of the style of the period are here, although the artist's contemporaries would no doubt have considered his work to be mere decoration of a functional object, rather than fine art.

202 COURTLY LOVERS IN A LANDSCAPE. Arras, c.1430. Tapestry. Musée de Cluny, Paris. This plate and the preceding one are filled with reverberations of the International Gothic Style that flourished at the turn of the century. The widespread style stimulated similar work produced later in various cultural areas not directly related to one another. It is a characteristic feature of early 15th-century art that little difference is made by scale. Thus, although the playing card is only half the size of a flowering shrub on the tapestry, it stands up to enlargement very successfully.

203 JAN VAN EYCK, VIRGIN IN A CHURCH. 1425–27 (according to Erwin Panofsky). Gemäldegalerie, Berlin, Stiftung Preussischer Kulturbesitz. Over and above the many-layered symbolism of its subject matter, this small painting brilliantly sums up the achievements of the Gothic style. The architectural framework has now become full architectural space. The full-length figure of the Madonna is three-dimensional and realistically exists in the space. The fact that the space is fashioned on the lines of Gothic architecture is particularly interesting in this context. It is not merely an abstract background, but seems to be bathed in light and raised to the level of an atmospheric shell. Finally, the light streaming into the church sets off the painting's delicate and intimate coloring to the full.

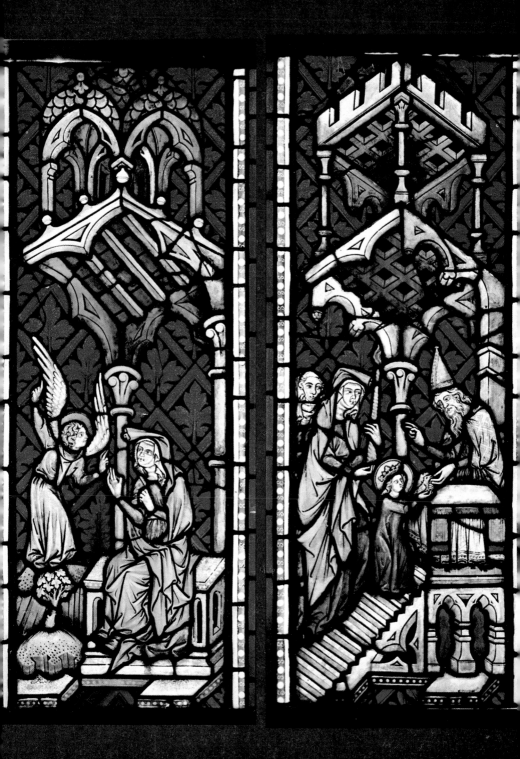

Coment nature voulant orendroit plus
que onques mes reueler & faire essaucier
les biens & honneurs qui sont en amours
vient a Guille de machaut & li ordene & en
charge afaire sur ce nouueaux dis amou
reux et li baille pour li conseillier & aidier
a ce faire trois de ses enfans. Cest asauoir
Sens. Retorique & musique. et li dit
par ceste maniere.

I e nature par qui tout est fourme
Quanque a ca ius & sur terre & en mer
Vieng ci a toy Guille qui fourme
T ai a part pour faire par toy fourmer
N ouueaux dis amoureux & plaisans
P our ce te bail et trois de mes enfans
Q ui ten donront la pratique
E t se tu mes deux, trois bien cognoissans
N ome sont Sens. Retorique & musique

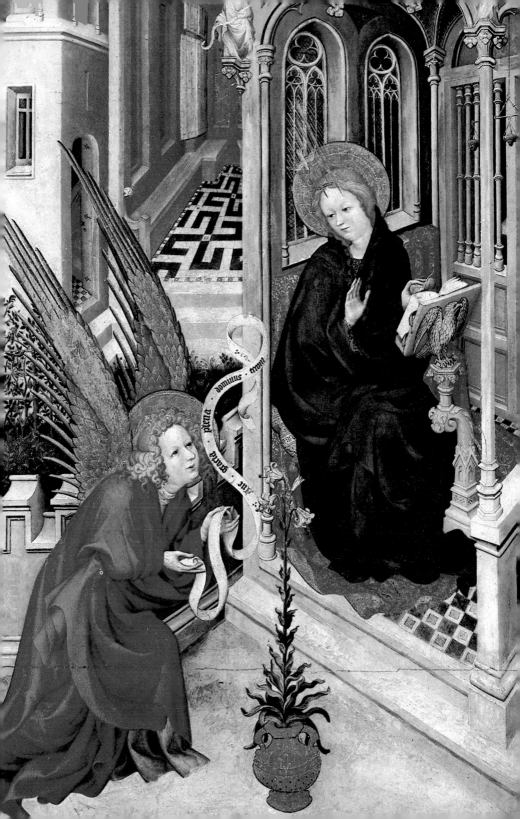

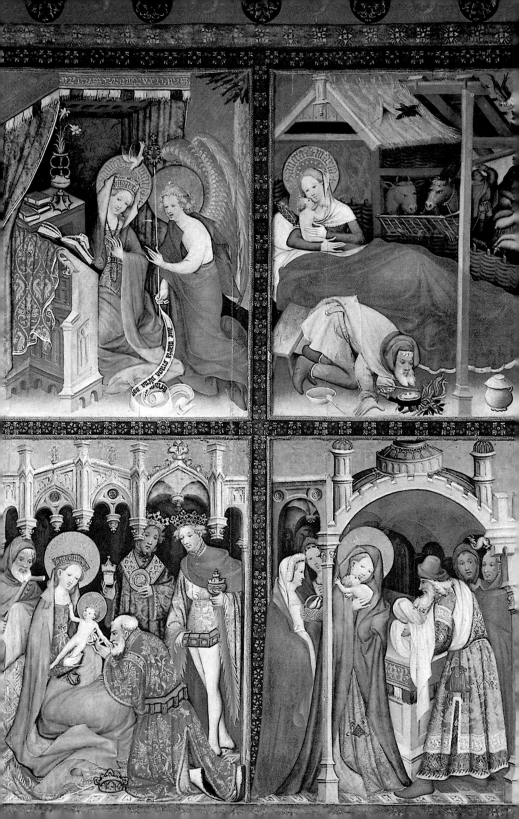

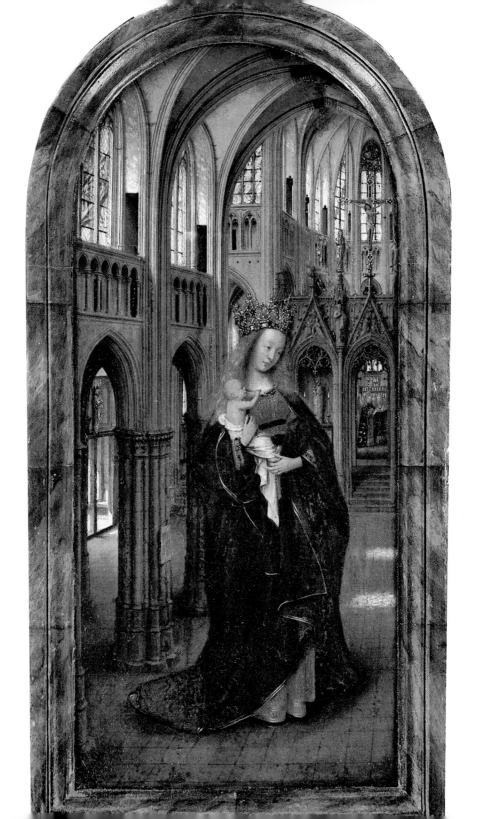

204 MADONNA AND CHILD. German woodcut, c.1440–50. Bibliothèque Nationale, Paris.

experiments were made in Strasbourg around 1434, and he continued them in Mainz after 1447. After a series of small-scale attempts, he embarked in 1452 on setting and printing his *Biblia latina* (42 lines per column), which he finished in 1456. It was followed in 1457 by the *Mainz Psalter*, printed by Johann Fust and Peter Schöffer. Printing quickly spread from Mainz all over Europe, reaching Bamberg in 1457, Strasbourg in 1459, Cologne in 1465, Basel and Augsburg in 1468, Italy in 1465, France in 1470, the Low Countries in 1472.

203

175

205 ALBRECHT PFISTER, BOOK OF THE FOUR HISTORIES. Woodcut. Bamberg, 1462.

206 JOHANN ZAINER, SAPPHO. Woodcut from Boccaccio's *De Claris Mulieribus*. Ulm, 1473.

207 PIERRE LE ROUGE, *Almanach des Bergers*. The March page. Woodcut. Paris, 1488.

In 1500, there were printing plants in about 260 places in Europe. Their geographical distribution has been rightly described as a faithful reflection of the diffusion of intellectual ideas and of economic development in Europe at that date. The styles adopted by this form of communication through pictures have little in common with Gothic art. Ornamental motifs such as pointed arches, Gothic gables, and pinnacles live on as mere decorative flourishes within a framework that was conceived in Italy and which soon ousted even these anachronisms, expressing as it did the spirit of the Renaissance (*207*).

BIBLIOGRAPHY

CULTURAL HISTORY

Cohen, Gustave. *Le théâtre en France au Moyen-Age*. 2 vols. Paris: Rieder, 1928–31.

Curtius, Ernst Robert. *European Literature and the Latin Middle Ages*. London: Routledge and Kegan Paul; New York: Pantheon, 1953.

Faral, E. *La vie quotidienne au temps de Saint Louis*. Paris: Hachette, 1956.

Gilson, Étienne. *History of Christian Philosophy in the Middle Ages*. London: Sheed and Ward; New York: Random House, 1955.

Huizinga, Johann. *The Waning of the Middle Ages*. London: E. Arnold, 1952; Garden City, N.Y.: Doubleday (Anchor), n.d.

Leff, Gordon. *Medieval Thought: St. Augustine to Ockham*. Harmondsworth: Penguin, 1958.

Painter, Sidney. *Medieval Society*. Ithaca, N.Y.: Cornell University Press, 1951; Oxford: Clarendon Press, 1952.

Pirenne, Henri. *Economic and Social History of Medieval Europe*. London: Routledge and Kegan Paul, 1936; New York: Harcourt, 1937.

Previté-Orton, Charles William. *A History of Europe from 1198 to 1378*. London: Methuen; New York: Putnam, 1937.

Renouard, Yves. *Les hommes d'affaires italiens du Moyen-Age*. Paris: Colin, 1949.

Smalley, Berye. *The Study of the Bible in the Middle Ages*. 2d ed. Oxford: Clarendon Press; New York: Philosophical Library, 1952.

Young, Karl. *The Drama of the Medieval Church*. 2 vols. Oxford: Clarendon Press, 1933.

GENERAL

Adhémar, Jean. *Influences antiques dans l'art du Moyen-Age*. London: Warburg Institute, 1939.

Berlat, Émile [Élic Lambert]. *Le style gothique*. Paris: Larousse, 1943.

Brieger, P. *English Art, 1216–1307*. Oxford: Clarendon Press, 1957. (Oxford History of English Art, 4.)

Clark, Kenneth. *The Gothic Revival*. 3d ed. New York: Holt, Rinehart and Winston, 1963; Harmondsworth: Penguin, 1964.

Dehio, Georg Gottfried. *Geschichte der deutschen Kunst*. 3 vols. 3d ed. Berlin: De Gruyter, 1923–34.

Deuchler, Florens. *Die Burgunderbeute*. Bern: Stämpfli, 1963.

Evans, Joan. *Art in Medieval France, 987–1498*. London and New York: Oxford University Press, 1948.

Harvey, John. *The Gothic World, 1100–1600: A Survey of Architecture and Art*. London: Batsford, 1950; New York: Harper (Colophon), 1969.

Henderson, George. *Gothic*. Harmondsworth and Baltimore, Md.: Penguin (Pelican), 1967. (Style and Civilization.)

Huth, Hans. *Künstler und Werkstatt der Spätgotik*. 2d ed. Darmstadt: Wissenschaftliche Buchgesellschaft, 1967.

Karlinger, Hans. *Die Kunst der Gotik*. Berlin: Propyläen, 1927. (Propyläen Kunstgeschichte, 7.)

Mâle, Émile. *The Gothic Image: Religious Art in France of the Thirteenth Century*. New York: Harper (Torchbooks), 1958.

Martindale, Andrew. *Gothic Art: From the Twelfth to the Fifteenth Centuries*. London: Thames and Hudson; New York: Praeger, 1967.

Meyer, P. *Europäische Kunstgeschichte*. Vol. I: *Vom Altertum bis zum Ausgang des Mittelalters*. Zurich: Schweizer Spiegel, 1947.

Panofsky, Erwin. *Abbot Suger on the Art Treasures of Saint-Denis*. Princeton, N.J.: Princeton University Press, 1947.

– Gothic Architecture and Scholasticism. London: Thames and Hudson; New York and Cleveland: World (Meridian), 1957.

Sitwell, Sacheverell. *Gothic Europe.* London: Weidenfeld and Nicolson; New York: Holt, Rinehart and Winston, 1969.

Swarzenski, Hanns. *Monuments of Romanesque Art.* London: Faber and Faber; Chicago: University of Chicago, 1954.

White, John. *Art and Architecture in Italy, 1250–1400.* Harmondsworth and Baltimore, Md.: Penguin, 1966. (Pelican History of Art.)

Worringer, Wilhelm. *Form in Gothic,* ed. Sir Herbert Read. Rev. ed. London: Tiranti, 1957; New York: Schocken, 1964.

ARCHITECTURE

Aubert, Marcel. *L'Architecture cistercienne en France.* 2 vols. 2d ed. Paris: Éditions d'Art et d'Histoire, 1947.

Bandmann, Günter. *Mittelalterliche Architektur als Bedeutungsträger.* Berlin: Gebr. Mann, 1951.

Bauch, Kurt. *Über die Herkunft der Gotik.* Freiburg: Speyer, 1939.

Booz, P. *Der Baumeister der Gotik.* Munich: Deutscher Kunstverlag, 1956.

Branner, Robert. *Burgundian Gothic Architecture.* London: Zwemmer, 1960.

– *Chartres Cathedral.* New York: Norton,1969.

– *Gothic Architecture.* London: Studio Vista; New York: Braziller, 1961.

– *St. Louis and the Court Style in Gothic Architecture.* London: Zwemmer, 1965.

Clasen, K. H. *Die gotische Baukunst.* Neubabelsberg: Athenaion, 1930. (Handbuch der Kunstwissenschaft.)

Colombier, Pierre du. *Les chantiers des cathédrales.* Paris: Picard, 1953.

Frankl, Paul. *The Gothic: Literary Sources and Interpretation Through Eight Centuries.* Princeton, N.J.: Princeton University Press, 1960.

– *Gothic Architecture.* Harmondsworth and Baltimore, Md.: Penguin, 1962. (Pelican History of Art.)

Gall, Ernst. *Die gotische Baukunst in Frankreich und Deutschland,* I. Leipzig: Klinkhardt and Biermann, 1925.

Gerstenberg, Kurt. *Deutsche Sondergotik.* Munich: Delphin, 1913.

Gimpel, Jean. *The Cathedral Builders.* New York: Grove, 1961.

Hahn, Hanno. *Die frühe Kirchenbaukunst der Zisterzienser.* Berlin: Gebr. Mann, 1957.

Jantzen, Hans. *High Gothic: The Classic Cathedrals of Chartes, Reims and Amiens.* London: Constable; New York: Funk and Wagnalls (Minerva), 1962.

– *Über den gotischen Kirchenraum.* Freiburg: Speyer and Kaerner, 1928.

Krautheimer, Richard. *Die Kirchen der Bettelorden in Deutschland.* Cologne: Marcan, 1925.

Lasteyrie, Robert Charles de. *L'Architecture religieuse en France à l'époque gothique.* 2 vols. Paris: Picard, 1926–27.

Mark, Robert. "The Structural Analysis of Gothic Cathedrals." *Scientific American* 227 (November 1972): 90–99.

Paatz, Walter. *Prolegomena zu einer Geschichte der deutschen spätgotischen Skulptur im 15. Jahrhundert.* Heidelberg: Winter, 1956.

Pevsner, Nikolaus. *An Outline of European Architecture.* 6th ed. Harmondsworth and Baltimore, Md.: Penguin, 1960.

Romanini, A. M. *L'Architettura gotica in Lombardia.* Milan: Ceschina, 1964.

Sedlmayr, Hans. *Die Entstehung der Kathedrale.* Zurich: Atlantis, 1950.

Simson, Otto von. *The Gothic Cathedral.* 2d rev. ed. New York: Pantheon, 1962.

Temko, Allan. *Notre-Dame of Paris: The Biography of a Cathedral.* New York: Viking (Compass), 1959.

Wagner-Rieger, Renate. *Die italienische Baukunst zu Beginn der Gotik.* 2 vols. Graz: Böhlaus, 1956–57.

Webb, Geoffrey, F. *Architecture in Britain: The Middle Ages.* Harmondswoth and Baltimore, Md.: Penguin, 1956. (Pelican History of Art.)

SCULPTURE

Aubert, Marcel. *French Sculpture at the Beginning of the Gothic Period, 1140–1225.* London: Hill; New York, Harcourt, 1929.

David, Henri. *Claus Sluter.* Paris: Tisné, 1951.

Koechlin, Raymond. *Les ivoires gothiques français.* Paris: Picard, 1924.

Mahn, Hannshubert. *Kathedralplastik in Spanien.* Reutlingen: Gryphius, 1935.

Natanson, J. *Gothic Ivories of the 13th and 14th Centuries*. London: Tiranti, 1951; New York: Transatlantic, 1953.

Panofsky, Erwin. *Die deutsche Plastik des 11. bis 13. Jahrhunderts*. 1924. Reprint, New York: Krauss, 1969.

Pinder, Wilhelm. *Die deutsche Plastik des 14. Jahrhunderts*. Munich, Wolff, 1925.

Pope-Hennessy, John. *Italian Gothic Sculpture*. London and New York: Phaidon, 1955.

Reitzenstein, Alexander von. *Deutsche Plastik der Früh- und Hochgotik*. Königstein im Taunus: Langewiesche, 1962.

Röhrig, Floridius. *Der Verduner Altar*. Vienna: Herold, 1959.

Sauerländer, W. *Von Sens bis Strassburg*. Berlin: De Gruyter, 1966.

Schädler, Alfred. *Deutsche Plastik der Spätgotik*. Königstein im Taunus: Langewiesche, 1962.

Steingräber, Erich. *Deutsche Plastik der Frühzeit*. Königstein im Taunus: Langewiesche, 1962.

Stone, Lawrence. *Sculpture in Britain: The Middle Ages*. Harmondsworth and Baltimore, Md.: Penguin, 1955.

Vitry, Paul. *French Sculpture During the Reign of St. Louis, 1226–1270*. London: Hill; New York: Harcourt, 1929.

Vöge, Wilhelm. *Bildhauer des Mittelalters: Gesammelte Studien*. Foreword by Erwin Panofsky. Berlin: Gebr. Mann, 1958.

PAINTING

Aubert, Marcel. *Le vitrail en France*. Paris: Larousse, 1946.

Aubert, Marcel; Chastel, André; Grodecki, L.; and others. *Le vitrail français*. Paris: Éditions Deux Mondes, 1953.

Deschamps, Paul, and Thibout, Marc. *La peinture murale en France au debut de l'époque gothique: De Philippe-Auguste à la fin du règne de Charles V (1180–1380)*. Paris: Centre national de la recherche scientifique, 1963.

Dodwell, C. R. *Painting in Europe, 800 to 1200*. Harmondsworth and Baltimore, Md.: Penguin, 1971. (Pelican History of Art.)

Drobna, Zoroslava. *Gothic Drawing*. Prague: Artia, 1956.

Dupont, J., and Gnudi, Cesare. *Gothic Painting*. Geneva: Skira, 1954.

Hahnloser, Hans R. *Villard de Honnecourt*. Vienna: Schroll, 1935.

Meiss, Millard. *French Painting in the Time of Jean de Berry*. 2 vols. London and New York: Phaidon, 1967.

Morand, Kathleen. *Jean Pucelle*. Oxford: Clarendon Press, 1962.

Oertel, Robert. *Early Italian Painting to 1400*. Rev. ed. London: Elek; New York: Praeger, 1968.

Panofsky, Erwin. *Early Netherlandish Painting*. 2 vols. New York: Harper (Icon), 1971.

Rickert, Margaret. *Painting in Britain: The Middle Ages*. Harmondsworth and Baltimore, Md.: Penguin, 1954. (Pelican History of Art.)

Ring, Grete. *A Century of French Painting, 1400–1500*. London: Phaidon, 1949.

Stange, Alfred. *Deutsche Malerei der Gotik*. 11 vols. Berlin: Deutscher Kunstverlag, 1934–61.

Tröscher, Georg. *Burgundische Malerei*. Berlin: Gebr. Mann, 1966.

Turner, D. *Early Gothic Illuminated Manuscripts*. London: British Museum, 1965.

Végh, János. *Fifteenth Century German and Bohemian Panel Paintings*. New York: Taplinger, 1968.

Winkler, Friedrich. *Die flämische Buchmalerei des 15. und 16. Jahrhunderts*. Leipzig: Seeman, 1925.

Worringer, Wilhelm. *Die Anfänge der Tafelmalerei*. Leipzig: Insel, 1924.

EXHIBITION CATALOGUES

Baltimore, Walters Art Gallery. *The International Style: The Arts in Europe Around 1400*. 1962.

Cleveland, Museum of Art. *Treasures from Medieval France*, ed. William D. Wixon. 1967.

Cologne, Wallraf-Richartz-Museum. *Der Meister des Bartholomäus-Altares; Der Meister des Aachener Altares; Kölner Maler der Spätgotik*. 1961.

Detroit, Institute of Arts. *Flanders in the Fifteenth Century: Art and Civilization*. 1960.

Krems, Minoritenkirche. *Gotik in Österreich*. 1967.

New York, Metropolitan Museum of Art. *The Year 1200: Between Romanesque and Gothic.* 1970.

Paris, Bibliothèque Nationale. *La librarie de Charles V.* 1968.

– *Les manuscripts à peintures en France de XIIIe au XVIe siècle.* 1955.

Paris, Louvre. *Cathédrales: Sculptures, vitraux, objets d'art, manuscripts des XIIe et XIIIe siècles.* 1962.

– *L'Europe gothique, XIIe–XIVe siècles.* Council of Europe, 1968.

Paris, Musée des Arts Décoratifs. *Les trésors des églises de France.* 1965.

Paris, Sainte-Chapelle. *Saint Louis à la Sainte-Chapelle.* 1960.

Salzburg, Domoratorien. *Schöne Madonnen, 1350-1450.* 1965.

Vienna, Kunsthistorisches Museum. *Europäische Kunst um 1400.* 1962.

INDEX

Descriptions of the illustrations are listed in boldface type